Lectures on the Affinity of Painting with the Other Fine Arts

Lectures on the Affinity of Painting with the Other Fine Arts

by Samuel F. B. Morse

Edited with an Introduction
by Nicolai Cikovsky, Jr.

University of Missouri Press
Columbia & London, 1983

Lectures and Textual Alterations
Copyright © 1983 by
The National Academy of Design
Introduction and Scholarly Apparatus
Copyright © 1983 by
The Curators of the University of Missouri
Library of Congress Catalog Card Number 82–13551
Printed and bound in the United States of America
University of Missouri Press
Columbia, Missouri 65211
All rights reserved

Library of Congress Cataloging in Publication Data

Morse, Samuel Finley Breese, 1791–1872.
 Lectures on the affinity of painting
with the other fine arts.

 Bibliography: p.
 1. Painting—Addresses, essays, lectures.
I. Cikovsky, Nicolai, Jr. II. Title.
ND53.M66 1983 750 82–13551
ISBN 0-8262-0389-2

All written material by Morse is used
courtesy of The National Academy of Design

To my mother—in memory

Acknowledgments

This edition of Samuel F. B. Morse's heretofore unpublished *Lectures on the Affinity of Painting with the Other Fine Arts* originated many years ago at Harvard University. I still remember my excitement in tracing the manuscript—less difficult I know now than it seemed then—to the archives of the National Academy of Design. I recall, too, my wonderment that no one seemed to share my interest in the lectures, or to recognize their importance as a major document of American art, cultural, and intellectual history—no one, that is, but Professor Benjamin Rowland, who encouraged and supported my work on the lectures and shared the excitement of their discovery.

Over the years, others have helped in numerous ways to see the project of editing the lectures and preparing them for publication through to completion:

John Dobkin, Director of the National Academy of Design, and members of his staff (most especially his assistants, Barbara S. Krulik and Abigail Booth Gerdts) have been boundlessly generous in providing access to Morse material in the Academy archives. And, of course, without the Academy's permission to publish the lectures, given freely and even enthusiastically, all of my work would have been fruitless.

The staffs of the Harvard University libraries (Fine Arts and Widener), the Library of Congress, and Yale University archives have repeatedly provided invaluable assistance and have been unfailingly cooperative.

Grants from the Research Allocations Committee of the University of New Mexico supported travel and the acquisition of photographs. This help was essential and it is a pleasure to acknowledge it.

A number of friends and colleagues have given encouragement, criticism, and assistance: Tom Barrow, William Gerdts, Elizabeth Hadas, the late H. W. Janson, Marvin S. Sadik, and Paul Staiti. I warmly thank them all.

To my wife, Sarah Greenough, go inexpressible thanks, innumerable apologies, and illimitable affection.

N. C., Jr.
Albuquerque, New Mexico
August 1982

Contents

Illustrations

Editor's Introduction

Morse "was not exclusively, perhaps not predominantly artistic; he wrote fluently, was an habitual student and observer in the field of general knowledge . . . ; of broad social instincts and enterprising mental scope, there was less of the professional limner, and more of the liberal and philosophical inquirer about him, than is often discoverable among our artists."

— Henry T. Tuckerman, *Book of the Artists,* 1867

"The art, however attractive, presents but a portion of its artist's mind, and . . . a true estimate of the man can only be gathered from evidence beyond that which his works can supply."

— Lady Eastlake, "Memoir of Sir Charles Eastlake"

I

As the inventor of the magnetic telegraph, Samuel F. B. Morse (1791–1872) was one of the great heroes of the nineteenth century. His fame as an inventor has overshadowed—or made a mere curiosity—his life and achievements as an artist.[1] But art was no transient fascination or youthful enthusiasm. On the contrary, Morse was a devoted, practicing artist for more than a quarter of a century, from 1811, when he went to England to study art, to about 1840, persisting in the practice of art despite discouragements that would soon have demoralized anyone less dedicated. Only in the 1840s did artistic disappointments combine with Morse's successful experiments with the telegraph to alienate him from art—although even in renouncing painting he said it was because "she has been a cruel jilt to me. I did not abandon her, she abandoned me," and he described himself as "an exile from Art."[2] Furthermore, Morse was the most richly endowed artist of his generation. Soundly trained and technically gifted as a painter, with the advantages of extensive foreign study and a liberal academic education (at Yale, class of 1810), he was learned, literate, articulate, cultivated,

1. This was so even during his lifetime. As early as 1847, Henry Tuckerman wrote, "He desired to identify his name with art, but it has become far more widely associated with science" (*Artist-Life; or, Sketches of American Painters,* New York, 1847, 70). Tuckerman later added, "The artistic reputation of Morse has long faded in the glow of his scientific fame; and the vicissitudes of his artistic life are forgotten in the prosperity of his executive career" (*Book of the Artists,* New York, 1867, 169).

2. SFBM to James Fenimore Cooper, 20 November 1849, in *Samuel F. B. Morse: His Letters and Journals,* ed. Edward Lind Morse, Boston and New York, 1914, 2:31 (hereafter cited as *Letters*); SFBM to Asher B. Durand, 7 April 1849 (National Academy of Design).

and cosmopolitan—a striking contrast, in these respects, to such contemporary American artists as Alvan Fisher and Thomas Doughty. Nor were Morse's interests confined to painting. He executed a significant piece of sculpture, the *Dying Hercules* of 1812 (fig. 1); was one of the first in America to experiment with and practice the daguerreotype (in 1839);[3] was the moving spirit behind the founding of the National Academy of Design (in 1825) and served as its first president (from 1826 to 1842); was the first Professor of the Literature of the Arts of Design at New York University (beginning in 1835); and was, most extensively in his *Lectures on the Affinity of Painting with the Other Fine Arts,* an eloquent and ingenious writer and speaker in the cause of promoting artistic culture in America. In addition to his artistic activities were Morse's many ventures into invention, politics, poetry, and music, because of which his modern biographer called him the "American Leonardo."[4]

Despite his many endowments and attainments, Morse's career as an artist was a thwarted and unhappy one. Every ambition, idealistic or mundane, ended in disappointment. Morse was led by his teachers Washington Allston and Benjamin West and by his own very considerable knowledge of the theoretical literature of art—of which his lectures on painting are the fullest result—to the practice of history painting as the most exalted form of art. He experienced early success in this field: his painting the *Dying Hercules* (fig. 2) was well received at its first exhibition in London, and the sculpture he made as a model for it (fig. 1) won a gold medal at the Society of Arts exhibition in London in 1812. Yet he was never able to support himself as an artist except as a portrait painter (see figs. 3, 4, and 5). He painted portraits skillfully and at times profitably, in the elegant and fluent manner of the English school, particularly in the style of Sir Thomas Lawrence (compare, for example, figs. 6 and 24). But portrait painting was drudgery for Morse. "I cannot be happy," he wrote, "unless I am pursuing the intellectual branch of the art. Portraits have none of it; landscape has some of it, but history has it wholly." He felt that painting portraits was "throwing away the talents which Heaven has given me for the higher branches of art, and devoting my time only to the inferior."[5] Portraiture was made more galling to Morse by having to practice it as an itinerant in New England and the South, traveling in search of the clients who did not come to him.[6] Projects aimed at financial rewards through art, such as *The Old House of Representatives* of 1822 (fig. 7) and *Gallery of the Louvre* of 1832 (fig. 8), which he showed in what he hoped would be lucrative public exhibitions, failed completely in that objective. And

3. Beaumont Newhall, *The History of Photography,* rev. and enlarged ed., New York, 1982, 28, and Robert Taft, *Photography and the American Scene,* New York, 1938, chap. 1.

4. Carlton Mabee, *The American Leonardo; A Life of Samuel F. B. Morse,* New York, 1943.

5. SFBM to his parents, London, 2 May 1814, in *Letters* 1:132. ". . . Had I no higher thoughts than being a first-rate portrait-painter, I would have chosen a far different profession. My ambition is to be among those who shall revive the splendor of the fifteenth century" (Ibid., 177).

6. Mabee, *American Leonardo,* especially chaps. 5 and 6.

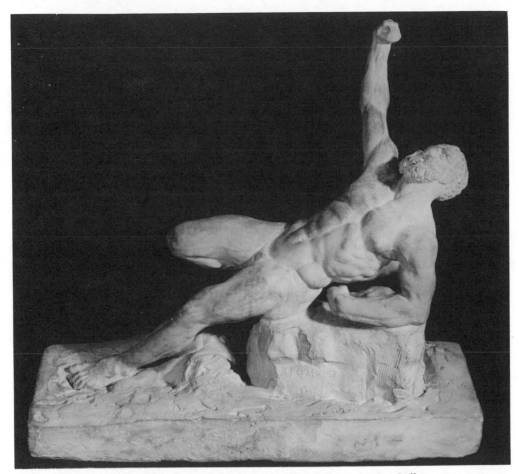

Figure 1. Samuel F. B. Morse, *Dying Hercules*, 1812. Yale University Art Gallery.
Gift of the Reverend E. Goodrich Smith.

Morse's expectation of receiving the greatest commission that his country could bestow upon an artist, a historical panel for the Capitol rotunda, never materialized. In short, every ideal Morse held or practical scheme he attempted in art led to frustration and failure. His artistic life consisted, he wrote, of "struggles and sacrifices . . . made under every disadvantage and discouragement."[7] Only as the inventor of the telegraph did Morse realize at last the fame and fortune that so persistently escaped him as an artist.

 Morse was continually distracted—even before the terminal distraction of the telegraph—from the concentrated practice of art. Whether from a constitutional changeableness that his father noticed in him as a boy ("Your natural disposition . . . renders it proper for me earnestly to recommend to you to *attend to one thing*

 7. Draft of letter from SFBM to Washington Allston, 21 March 1837 (Morse Papers, Library of Congress).

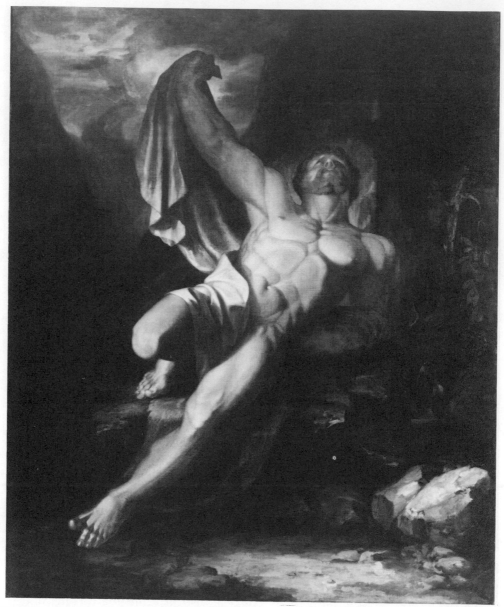

Figure 2. Samuel F. B. Morse, *Dying Hercules*, 1812. Yale University Art Gallery. Gift of the Artist.

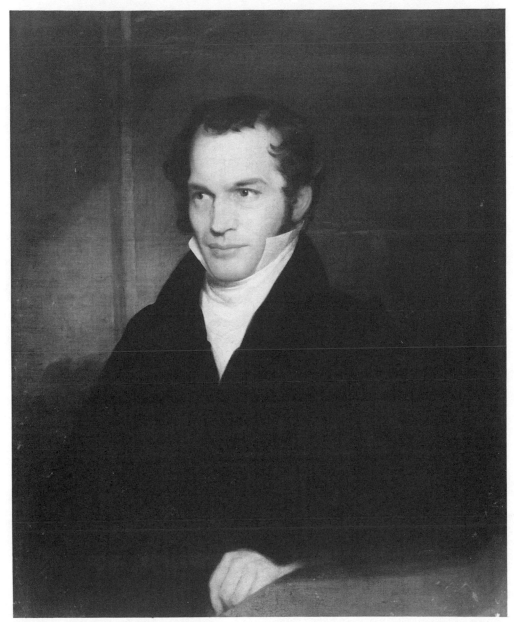

Figure 3. Samuel F. B. Morse, *William Cullen Bryant*, 1825. National Academy of Design, New York.

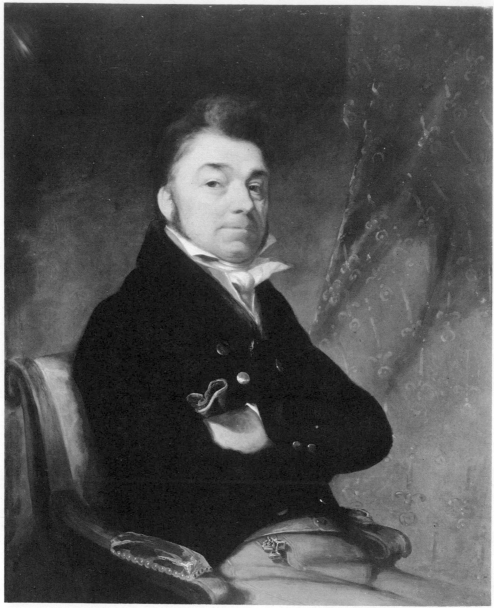

Figure 4. Samuel F. B. Morse, *David C. DeForest*, 1823. Yale University Art Gallery. Gift of Mrs. P. J. Griffin, 1893.

Figure 5. Samuel F. B. Morse, *Mrs. David C. DeForest*, 1823. Yale University Art Gallery. Gift of Pastora Jacoba DeForest Griffin.

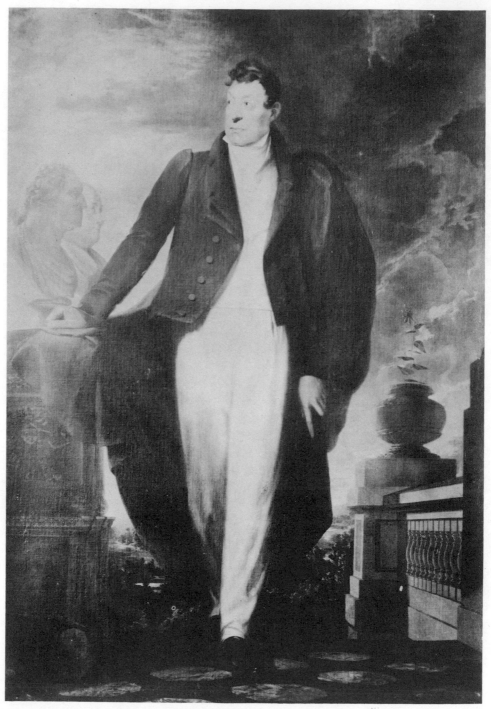

Figure 6. Samuel F. B. Morse, *Lafayette,* 1825. City Hall, New York. Courtesy of the Art Commission of the City of New York.

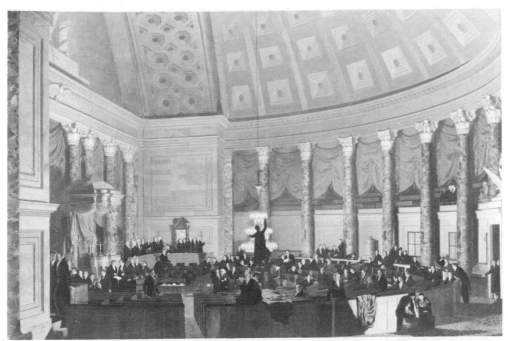

Figure 7. Samuel F. B. Morse, *The Old House of Representatives,* 1822. In the collection of The Corcoran Gallery of Art, Museum Purchase.

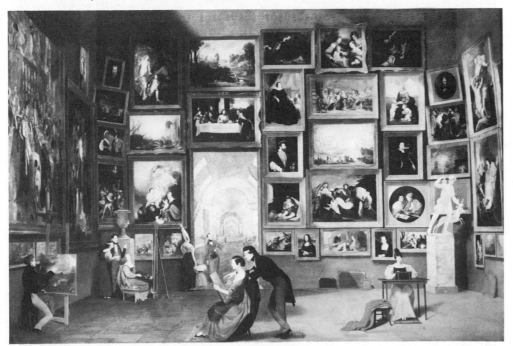

Figure 8. Samuel F. B. Morse, *Gallery of the Louvre,* 1831–1833. Courtesy of the Daniel J. Terra Collection, Terra Museum of American Art, Evanston, Illinois.

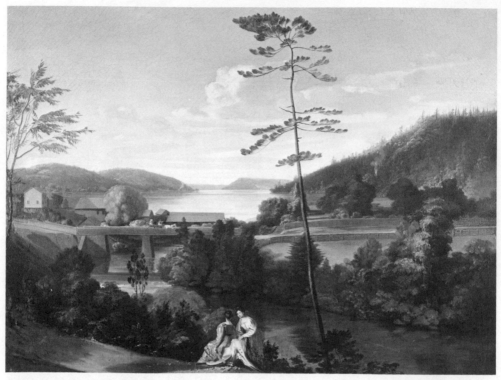

Figure 9. Samuel F. B. Morse, *View from Apple Hill*, c. 1829. The Clark Estates.

at a time");[8] or because of the tragic death of his young wife in 1825, at the most promising point in his artistic career;[9] or by the many, varied, and always abortive schemes undertaken in the pursuit of income sufficient to allow him to paint the history paintings that made him happy; or by his Nativist political activities and campaigns for office;[10] or by his institutional and pedagogical services to art[11]—for some or all of these reasons he was never able to sustain a

8. Jedidiah Morse to SFBM, Charlestown, Mass., 21 February 1801 (Ibid.).

9. She died unexpectedly on 7 February 1825, while Morse was in Washington for the first sittings for the Lafayette portrait (Mabee, *American Leonardo*, 98ff.).

10. Morse became actively involved in Nativism and anti-Catholicism in 1834, to a great extent because of his first-hand experiences of political turmoil in France and Italy and his contact with the Catholic church in Italy. In 1835 he published *Foreign Conspiracy Against the Liberties of the United States* and *Imminent Dangers;* in 1841, *Our Liberties Defended.* He edited *The Proscribed German Student* in 1836 and *Confessions of a French Catholic Priest* in 1837. In 1836 he ran unsuccessfully for mayor of New York on the Native American ticket; in 1841 he was again an unsuccessful candidate (Mabee, *American Leonardo,* chap. 15).

11. Thomas S. Cummings traced Morse's failure as an artist to such service: "At the time of our first acquaintance [in 1825–1826] Mr. Morse was in the enjoyment of lucrative and prosperous practice, as a portrait-painter, in the city. His studio was crowded with works in progress, and the demands on his pencil unceasing from the talent, wealth and fashion of the city, daily refusing

10

continuous artistic growth. As a result, his art presents an appearance of variety—composed of history paintings, portraits, subject pictures like *The Old House of Representatives* and *Gallery of the Louvre*, allegories, and landscapes (see fig. 9)—that, although partly the reflection of a fertile mind, resourceful spirit, and flexible talent, was determined as much by circumstance as by conviction, as much by opportunity—or, usually, its semblance—as by choice.

Despite its failure, frustration, and fragmentation, however, Morse's artistic life was by no means inconsiderable. He must be taken seriously to some extent if only because his career, in which invention triumphed over art and the practical succeeded the imaginative, is an irresistible exemplification—almost a parable—of the plight of art in early nineteenth-century America. But Morse is much more than a mere example, and one way of seeing him wholly, in the fullness of his artistic culture, is through his *Lectures on the Affinity of Painting with the Other Fine Arts*. A great deal is known about Morse's ideas and feelings from his many letters and journals that have been preserved and, to a large extent, published.[12] In none of them, however, nor in Morse's published lecture, *Academies of Art* (1827), are his artistic beliefs and intellectual resources as available as they are in his lectures on painting. In no other single literary undertaking did Morse invest so much thought and energy for so long—indeed, for virtually his entire active life as an artist—or so systematically and extensively express his ideas. In none, for this reason, can one so clearly read his artistic character, or see the source of his artistic difficulty. Furthermore, Morse came to realize that the effective part of his artistic career lay less in his paintings than in his literary and promotional activities: "I am more and more persuaded," he wrote James Fenimore Cooper in 1833, "that I have quite as much to do with the pen for the arts as the pencil [brush], and if I can, in my day, so enlighten the public mind, as to make the way easier for those that come after me, I don't know that I shall not have served the cause of the fine arts as effectively as by painting pictures which might be appreciated 100 years after I am gone."[13] Morse's lectures on painting are his largest literary and promotional effort; as such, they occupy a very special place in his artistic enterprise.

The lectures were not published during Morse's life nor after his death. Why they have been neglected—sometimes noted but almost never read—is difficult to say. They were received favorably. The *New-York American* reported after

commissions, and sending the applicants to other artists for execution. . . . Mr. Morse's connection with the Academy was doubtless unfavorable in a pecuniary point of view. His interest in it interfering with professional practice, and the time taken to enable him to prepare his course of lectures, materially contributed to favor a distribution of his labors in art to other hands, and it never fully returned to him" (quoted in Samuel I. Prime, *The Life of Samuel F. B. Morse, LL.D.,* New York, 1875, 159–60).

12. Chiefly in Prime, E. L. Morse, and Mabee.

13. New York, 21 February 1833 (Morse Papers, Library of Congress).

the first lecture that "notwithstanding the inclemency of the weather, [it] was most respectably attended, and the attention of the auditory was well rewarded. Mr. Morse treated his subject with taste and skill, evincing that he was not less ready with the pen than with the pencil."[14] The *New-York Review and Athenaeum Magazine* said the first two lectures "do him great honor."[15] A correspondent to the *New-York American* reported after the second lecture: "The lecture room last evening was filled to overflowing, with the beauty and fashion of our city. Every one seemed pleased—the ladies in particular, if one might judge from appearances, were highly gratified."[16] Morse's brother Sidney wrote their parents, "His lectures have done him great credit & bro't the arts into more estimation,"[17] and Morse himself wrote them on the same day "I think I have been successful; my audience, (consisting of the most fashionable and literary society of the city), regularly increased at each successive lecture, and at the last, it was said that I had the largest audience ever assembled in the room."[18] William Dunlap said the course of lectures "was received by crowded audiences with delight."[19] Furthermore, the lectures were mentioned by all of Morse's early biographers: Dunlap, Tuckerman, Prime, and E. L. Morse.[20] Apparently the only person to have actually read the lectures, however, was Winifred Howe, who, in her *History of the Metropolitan Museum,* gave a brief summary of them.[21] Mabee, who otherwise so diligently explored primary source material, mentioned the lectures only in a note, deferring to Howe for their contents.[22]

The lectures did not receive their due, of course, largely because they were never published. That Morse originally intended them to be published is suggested by the bibliographical citations in the text, which would have been unnecessary if it was to be used only for oral presentation. It was reasonable to expect them to be published. Other lectures in the Athenaeum series were published, as were contemporary discourses on art by Giulian Verplanck, William Beach Lawrence, and Richard Ray.[23] One reason Morse's lectures were not published at the time they were delivered may have been the difficulty and expense of printing a text containing illustrations and diagrams, some in color. Or perhaps, in the busy years of the mid-1820s, Morse never found time to put them into proper shape for publication. In a passage added to the lectures in the

14. 21 March 1826.

15. 2 (April 1826): 367.

16. 4 April 1826.

17. Letter of 18 April 1826 (Morse Family Papers, Yale University Archives).

18. Morse Papers, Library of Congress.

19. *History of the Rise and Progress of the Arts of Design in the United States* (New York, 1834), 2:316.

20. Dunlap, *History* (1834), 2:316; Tuckerman, *Book of the Artists* (1867), 165; Prime, *Life* (1875), 169–70; *Letters* (1914), 1:284–86.

21. New York, 1913, 53–54.

22. *American Leonardo*, 393n.

23. See below, n. 46.

1830s he said, "The theory I endeavored to establish I then considered as a Foundation upon which I hoped to erect at a future period, (should time and opportunity permit), a larger and more complete edifice," but the time and opportunity never came.

That the lectures have remained unpublished and unknown has to do with a lack of serious modern interest in Morse as an artist. But it has also to do with a general modern distaste—or mistrust—for formal and public artistic expression, and the preference instead for the intimate and informal utterance in letters and journals—the counterpart of the modern preference for the sketch over the exhibition piece.

Morse's other major lecture, *Academies of Art,* is, by virtue of its publication, more widely available and more famous than the lectures on painting. Although it is undeniably a good specimen of Morse's erudition and cultivation, they are enlisted there in a special cause: the historical justification of the purpose and form of the National Academy of Design. (It was delivered to mark the first anniversary of the Academy's founding.) The lectures on painting are less special and more spacious, broader in their scope and purpose, more capacious in their content. The fact that they were never published, rather than being in any way a sign of Morse's imperfect regard for them, suggests instead how much they meant to him. It is as though they never could have—that Morse would never *allow* them to have—the fixity and finality that would make them publishable, as though he wanted them to remain a continually malleable medium for his ideas, an always adaptable vehicle for their expression. As such, they were the most intimate reflection of his beliefs that a mode of public discourse would allow.

II

Morse delivered the series of four lectures in 1826, on the Monday evenings of 20 and 27 March and 3 April, and Wednesday, 12 April (he was scheduled to complete them on the 10th but a freak snow storm and his own "indisposition" prevented it).[24] The lectures were read in the chapel of Columbia College for the New York Athenaeum—not, as it has been said, for the National Academy of Design, the presidency of which Morse assumed in the spring of 1826. His lectures were part of a series of lectures sponsored by the Athenaeum, founded in 1824 to furnish "opportunity for the highest culture, and to advance science, art, and literature."[25]

Morse chronicled his effort in preparing the lectures, his perception of their importance, and his misgivings about them in letters to his parents. He first mentioned the lectures to them on 3 November 1825, and though it was more than four months before they were to be delivered he was already hard at work

24. *New-York American,* 10 April 1826.
25. M. J. Lamb, *History of the City of New York,* New York, 1881, 1:705.

upon them: "Every leisure moment must be devoted to my lectures, which I hope to complete by March if possible, but I have made it conditional altogether whether I lecture or not." He attached this condition because "I devote only my evenings to this purpose and if I cannot complete them by devoting this time to them I defer them to another season."[26] By 1 January 1826 Morse had made considerable progress despite his difficulties: "I am much engaged in my lectures, have completed two, nearly, and hope to get through the four in season for my turn at the Athenaeum." He then explained his diligence: "These lectures are of great importance to me, for, if well done, they place me alone among the artists; I being the only one who has yet written a course of lectures in our country. Time bestowed on them is not, therefore, misspent, for they will acquire me reputation which will yield wealth."[27] About two weeks later, however, he found the burden of the lectures oppressive and entertained the thought of postponing them: "My lectures I find I can easiest defer until another season and have them better for the delay. I think of notifying the Athenaeum Committee that I shall be unable to fulfill my engagement. This will relieve my mind from a great weight."[28] But he persevered in completing and delivering them, and he wrote his parents at the conclusion of the series: "The pressure of my lectures became very great towards the close of them, and I was compelled to bend my whole attention to their completion. I did not expect when I delivered my first that I should be able to give more than *two*, but the importance of going through, seemed greater as I advanced, and I was strengthened to accomplish the whole number."[29]

It is clear from the letters that the most intensive and conclusive work on the lectures took place in roughly the six months from November 1825 to their completion in April 1826, during which time he devoted "every leisure moment" and later bent his "whole attention" to them. At that time they received their present form, organization, and dimension. The lectures are so interesting and important, however, because they reach beyond the time in which they were written and delivered; because in them Morse drew upon many years' thought and preparation; and because they became the most important vehicle for the expression of Morse's artistic beliefs and the exertion of his artistic influence.

The notion of developing formal lectures on art occurred to Morse at least five years before the Athenaeum lectures were delivered. In January 1821, he was one of the founders of an academy of art in Charleston, South Carolina—where he was living as an itinerant portrait painter—before which "it was intended to have lectures read."[30] In April of the same year, back at the family home in New

26. Morse Papers, Library of Congress.
27. *Letters* 1:284.
28. New York, 17 January 1826 (Morse Papers, Library of Congress).
29. New York, 18 April (ibid.).
30. SFBM to his wife, Charleston, 28 January 1821, in *Letters* 1:235–36. See Paul Staiti, "Samuel F. B. Morse in Charleston, 1818–21," *South Carolina Historical Magazine* 79 (April 1978): 109.

Haven, Connecticut, Morse considered opening his own academy there and evidently prepared lectures for it.[31] Nothing survives of the Charleston and New Haven lectures, and they may have been no more than projected or sketched.[32] Even so, they unquestionably compelled Morse to think systematically about the expression of his artistic ideas, and for this reason they represent the immediate source of his Athenaeum lectures. Yet their roots lie even deeper in Morse's artistic past—indeed, in the very beginnings of his artistic being. As early as 1809, in a college essay on the principles of beauty (variety, proportion, uniformity), germs of the method and terminology of the Athenaeum lectures are visible.[33] A few years later, while an art student in England, Morse thought more fully about issues that appear in developed form in the lectures of 1826. In 1812, for example, Morse explained in a letter to his parents the very different virtues of Sir William Beechey and Benjamin West: he compared them respectively to Pope and Milton, for "by comparing or rather illustrating one art by the other I can give you a better idea of the art of painting than in any other way."[34] Morse particularly enjoyed comparing poetry to painting—always to the advantage of painting—and prodded his literary brother Sidney into a playful, though by no means frivolous, *paragone* of the two arts, believing that he had on his side the "incontrovertible" argument that "a painter *must* be a poet, but a poet need not be a painter."[35] He explained this more exactly to his parents: "The painter possesses with the poet a vigorous imagination, where the poet stops, while the painter exceeds him in the mechanical and very difficult part of the art, that of handling the pencil."[36] The Athenaeum lectures, therefore, were organized around a consideration of the kinship of the arts that Morse had explored while he was still a student.

He also understood two other main ingredients of his later lectures at that time. His observation that a "vigorous imagination" was the common endowment of the painter and the poet foreshadows his definition of a fine art as "an Art whose principal intention is to please the imagination." And one of the exceptions that Morse took in the Athenaeum lectures to the general opinion of

31. Mabee, *American Leonardo,* 82.

32. In the third lecture Morse included passages from Edwin Atherstone's epic poem, *The Last Days of Herculaneum,* published in 1821 and never reprinted. In the first lecture is a quotation from the first volume of *The Magazine of the Fine Arts,* which was first published in 1821 and had a short life. Both may be remnants of the Charleston and New Haven lectures. Atherstone's poem is so obscure and *The Magazine of the Fine Arts* was so transient that it is unlikely that Morse would have consulted either four or five years later when preparing the Athenaeum lectures. But a new poem and a new art magazine would excite his interest when they first appeared in 1821 and find their way into material Morse was gathering that year in preparing his lectures.

We may know something of the form of lectures Morse was planning or contemplating in 1821; see pp. 27–29.

33. Morse Papers, Library of Congress.

34. *Letters* 1:63.

35. Ibid., 100, 110; Edwards's response, 117.

36. Ibid., 63.

earlier theorists was the greater favor in which he held "mechanical imitation," exact illusionist depiction, which classical theory disdained as mindless labor.[37] This tolerance is present earlier in Morse's belief that it is in "the mechanical and very difficult part of the art" that painting excels poetry.

Another aspect of the Athenaeum lectures had antecedents. Morse was a keenly ambitious artist, particularly in the mid-1820s when he prepared the Athenaeum lectures. They were an important instrument of this ambition: Morse hoped they would acquire him "reputation which will yield wealth," and they were part of a carefully calculated—and in some respects calculating—scheme to place himself in the first rank of New York artists. His scheme was based on a shrewdly perceptive reading of the economic and artistic situation in New York. He sketched it in detail in an August 1823 letter to his wife:

> The more I think of making a push at New York as a permanent place of residence in my profession [the years before had been ones of itinerancy], the more proper it seems to me that it should be pretty soon. There is now no rival that I should fear; a few more years may produce one that would be hard to overcome. New York does not yet feel the influx of wealth from the Western [Erie] canal, but in a year or two she will feel it, and it will be advantageous to me to be previously identified among her citizens as a painter. It requires some little time to become known in such a city as New York. Colonel [John] T[rumbull] is growing old, too, and there is no artist of education sufficiently prominent to take his place as President of the [American] Academy of Arts. By becoming more known to the New York public, and exerting my talents to discover the best methods of promoting the arts and writing about them, I may possibly be promoted to his place, where I could have a better opportunity of doing *something for the Arts in our country,* the object at which I aim.[38]

Self-interest and self-promotion are clearly central to this plan. But a public-minded concern for improving the condition of art in America is no less plainly a part of it. While still a student in England, before his disappointments or his efforts to gain artistic leadership in New York sharpened his self-interest, Morse expressed sincere interest in the improvement of public taste. In "Thoughts and Observations on the Fine Arts, in an unconnected manner, as they came across my mind at various times," he wrote: "On returning to America let my endeavor be to rouse the feeling for works of art, by essays in the papers, . . . perhaps a little pamphlet got up in an interesting way, with little anecdotes, would be well to distribute among rich men &c."[39] And in 1814, he wrote of his plan for—or more exactly, perhaps, his vision of—national cultural improvement:

37. For example, Sir Joshua Reynolds: ". . . A mere copier of nature can never produce any thing great; can never raise and enlarge the conceptions, or warm the heart of the spectator" (Discourse 3, *Discourses on Art,* ed. R. R. Wark, San Marino, Calif., 1959, 41); references are to this edition of the *Discourses* throughout.

38. *Letters* 1:248–49.

39. Morse Papers, Library of Congress.

All we wish is a *taste* in the country and a little more *wealth*. . . . In order to create a taste, however, pictures, first-rate pictures, must be introduced into the country, for taste is only acquired by a close study of the old masters. In Philadelphia I am happy to find they have successfully begun [with the founding in 1806 of the Pennsylvania Academy of Fine Arts]. I wish Americans would unite in the thing, throw aside local prejudices, and give their support to *one* institution. Let it be in Philadelphia, since it is so happily begun there, and let every American feel a pride in supporting that institution; let it be a *national* and not a *city* institution.[40]

Years later Morse was able to give this vision concrete form. He justified calling the academy he was largely responsible for creating *National* because no other name would place it above its rival, the American Academy.[41] But surely that choice was not so pettily inspired, and in Morse's title there survived that magnanimous wish for a national artistic institution that he had expressed more than a decade earlier.

Because the Athenaeum lectures represented a gathering of long-standing ideas and beliefs and were not, though composed under the pressure of time, the hasty concoction of the moment, they can be considered the authoritative version of Morse's artistic thought. But not for this reason alone. Another more certain indication of their authority is their repeated use after the initial delivery in 1826. It is impossible to say exactly when, how often, in what form, or in what circumstances the lectures were delivered again. But evidence suggests that Morse used them off and on for the Athenaeum and perhaps for the National Academy of Design until 1829, when he began a three-year visit to Europe.[42] He surely used them after his return. In 1835, Morse began teaching at the recently founded New York University as its Professor of the Literature of the Arts of Design, a title that reflects the true character, by this time, of Morse's artistic contribution and concern. Morse referred to his academic title in an introductory passage that he added to the first lecture, so it is certain that he was using the lectures again by 1835.[43]

40. *Letters* 1:122.
41. Thomas S. Cummings, *Historic Annals of the National Academy of Design*, Philadelphia, 1865, 27.
42. Dunlap reported that the lectures "were repeated to the students and academicians of the National Academy of Design" *(History* 2:316). Cummings noted, in September 1828, that "arrangements were made for the usual lectures," which included ones by Morse *(Historic Annals,* 114). Morse's lectures "on Painting in connexion with the other Fine Arts," scheduled for February, were part of the 1827–1828 Athenaeum lecture season *(Records of the Meetings of the Board of Associates of the New York Athenaeum,* entry of 27 November 1827; New-York Historical Society). Morse wrote his mother on 1 March 1828: "My lectures at the Athenaeum closed Thursday evening to a 'most *fashionable* and *crowded* house,' as the phrase is" (Morse Papers, Library of Congress).
43. Daniel Huntington was Morse's pupil in 1835 and remembered that he was preparing lectures at that time (Prime, *Life,* 246). An obituary notice stated, "In the year 1835 he delivered a course of lectures [for New York University] upon art" ("S. F. B. Morse, LL.D.," *Harper's Weekly* 16 [20 April 1872]: 311).

There are other signs in the lectures themselves that he was using them in the 1830s,[44] the most important of which is a clipping pasted into the second lecture that provides the latest certain date for the presentation of the lectures. The clipping is from an unidentified newspaper, but it reprints an article from an 1840 issue of *Family Magazine* and thus can date no earlier than that year. Other signs of Morse's continuing use of the lectures are revisions to the original manuscript so extensive that hardly a page of it remained untouched, as well as a nearly exact transcription of the first two lectures, the well-creased folds of which testify to its repeated use.[45]

By about 1840, Morse's significant pictures had been painted and his active life as a painter was virtually at an end. But his continuing use of the lectures shows that his devotion to and engagement with the arts retained tangible form until at least 1840. That Morse's serious concern for art survived until that time, with its major form of expression his lectures on painting, shows, in turn, how central the lectures were, not merely in the propagation of his artistic views, but as a manifestation of his artistic being. It is possible to argue, to be sure, that he used them so often and so long merely from inertia. Alternatively, one might contend that as Morse's artistic disappointments multiplied and his interest in art waned, he relied more on his earlier lectures, tricked up a bit but not fundamentally changed since they were originally delivered in 1826.

But Morse's lectures are more correctly regarded as an expression of his artistic views so complete in their substance and so adaptable to varying uses—for general audiences, for the pupils and instructors of the Academy, and for the students of New York University—that they are virtually a canonical statement. Morse said as much in the introductory remarks added to the first lecture in the 1830s: "I have since [first presenting them in 1826] had the opportunity, by a

Although he was appointed in 1832, Morse did not actually begin teaching until 1835, when he occupied rooms in the newly completed University building on Washington Square. A set of notes in the Morse Papers, Library of Congress, dated 1835 in what seems to be Morse's hand, is probably related to his teaching. The first preserved New York University catalogue, of 1836, listed Lectures on the Principles of the Arts of Design as one of the two courses under Literature of the Arts of Design *(New York University: Its History, Influence, Equipment and Characteristics,* ed. Joshua L. Chamberlain, Boston, 1901, 81).

44. For example, in his revised introductory remarks in the first lecture he spoke of "preparing and delivering the following lectures ten years since," then changed this to "some years since," and finally deleted all reference to the passage of time. In the third lecture he wrote that the impression made by Handel's Halleluiah Chorus had not departed after twenty years, a memorable performance that must have occurred in England in the period 1811–1815. The passage on color added to the fourth lecture, because of its indebtedness to George Field's *Chromatography* of 1835, can have been added no earlier than that year.

45. Morse did not always deliver the full set of four lectures, for in a passage added to and then deleted from the first lecture he spoke of "the circumscribed limits of two lectures." He meant the first two, and at some time produced a slightly digested version of them (National Academy of Design). The lectures as a whole are governed by a clear plan, but they nevertheless tend to fall into two parts. Their main propositions and most careful and ingenious arguments are made in the first

long residence in England, France and Italy [from 1829 to 1832], more thoroughly to prove the soundness of the principles I had advanced. With a wider range of objects presented for my examination, I was gratified to find that these principles stood the test to which they were submitted."

III

Morse was fully aware of the novelty of his lectures. He was, he said, "the only one who has yet written a course of lectures [on art] in our country," which, he believed, would place him "alone among the artists." These were not mistaken or exaggerated claims. Addresses on art had, of course, been delivered in America before Morse lectured at the Athenaeum.[46] But if they were predecessors, they were not precedents, not sources or models. They differed from Morse's lectures in three essential ways. First, they were discourses or addresses, not lectures; that is, they were oratorical in tone and structure, not explanatory or pedagogical. Second, Morse was the first person to give a *series* of lectures on a single theme. Third, he was the first practicing artist to lecture in America.[47] To these innovations Morse later added another: being the first to deliver untechnical lectures on art for an "American Collegiate institution," New York University.

The Athenaeum lectures were conceived on a scale unprecedented in America, by a painter whose knowledge of the subject none of the laymen who spoke on it—and few artists—could match. None of Morse's predecessors had been so ambitious in scope, and none was as fitted professionally, by training and experience, as Morse was to treat the issues of painting involved. Nor was any

two lectures. The last two are devoted mostly to illustrative material, with texts and literary analysis in the third and pictorial examples in the fourth. They add enrichment and reinforcement, but lack the wholeness of the first two lectures and cannot stand separately. Indeed, from what Morse wrote of his lectures the last two seem to have been done somewhat perfunctorily, and in places they show it. He wrote, "I did not expect when I delivered my first that I should be able to give more than *two*" (18 April 1826, Morse Papers, Library of Congress), implying that he had little more to say. This is not true, but the heavy dependency on Blair and the long quotations from Atherstone and Whately, for example, do suggest flagging inspiration and the need to fill space.

Occasional notations on pronunciation ("hard" over the *g* in *target;* "poé-nant" for *poignant)* are perplexing. Surely Morse knew how to pronounce what he himself wrote. Possibly at some time someone else read the lectures for him and made the notations.

46. George Clymer addressed the Pennsylvania Academy of Fine Arts in 1807 (E. S., "The First American Academy," *Lippincott's Magazine* 9 [February 1872]: 148), and Joseph Hopkinson spoke at the first of its annual exhibitions in 1811. Theodore Sizer mentions addresses by Giulian Verplanck (1824) and William Beach Lawrence and Richard Ray (both in 1825) for the American Academy of Fine Arts in New York ("History of the American Academy," in *American Academy of Fine Arts and American Art-Union,* ed. M. B. Cowdrey, New York, 1953, 34–36). DeWitt Clinton addressed the American Academy in 1816 (Cummings, *Historic Annals,* 8–17). The addresses of Hopkinson, Verplanck, Lawrence, and Ray were published soon after their respective deliveries.

47. John Trumbull was scheduled to address the American Academy in 1824 but was replaced by Verplanck.

artist as prepared as Morse by liberal education and aspiration or by wide-ranging interests and experiences to deal with subjects related to painting.[48]

The Athenaeum lectures required someone with Morse's breadth of learning, for the audience he addressed was neither a professional nor even an artistically sophisticated one. And there was not—because of the "peculiar situation of our country," as Morse put it—an "atmosphere of art" in America. This meant that he could not assume that his audience had any experience of painting; it was, as he described it, "an assembly . . . of those who with knowledge and refinement and discernment in literature and science have from the necessity of circumstances been without the means of acquiring to any great extent a knowledge of the principles of Painting." For this reason, Morse could not speak about artists and their works with the assurance that they would be familiar—unlike the English academicians Reynolds, Fuseli, Barry, and Opie, whose discourses and lectures Morse used as models.

Morse was not, however, addressing an untutored audience. On the contrary, it was a discerning one, composed, he said, of the "most fashionable and literary society of the city." The strategy he followed was not to speak directly about painting itself, of which he knew most and his audience least, but to approach painting by way of more familiar arts. He made his subject not the principles, technicalities, personalities, or history of painting—as did those he took as models—but the affinity of painting with other fine arts. By demonstrating the operation of the same principles and methods within and among them, he explained the strange art of painting through operations and effects it shared with arts more familiar to his audience—particularly poetry, music, and landscape gardening—aided in his explanations by a distinct gift for apt illustration.

Morse developed his subject in four stages, corresponding to each of the four lectures:

In the first lecture he defined the fine arts, "classing them on the quality of their principal aim to please the imagination." He found six arts to be fine—as opposed to useful, necessary, or elegant—arts, in addition to painting and sculpture: poetry, music, landscape gardening, architecture, oratory, and theatre (the "histrionic art"). The first three were perfect arts, the last three imperfect, because they obtain their ends impurely through a mixture of the arts. He also "treated cursorily of the Imagination as the faculty excited and Taste as the faculty judging and selecting objects of Beauty and Sublimity to excite it."

Morse began the second lecture by contrasting mechanical and intellectual imitation, the former "copying exactly any object just as it is," the latter "making

48. Morse made sculpture, wrote poetry, knew something of the theatre, entered an architectural competition for a building at Andover Seminary (Mabee, *American Leonardo*, 61), and was adept at and charmed by music, "that enchanting art." He boasted of his versatility to his cousin, Sarah Ann Breese: "I am a sculptor, as well as a painter, something of a musician, and can write poetry" (Ibid., 116).

something on the Creator's principles" by imitating the principles rather than the appearance of nature. The bulk of this lecture consists of the enumeration and illustration of "the principles in nature upon which the Fine Arts are based" and which they have in common. These Morse "referred to one general . . . *law of change,*" with its subsidiary principles: motion (the progress of change); order; novelty; connection (including such kinds of connection as contiguity, variety and uniformity, resemblance, gradation, contrast, congruity, relation of whole and parts, unity, and mystery).

In the third lecture, confining his attention to the three perfect fine arts—poetry, music, landscape gardening—Morse discussed the *"materials* and *methods* which the Fine Arts employ in accomplishing their common end to please the imagination" and "their accordance with the principles of nature." This lecture consists mostly of illustrative examples.

Morse reserved the final lecture for painting. In it he showed by argument and pictorial analysis that painting is "entitled to a rank among the Fine Arts, that it possesses material for affecting the Imagination, and that its rules are also founded on the same solid basis of nature" as the other fine arts previously considered. More importantly, he pleaded the necessity of enlightened patronage and public taste as the indispensable conditions for the encouragement of art.

What is most striking about the form of the lectures, even before Morse used them for teaching, is its pedagogical design. It is the most original aspect of the lectures, the one in which they stand furthest from earlier models, and the one that Morse could most justly claim as his invention—in the sense in which invention was then used in art theory to mean a new and artful combination of existing ideas and materials, or in the sense in which Morse's invention of the telegraph was a synthesis of available knowledge and technology.

Their design, too, is what made the lectures so adaptable. Although they were intended for a lay audience, they were, because of their instructive plan and purpose, also suitable for academic and scholastic use. They were particularly adaptable because of Morse's scheme of showing the resemblances between the arts, explaining one by the operations of others. The lectures were thereby not only enlightening for the laity, whose appreciation of painting it was their original purpose to improve, but they could lead those more familiar with painting, even those aspiring to it as a profession, to a greater knowledge of cognate arts by the same comparative method. "The effect on the artist of such a view of the other fine arts," Morse said, "is to elevate his aim, and by showing him the general laws by which all the arts are alike governed, to give him more confidence in the pursuit of his studies, and to open a wider range of research, and at the same time to establish a more solid foundation for his discoveries."

There is another level to the lectures, however, one that—although the larger arrangement never disappears—is more apparent to the reader or listener. It constitutes their surface rather than their structure, and is comprised of the

particular beliefs, theories, and examples, both visual and verbal, that Morse used as illustration and proof. It is at this level that one sees Morse's erudition—often because he made a display of it. It is here, also, that one sees Morse's considerable debts to others and to the received ideas of his age.

The full extent and specific nature of this indebtedness are apparent in the annotations to the lectures, in which can be found the particular sources for Morse's thoughts, expressions, and related ideas. What this editorial apparatus does not convey are two important aspects of his sources: their range and the degree of his dependence on them.[49]

As can be seen by looking at the list of sources used by Morse in the Bibliography, Morse's reading comprises an extraordinarily varied group, ranging—sometimes without apparent reason—from the classical to the contemporary; from standard authors to obscure ones; from texts on the practice, appreciation, criticism, and history of the arts, which are to be expected, to treatises on religion; from works of original conception to reference books. The variety of the works cited reflects Morse's scholarly upbringing and academic education,[50] but it also reflects an active intellectual curiosity that survived well into his maturity.

Morse certainly did not own every volume that he cited or used, but his readings constitute a "library" that provides a measure of the shape and substance of his intellectual being, of the truly liberal scope of his learning.[51] Morse's "library" reveals an artist of exceptional intellectual endowments, but it can serve as a library for Morse's age as well, as a compendium of the resources available to—though never to the same extent used by—other American artists of Morse's time that contributed to the formation of their collective artistic belief.

In the final analysis, though, Morse's "library"—if it will not overstrain the figure—was less a public than a private one. For it was gathered not randomly or with scholarly disinterest (despite his academic training and intellectual curiosity, Morse was never a disciplined scholar),[52] but with the specific purpose of

49. In addition to references made in the lectures themselves, the best source of knowledge about Morse's preparatory reading is the notebook "Thoughts on Painting and the Fine Arts generally with a view to a Series of Lectures, adapted particularly to this country" (National Academy of Design). Other references are found in the August 1823 notebook "Hints and Remarks on Painting and the Fine Arts generally & also more particularly with reference to a Series of Lectures on the Fine Arts," as well as numerous pages of notes, most of which are in the National Academy of Design.

50. Blair's *Rhetoric* was adopted by Yale in 1785 and used until the Civil War; Butler's *Analogy* was used in the early nineteenth century (John C. Schwab, "The Yale College Curriculum, 1701–1901," *Educational Review* 22 [June 1901]). Kett's *Elements* was "designed chiefly for the junior students in the universities." The bulk of Morse's reading, however, is postcollegiate.

51. My model for this usage is Elizabeth Johns, "Washington Allston's Library," *American Art Journal* 7 (November 1975): 32–41.

52. His tutor at Yale wrote, "His aversion to study is unconquerable," and Morse himself

enlightening public utterance—of lecturing—always in mind. All of Morse's reading—at any rate, all of his postcollegiate and nonscientific reading—was in some way preparation for this responsibility.

The variety of Morse's reading, the richness of his "library," served him well when it came to preparing the Athenaeum lectures, for their scope and plan would have been impossible without the broad literary culture that reading represented. The lectures could not, in fact, have been contemplated by anyone who did not possess that background. Obviously, not all of Morse's reading was of equal value to him. There is an essential distinction, for example, between works upon which he depended in the Athenaeum lectures for significant theoretical formulations or as models of thought or form and those that were used merely to illustrate particular propositions or to serve as authorities for specific points. By far the largest number of citations belong to the second category: those from the classics, English poetry, and Shakespeare; from Alison, Burney, Gerard, Gillies, and Forsyth—all were used for special purposes only. On the other hand, the influence on Morse's lectures of Blair's *Rhetoric,* Kames's *Elements of Criticism,* and Reynolds's *Discourses* was extensive and profound.

Of all the writers Morse consulted, none influenced him more than Reynolds. Observations and ideas expressed in the *Discourses* resound throughout the lectures. A long passage that Morse quoted from the Thirteenth Discourse, in which Reynolds spoke of the interconnectedness of the arts and their common address to the imagination, so perfectly expressed the organizing principle of Morse's lectures that it is difficult to believe his assertion that he "accidentally perused" it after having "nearly completed [their] plan."

It is easy to understand Morse's dependence on Reynolds. The *Discourses* stated the doctrines of classical art theory so fully and with such felicity of language that they were—and remain—its standard English text. Apart from this, they were especially useful to Morse because they were an example of philosophical rather than technical observations on art, and for this reason more applicable than other available models to Morse's special needs.[53]

Morse may not have depended on the *Discourses* alone, however, but on the example of Reynolds himself. In 1826, when Morse prepared and first delivered the Athenaeum lectures, he was also deeply engaged in the establishment of the National Academy of Design. For this reason, he could not fail to perceive, and may have wished openly to establish, a kinship between Reynolds—the first president of the British Royal Academy and learned writer of the *Discourses*—

acknowledged a "disposition of mind, which was never that of a student's" (Mabee, *American Leonardo,* 16, 63).

53. Fuseli, Barry, and Opie, whose lectures Morse knew and used, confined themselves, as it was said of Benjamin West's discourses, "more strictly to professional topics" (John Galt, *Life of Benjamin West,* London, 1820, 82).

and himself—the first president of the American National Academy of Design (modeled primarily on the Royal Academy)[54] and the first American artist to deliver a course of lectures on art (made as conspicuously learned as possible).[55] Morse may have wished to see himself, and be seen, in his roles as lecturer and president of the National Academy of Design, as the "American Reynolds," with all that that resemblance then implied of artistic eminence and influence.

It is probably for this reason that one can detect in the lectures instances of erudite display. More than once Morse took important passages from the preface or introduction to a work rather than from the body of the text, which suggests that he had dipped lightly into it for the purpose of embellishment. Morse also appropriated from one writer citations of another without clearly acknowledging the debt.[56] His consultation of encyclopedias and other reference books and his close, extensive, and not always clearly announced paraphrases, particularly of Blair's *Rhetoric* and Whately's *Modern Gardening,* may be still other signs of his attempt to give the impression of wider learning than he actually possessed.

The pressure of time when Morse composed the Athenaeum lectures might account for his occasionally cursory use of texts and his resort to reference books. He felt this pressure with special keenness, no doubt, because of the importance he attached to the lectures. Not only was Morse faced with making his best possible appearance for the Athenaeum before the "most fashionable and literary society of the city," but he and his fitness for leadership had become a matter of public attention when he assumed the presidency of the National Academy of Design in January 1826. The scope of Morse's subject and the range of his citations displayed very real richness and depth of learning, showing him to be truly the "artist of education" that he wanted to appear. But because the stakes were so high, Morse succumbed to a temptation to embellish his erudition that is understandable and—because he never resorted to flagrantly empty or pointless display, much less to outright plagiarism—even forgivable.

54. "We have taken the English Royal Academy for our model, as far as the different circumstances of form of government and state of taste will permit" (Morse, address to students of the National Academy of Design, 1827, quoted in Cummings, *Historic Annals,* 42).

55. Morse defended Reynolds's learning in a passage on ancient and modern writers on art removed by him from the first lecture (see Appendix 1).

56. Instances of Morse taking important passages from the preface or introduction to a work rather than from the text include citations from Alison's *Essays,* Burney's *History of Music* (of which he used only the first volume, as he did too of Gillies's *Greece* and Rollin's *Belles Lettres),* and Beattie's *Essays;* his quotation from Beattie's *Minstrel* consists of the first lines of the first book. He also borrowed from one writer references to another without clearly acknowledging the debt: the citations of Pope and Cardinal Bembo are from Reynolds's Thirteenth Discourse; his quotation from Locke is from Lord Kames; one citation of Quintilian is from Rollin; he took Vitruvius's enumeration of the architect's prerequisites from Chambers's *Cyclopedia;* a passage from Milton suspiciously appears also in Hogarth's *Analysis of Beauty;* lines from the *Iliad* appear also in Field's *Chromatography;* and a passage from Romans appears in Field's *Chromatics* (although it must be said that Morse certainly had first-hand knowledge of Homer, Milton, and the Bible).

Regardless of which writer had the most influence on Morse or of how and to what extent he used his various sources, one thing about them is unmistakable: they belong preponderantly to the eighteenth century. The lectures are influenced by the thought and flavored by the critical language of that time. Vigorously alive in Morse's lectures are such concepts as the association of ideas; the chain of being; the sisterhood of the arts, upon which the entire plan of the lectures is founded; the hierarchical classification of subject matter, with "intellectual" or history painting at its top; mankind's innate sense of beauty and taste; and such critical terms—and the issues that hinged on them—as beauty, sublimity, imagination, and taste, all of which one encounters at every turn in the aesthetics and criticism of the eighteenth century. They were modes of thought and discourse upon which Morse and his generation had been raised and that recurred in texts—by Reynolds, Blair, Kames, Alison, and Beattie—that were still considered standard well into the nineteenth century.

In being so greatly dependent upon the beliefs of an earlier time while writing well into the new century, Morse was not expressing some archaic system of thought. Yet it was one to which there were already alternatives in the eighteenth century, which had become open challenges by the time Morse was writing. They arose from that collection of ideas and feelings that is usually called romantic. There are many signs in the Athenaeum lectures that Morse was not impervious to them: he quoted Byron and mentioned Scott;[57] he placed greater weight upon imagination as a source of artistic impulse and a sensibility of artistic appeal than did writers more fully in the classical tradition; he construed the classical principle of General Nature, to use Reynolds's term for it, in a distinctly metaphysical way; he made greater allowance for "mechanical" imitation, moving away from Reynolds's contempt for the "mere copier of nature" and toward the romantic rejection of abstraction in favor of experience directly grasped and faithfully rendered;[58] he gave much attention to color, a departure from the classical preference for line and sculptural form; and in the before-and-after changes he proposed for a house and grounds, he almost categorically replaced classical regularity with romantic variety.[59]

57. He wrote Scott expressing his "homage to a genius which shines unrivalled and deservedly commands the enthusiastic admiration of millions" (1? May 1829, Morse Papers, Library of Congress).

58. As in Hazlitt, for example: "It would be needless to prove that the generality of the Dutch painters copied from actual objects. . . . I forgive them. They perhaps did better in faithfully and skillfully imitating what they had seen than in imagining what they had not seen" (*Criticisms on Art*, ed. W. Hazlitt, London, 1843, 178–79).

59. The background of his lost portrait of Sarah Alston (about 1819) was strikingly and, to one observer, innovatively romantic: "The whole canvas is covered with the ruins of a venerable architecture—gothick—crumbling—and falling. . . . We want, and have long wanted, a somebody who should have courage enough to introduce the romantic irregularities of the Gothick—and abandon the tame, unmeaning, straight, graceful colonnades of Greece" ("Mr. Morse's Picture," *New-England Galaxy & Masonic Magazine* 3, 19 November 1819, 22).

Yet if in these ways Morse reflected new tastes and artistic principles, their effect was more revisionary than revolutionary. There is nothing in his modifications of classical theory at all comparable to the assaults made upon it, for example, by William Blake, William Hazlitt, or John Ruskin. On the whole, Morse accepted his inheritance as he received it. He believed in an art based on universal and unchanging characteristics of nature, reconstituted by the mind of the artist to appeal to the intellect of an educated, cultivated elite. When Morse said that his "path was untrodden," he meant that no lectures like his had been delivered in America. He was not asserting their novel content, and anyone expecting new critical formulations or new theoretical positions will find instead an array of largely familiar ideas. But the lectures, after all, were not a forum for original critical thought. They were persuasive and pedagogical, designed to educate the public about established artistic and critical beliefs, not to assail such beliefs or to concoct new ones.

Likewise, anyone looking to the Athenaeum lectures for explicit Americanness will be disappointed. It is not surprising that Morse, steeped as he was in classical theory, spoke forthrightly of neither modernity nor nationality. Classical theory repeatedly condemned localism of place or time as a confinement of the proper universality of art. The painter, Reynolds wrote, "must divest himself of all prejudices in favour of his age or country. . . . He addresses his works to the people of every country and every age; he calls upon posterity to be his spectators."[60]

Although Morse chose to speak in a universal voice, time and place intruded nevertheless and made themselves essential parts of the lectures. In his political, social, religious, and, to a considerable extent, artistic views, Morse was profoundly conservative. Yet his invention, the telegraph, was a paramount instrument and symbol of progress in the nineteenth century; because of it, Morse occupied the most prominent place in Christian Schussele's *Men of Progress* (1862).

Morse's life and art are filled with similar contradictions. They grew neither from his personality nor his nationality but from the age in which he lived, a time of rapid, revolutionary change that brought old beliefs and new realities into uncomfortable and often incompatible relationships. Thus the mixture in his lectures of classical convictions and critical principles with romantic tastes is not—or is not only—the result of intellectual or aesthetic indecisiveness but the symptom of an uncertainty that Morse shared with his age. The variety of Washington Allston's subjects reflects it, and a similarly uncertain mixture characterizes the work of Morse's French contemporary Théodore Géricault. In this respect, Morse's lectures are fully of their time, completely, if not willingly, modern.

60. Discourse 3, *Discourses on Art,* ed. Wark, 48–49.

American art and artists are virtually unrecognized in his lectures—only Benjamin West is mentioned, and only John Trumbull is illustrated—and Morse said he could detect no "truly American school of art." Nevertheless, the lectures are fundamentally shaped by their nationality—their form and pedagogical purpose are a direct result of the "peculiar situation" of American culture. It is possible to say with some precision when this happened, for it had not always been so. In August 1823, Morse began a pocket notebook that he entitled "Hints and Remarks on Painting and the Fine Arts generally & also more particularly with reference to a Series of Lectures on the Fine Arts."[61] One must suppose that he had thought seriously about—and had begun, at least, to prepare—lectures for the Charleston and New Haven academies in 1821. It is only two years later, however, in the "Hints and Remarks," that concrete evidence of planning for a series of lectures exists. There is no indication of how the "Hints and Remarks" were to be used, but the time at which he began them, August 1823, is significant. It is precisely the time that Morse wrote (in a letter to his wife) with great clarity of purpose and procedure of "making a push at New York as a permanent place of residence in my profession," a push that involved showing himself to be an "artist of education," "becoming more known to the New York public" and "promoting the arts and writing about them," and "doing something for the Arts in our country." From the date of "Hints and Remarks" it is clear that lecturing was to be part of his push on New York, a way of displaying himself and his education and of doing something for the arts.

Morse divided the 150 pages of the "Hints and Remarks" notebook into fifteen "Heads," under which he intended to gather pertinent material. They were: Painting, Sculpture, Architecture, Color, Light and Shade, Drawing, Public Taste, Ancient Art, Modern Art, Illustrations of Principles, Resemblance of Fine Arts to Each Other, Miscellaneous Remarks, Influence of Fine Arts on the Habits and Other Arts of a Country, Effect of Form of Government and Religion on the Fine Arts, and Books to Be Consulted on the Arts. He was obviously planning an ambitious series of lectures in 1823. That many of the "Heads" remained empty suggests that he was too ambitious. Or perhaps it shows that after beginning "Hints and Remarks" Morse's conception of the lectures underwent a fundamental change. For surely it did, and the title of another pocket notebook (undated, but later), "Thoughts on Painting and the Fine Arts Generally with a view to a Series of Lectures, adapted particularly to this country," shows in what way.[62] The lectures envisioned in the 1823 "Hints and Remarks" were clearly intended for academic instruction. Their completeness and the topics they cover reflect the type of lectures that Fuseli, Barry, and Opie delivered at the Royal Academy; and they are, therefore, the remnants, in outline, of

61. National Academy of Design.
62. Ibid.

Morse's own projected academic lectures. But Morse came to believe that this borrowed and largely conventional form, designed for professional use, would not do for America, so his next thoughts on lectures were "adapted particularly to this country." In these nationalized "Thoughts," not in the "Hints and Remarks," one discovers the source of the Athenaeum lectures of 1826.

And yet Morse's "Thoughts on Painting" were not the immediate source of his lectures. From the table of contents on the inside front cover of "Thoughts on Painting"—which included the headings Introductory, History of the Art, Invention, Composition, Design, Chiaroscuro, Coloring, and Miscellaneous Remarks—one sees that although the scope of the series was now much contracted, it was still largely technical. That most of the headings were unused suggests that Morse realized that this plan, too, was unsuitable.

Exactly when Morse found the plan he would follow in the Athenaeum lectures one cannot tell; or rather, it is not certain when he recognized that what was always to have been a *part* of his lectures could become their organizing principle. But in "Hints and Remarks" and "Thoughts on Painting" one can observe its emergence. This organizing principle was the resemblance of the fine arts to one another. It had interested him as a student. It was one of the heads in "Hints and Remarks," although it was only the eleventh out of fifteen, and Morse had nothing to say about it there. It does not appear in the contents of "Thoughts on Painting," but it is twice referred to in its texts: once as part of "The Philosophy of Painting" ("here also compare the fine arts together and illustrate one by the others showing their likeness and relationship"), and later as one of the "Miscellaneous Remarks" ("Illustrate the principles of Painting by the principles of the other arts, Music, Rhetoric, &c."). It was clearly soliciting Morse's attention, doing so, certainly, because he saw in it a way of structuring his lectures to conform to the "circumstances of the country," the "peculiar situation" of America's cultural "infancy." It allowed a form of discourse fundamentally different from those of both his European prototypes and American predecessors, a form that did not assume artistic sophistication or technical knowledge, but that was suitable for popular edification rather than for narrow professional education or scholarly discussion. It is a form that may be justly described as democratic—however much Morse, who had an aristocratic disdain for popular opinion in matters of taste, might object to such a description.[63] Although Morse's ideas and critical language stem mostly from eighteenth-century England, although he refrained from speaking of American art, and although the comparative consideration of the arts that he took as his mode of discourse is an application of the familiar doctrine of the sisterhood of the arts *(ut pictura poesis)*, Morse's lectures were deliberately cast in a form of popular address to adapt them to their American setting.

63. He quoted Lord Kames approvingly in the first lecture: "Those who depend for food on

In essential ways, therefore, Morse's lectures were both modern and American. But in other ways, and more obviously, they were set against their time and country—even against Morse's own art. He upheld an ideal of "intellectual" art—one imitating ideas and principles rather than appearances—that is almost completely at odds with his own practice as a portraitist and as a painter of such perfect specimens of "mechanical" imitation of appearance—relying as they did on abundant and convincing illusion—as *The Old House of Representatives* and *Gallery of the Louvre*.

There may always be in the very nature of the relationship a disparity between theoretical prescription and actual performance, between an artist's words and his artistic deeds. But in Morse's case, in the America of the 1820s and 1830s, the distance between theory and practice was so great and signified a misalignment of the artist with his times so profound and so irresolvable that it finally drove him from art to science. To be sure, Trumbull, Vanderlyn, and Allston before him had all been in some degree unable to realize their artistic ideals or to reconcile them with what was possible for or expected of them as artists in America. Morse never became embittered like Trumbull; he never was as tragically neglected as Vanderlyn; and he was never as bemusedly out of touch with reality as Allston (who proposed as a subject for a mural for the United States Capitol the three Marys at the tomb).[64] But he was even more at odds with his age than they. To console himself for the unremitting difficulties he faced as an artist in America, Morse believed he had been "born 100 years too soon for the arts in our country."[65] But he might more correctly have said he had been born too late, for his artistic views were largely retrospective. His lectures show this in their sources, language, and belief. They show, too, how fixed this orientation was, for when Morse delivered the lectures again in the 1830s he found no reason to change in any fundamental way what he had written a decade earlier.

The dichotomous relationships between old and new, ideality and reality, theory and practice, all more clearly apparent in Morse's lectures than in any other of his artistic undertakings, were not unknown to American artists before him. But in his case and in his time, they became incapable of resolution within art itself, so he forsook art for the practical realm of invention and business. The failure of Trumbull, Vanderlyn, and Allston to enact their artistic ideals stemmed

bodily labour, are totally void of taste; of such taste at least as can be of use in the fine arts." And in a draft dated 1835 for what appears to be a passage in a lecture, Morse wrote, "A fine picture is supposed to be addressed to all, and if it has merit it is supposed that every man down to the most illiterate can instantly comprehend it, that, in truth, excellence in a picture can be decided by vote and that too on the principle of *universal suffrage;* however plausible this may be in politics, it is a principle wholly inadmissible in Taste The truth is, the Fine Arts are addressed not to the great mass of the community, but to the majority of the well educated and refined in Society" (Morse Papers, Library of Congress).

64. Jared B. Flagg, *Life and Letters of Washington Allston*, New York, 1892, 230–34.
65. SFBM to Cooper, 21 February 1833 (Morse Papers, Library of Congress).

largely from indifference to them. Morse knew indifference, too, but he also faced, as they did not, alternative artistic needs and possibilities, ones clear and compelling enough to be acted upon by a younger generation of American artists.

During 1825–1826, just at the time Morse was preparing and delivering the Athenaeum lectures, Thomas Cole's first important Hudson River landscapes were shown and acclaimed in New York. Cole followed them with a series of landscape paintings in which he explored with astonishing richness and rapidity such basic issues of art in his time and place as national subject matter, the meaning of wilderness nature, and the dignity and capacity of landscape painting itself (fig. 10). What began in Cole's art in the 1820s was unmistakable in it by about 1840, when Morse had effectively ended his career as a painter. By that time, Cole had impressively demonstrated the ability of landscape painting to deal articulately with subjects of high meaning in his five-part *Course of Empire* of 1836 (fig. 11), while in *Oxbow* of 1836 (fig. 12), and in *Schroon Mountain* of 1838 (fig. 13), he painted precisely legible statements of American nationality. In genre, William Sidney Mount was painting characteristic scenes of American life (for example, fig. 14).

Such manifestations of interest in new subjects, forms, and meanings, all of a national character, were perhaps not sufficiently visible in the 1820s, so that Morse could say then with some justification that there was "no truly distinctive American school of Art." But to say the same when he repeated the lectures in the 1830s no longer had that justification. By that time, the shape of a distinctively American art—of which landscape was the main embodiment and Cole the major theorist—was clearly discernible. Morse was a friend of Cole, and Morse himself painted landscape throughout his career. Yet neither friendship with Cole nor an interest in landscape were enough to give Morse any true sympathy for or understanding of developments—represented by Cole as an artist and landscape as a type of artistic expression—that were both beyond and beneath his conception of artistic perfection. In *The Old House of Representatives,* for example, Morse tried to capitalize on the aroused nationalism of the years following the War of 1812, but compared to such stirring subjects as naval battles (fig. 15), Niagara, and wilderness landscape (fig. 10), by which other American artists expressed a national consciousness, Morse's subject was pallid and unimaginative—or, what amounts to the same thing, perhaps too intricate and subtle in its meaning—which accounts for its lack of popular appeal.

If the failure to receive a commission for a Capitol mural and the successful development of the telegraph were the immediate causes of Morse's abandonment of art in the 1840s, its essential cause was the manifestly hopeless irreconcilability, by that time, of his cherished and, he felt, proven artistic beliefs with the prevailing condition and direction of American art. This is surely what he meant when he said in 1849 that he did not abandon art (as he knew it), but that art abandoned him (by departing from the ideals he held dear); or when he said, "I

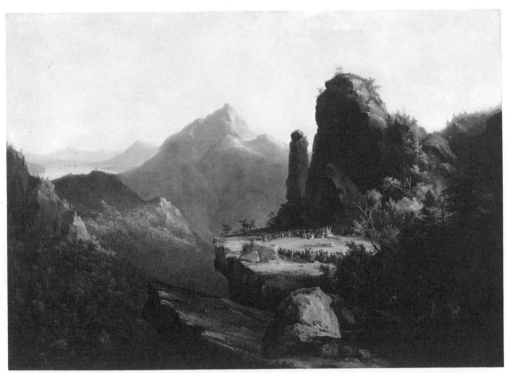

Figure 10. Thomas Cole, *Last of the Mohicans*, 1827. Wadsworth Atheneum, Hartford, Connecticut.

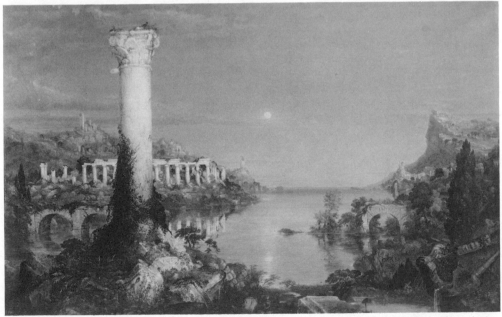

Figure 11. Thomas Cole, *Desolation*, from *The Course of Empire*, 1835–1836. Courtesy of The New-York Historical Society.

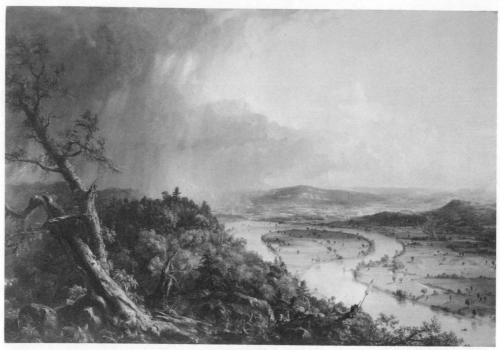

Figure 12. Thomas Cole, *Oxbow*, 1836. Metropolitan Museum of Art, New York. Gift of Mrs. Russell Sage, 1908.

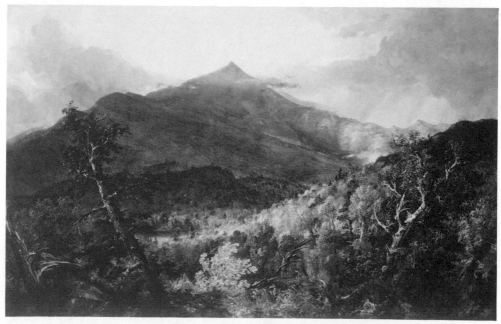

Figure 13. Thomas Cole, *Schroon Mountain, Adirondacks,* 1838. The Cleveland Museum of Art, The Hinman B. Hurlbut Collection.

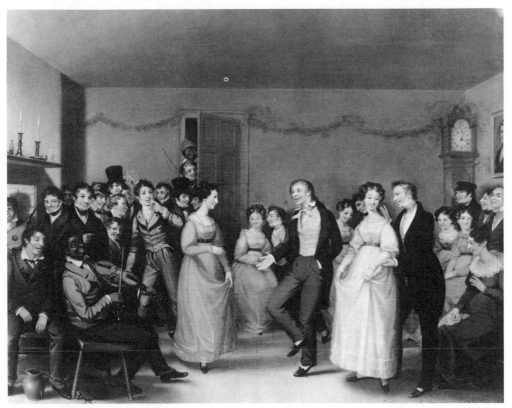

Figure 14. William Sidney Mount, *Rustic Dance after a Sleigh Ride,* 1830. Courtesy, Museum of Fine Arts, Boston. M. and M. Karolik Collection.

never was a painter. My ideal of that profession was, perhaps, too exalted—I may say is too exalted. I leave it to others more worthy to fill the niches of art."[66]

IV

Morse spoke of painting only in the fourth and final lecture. Having discussed and illustrated in previous lectures the natural principles of resemblance observable among other fine arts, he now considered their operation in painting. He did so by diagrams of his own making (which have not survived, although Appendix 3 may suggest their appearance) and by formal analysis of works of art (consisting of engravings, with the exception of one painted copy). He used works by Reynolds, Correggio, Ribera, Trumbull, Rembrandt, Lawrence, Opie, Murillo, Rubens, Claude, Poussin, Titian, Dürer (or so he thought), Guercino, Jacques Louis David, Fuseli, Salvator Rosa, and perhaps ones by Piranesi and Giulio

66. SFBM to Cooper, 20 November 1849 (*Letters* 2:31).

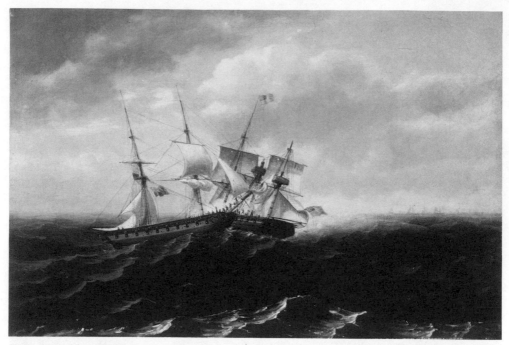

Figure 15. Thomas Birch, *The "Wasp" and the "Frolic,"* 1820. Courtesy, Museum of Fine Arts, Boston. M. and M. Karolik Collection.

Romano (their identification is not clear). These works form a varied group, like his literary examples and resources. While it is possible to view Morse's literary resources as a "library" that reflected his learning, it is not possible to regard his visual resources as a "gallery" that precisely reflected his artistic preferences. This is because he gathered his visual examples hastily from what was available in his own collection, in public collections, or in friends' collections (he almost never cites his source), and the examples would have been different, he said, had he been able to make a wider, more careful selection. He also chose works as examples not just because they were notably good or famous—though most of them were—but because they best illustrated modes of affinity, or more simply because they would be most visible at a distance in artificial light (the lectures were delivered in the evening).[67] Nor were his illustrations even essential to the argument of the lectures; on occasion he delivered only the first two lectures, in which no illustrations were used.

67. He apologized for their poor visibility, for which he compensated by fuller description. One listener complained publicly about her inability to see the illustrations in the third lecture: "I was one of an unfortunate party in the Gallery of Columbia College, when the sketches of the 'unadorned' and 'adorned' house and grounds were exhibited, and owing to the distance a number of 'bright eyes' were unable to see them distinctly," and she requested that they be shown again (Letter to the Editor, *New-York Statesman,* 10 April 1826).

But if pedagogical or practical considerations weighed more in his selection of pictorial examples than his own taste and judgment of artistic quality, his illustrations do, in their range and variety, show Morse's substantial knowledge of other art and suggest a generous artistic tolerance. And because most of the examples were probably gathered in New York, they suggest something of the taste and artistic resources of that city in the early nineteenth century.

The parts of the final lecture that were most important to Morse—although they received less attention than the discussion of the formal means of painting and the analysis of pictures—are passages at its beginning and end in which he spoke with obvious feeling of matters of the deepest personal and professional concern.

At the beginning of the last lecture, Morse stressed the difference between a sensual taste for art satisfied by the precise imitation of nature and a higher taste that understood the intellectual responsibility of art, in its noblest and truest form, to transform and improve nature and appeal to the imagination. The issue here is not only the distinction between sensual and intellectual taste, but the more important one of the dignity of painting. For only in its intellectual nature could painting find the place, to which Morse fervently believed it had a claim, among the liberal arts. Now this was hardly a new issue when he wrote, and it was scarcely one of his own invention. It was, on the contrary, an issue of great age, one that had figured in nearly every treatise on painting during and since the Renaissance. The doctrine of *ut pictura poesis*—contrived during the Renaissance and pervasively influential until the nineteenth century (in the case of Morse's lectures, well into it)—allowed painting to share poetry's unquestioned stature as a liberal art.[68] And the purpose of academies of art founded from the sixteenth century onward, including the National Academy of Design, was to transform painting from a craft into a liberal profession.[69] Despite the age of this issue and the fact that he was addressing a lay audience, not a professional one, Morse felt obligated to uphold the dignity of painting. He wanted particularly to distinguish painting as a mechanical art (as in sign, heraldic, ornamental, and decorative painting, to give Morse's own examples) or as a polite accomplishment of an amateur from the reach and richness of painting practiced by those who, like him, professed it as an intellectual and liberal art. That Morse dwelt upon this distinction before an intelligent audience in America's largest and wealthiest city in the second quarter of the nineteenth century may say something about the condition there of the artistic profession and the level of artistic cultivation. It unquestionably says something about Morse's low regard for both.

68. See Rensselaer W. Lee, *Ut Pictura Poesis: The Humanistic Theory of Painting*, New York, 1967.

69. See Rudolf and Margaret Wittkower, *Born Under Saturn*, New York, 1969, chap. 1.

The National Academy of Design was Morse's attempt to reform and redress the professional laxity and irresponsibility of the American Academy and place control of the profession in the hands of artists. One should bear in mind, too, that at the time Morse spoke, American artists of serious and elevated aspiration were still forced to do ornamental painting. For example, William Dunlap reported in 1834 of John Quidor: "His principal employment in New York, has been painting devices for fire engines, and work of that description."[70] There can be no doubt that Morse had a low regard for the state of American taste. He observed in his "Thoughts on Painting" that there was an "almost total want of taste for the Fine Arts in our country." He was not so candid in the Athenaeum lectures, but he nevertheless took pains in them to dispel the "deep-rooted error" of taste that "smoothness of surface and mere naturalness of objects" were the highest aims or highest reaches of painting—such pains that he obviously felt it an error rampant in his audience.[71]

While Morse spoke of artistic dignity and misguided taste from a sense of professional responsibility and a duty to enlighten and instruct, he did so more urgently from personal need. For it was the inability of even the "most fashionable and literary society of the city" to appreciate the dignity of painting—to recognize that painting, in the form in which Morse desired to practice it, appeals to the imagination through essentially artificial constructions made according to natural principles, not by gratifying the senses with displays of dexterity or illusionism—to which Morse attributed his disappointments as a painter in America.

If Morse and others of similarly elevated aims were to receive any artistic recognition in America, it could only come by enlarging the public understanding

70. *History* 2:308.
71. Benjamin Robert Haydon, whom Morse knew during his student years in England, expressed the same feelings with his characteristic strength: "To hear terms that would be applicable to the highest beauties of Art applied to a tame, insipid, smooth, flat, mindless imitation of carrots—Good God, is this the end of Art, is this the use of Painting? Mere mechanic deception; can Painters really excite pity or terror or love or benevolence or lift your soul above this world by sublime, heavenly fancies, or carry your mind to Hell by grand furious conceptions? Can Painters really stimulate a Man to Heroism, or urge a Man to Repentance, or excite a Man to virtue? No, certainly, not in such minds, it never can" (*The Diary of Benjamin Robert Haydon*, ed. Willard Bissell Pope, Cambridge, Mass., 1960, 1:7).

In a note in "Thoughts on Painting" (1823), however, Morse entertained a more comforting interpretation of the absence of taste in America: "I have tho't whether our own country did not afford a fine field for the philosophical artist to trace the progress of taste in the arts; is not the honest opinion of an untutored public nearer to true judgment than the same opinion by a European public; we have nothing to unlearn, no false notions of taste to eradicate; in Europe a connoisseur must come back to his native unbiased opinion before he is perfect; this native judgment may be compared to our own wide forests, so grand and picturesque they affect us in all their native grandeur; the taste for cropped box and fantastic [illegible word] trees must give place to this nature, and thus we find that as taste increases, we return to our first formed simple notions of taste, &c."

of the objectives of high art. By 1826, after a decade of disappointment and the drudgery of portrait painting—and, of course, even more by the 1830s—enlightened public taste was not some abstractly desirable ideal but the condition upon which nothing less than Morse's survival as a serious artist depended. He said in the concluding remarks of the final lecture that the aim of the artist is determined by his public and that if it expects nothing more of him than polished imitations then "to these parts will his attention be confined, and feeling it to be in vain to aspire to a height which he can see, but where he can find no sympathies to support him, he wastes his energy and his spirits in unavailing efforts to rise." Although he was speaking of and for artists generally, this is really special pleading, for it is impossible not to sense in these words Morse's own bitterness and thwarted hopes, his disappointments and frustrated ideals.

V

All of Morse's intellectual endowments, artistic training, learning, literacy, rhetorical gifts, and pedagogical strategies were concentrated in the lectures these words conclude, not merely to bring himself "reputation which will bring wealth," but to create in America an atmosphere of taste, of artistic intelligence, that was the indispensable sustenance of his life as an artist. Despite his efforts at public instruction and suasion, Morse could not shape the course or character of American artistic taste to the form of his ideals. In this respect, his lectures on painting—the major instrument of his persuasion—were, like all his other efforts in art, a failure. Yet Morse was more responsible than anyone else of his time for the elevation and enhancement of the professional practice of art in America. The National Academy of Design, of which he was unquestionably the animating force and guiding spirit, was throughout his lifetime the most effective and progressive artistic institution in America. Its schools provided training of a kind and quality never before available in America. Its annual exhibitions of new American art were a forum for its exposure and critical evaluation, as well as a way of metering its progress, that had no precedent. And the Academy provided the structure for an artistic community the size, closeness, and attainment of which had never before been equaled.

Morse himself, not only his institution, set new artistic standards. He represented a new type of artist: broadly cultivated, thoughtful, literate—the artist as "liberal and philosophical inquirer," not the "professional limner."[72] Allston, of course, was similarly cultivated; and both Allston and Morse were, in this respect, obedient to an ideal prescribed and enacted by Reynolds. But Allston isolated himself in Cambridgeport, so that his example was not easily available.

72. Tuckerman, *Book of the Artists,* New York, 1867, 165.

Morse's was. As a speaker and writer on art, he set a public example, and he did so in America's most vital artistic community.

Younger artists like Thomas Cole and William Page, who were exposed to his example—Cole as a friend and fellow founding Academician, Page as a pupil and one of the first students at the Academy—did not specifically mention Morse's influence, nor is it to be seen in the character of their work. But the learned and literate artistic type that both Cole and Page represented in *their* generation, one so vastly different from the usual eighteenth- and early nineteenth-century American artist—the "professional limner"—had in Morse its most proximate and plausible model. Morse's Athenaeum lectures were, with his presidency of the National Academy of Design, the most prominent part of this example. It is not necessary that Cole or Page (or others) actually heard the lectures, and there is no evidence that they did. Yet the very fact that an artist could lecture, express ideas, convey knowledge, and embody liberal learning—indeed, felt it a professional obligation to do so—was in itself a profoundly impressive enlargement of the dignity and scope of the artistic vocation in America. Morse, more than any American artist before him or in his time, by words that were deeds, made these possibilities reality.

Editorial Note

The manuscript of Samuel F. B. Morse's "Lectures on the Affinity of Painting with the Other Fine Arts" is in the possession of the National Academy of Design. It consists of four booklets bound in paper covers by light stitching. They measure approximately eight by ten inches. The text is written in pen, pencil, and pen over pencil. It has been much altered and amended as the result of repeated use over many years. The latest state of the text, insofar as it is possible to determine it, is the one given below, on the assumption that it is the most considered formulation of Morse's thought and expression. Significant alterations, when decipherable, are found in the Text Alterations section. Morse's notes are indicated by asterisks, while my explanatory notes are indicated by numbers.

Because the lectures were somewhat hastily written and subsequently much corrected, spelling, punctuation, and capitalization are sometimes erratic and inconsistent. To reproduce them exactly would only cause illegibility. They have not, however, been made to conform rigorously to modern usage. I have regularized capitalization (Landscape Gardening or Fine Arts, instead of Landscape gardening or Fine arts, for example); eliminated abbreviations, used to hasten writing but unnecessary and inappropriate in a printed text (*&* changed to *and, whh* to *which*); replaced semicolons with periods to break up long sentences; and omitted dashes. But for flavor I have retained the practices of the period in such things as the capitalization of nouns (Imagination, Painter) and spelling (antient,

connexion), as well as some of Morse's idiosyncratic spelling (rouze, rhime) and inconsistent usage, when the manuscript calls for it and clarity is not offended. All changes have been made silently. Parentheses indicate Morse's insertions; editorial insertions are given in brackets.

Textual notes provide the sources for Morse's citations. Minor differences between source and citation are—again silently—unrecorded. Some notes also furnish material that has a parallel rather than a direct relationship to Morse's ideas and observations.

Morse's pictorial examples were in the form of engravings. For that reason, engravings have been used to illustrate this text.

On the Affinity of Painting
with the Other Fine Arts

Lecture 1

In establishing in the University the Department of Literature which I have the honor to introduce to your notice this evening, the Founders of this institution peculiarly deserve the thanks of the Amateurs and Professors of the Arts of Design.[1] This University has taken the lead of the other American Collegiate institutions in being the first to create a separate department for a most extensive and important branch of Literature hitherto entirely neglected, or for the most part but incidentally and incorrectly illustrated in our systems of classical study. If the Arts of Design themselves in their practical character have been made a part of education in some of our seminaries, those parts only have been thought of importance, which have the most obvious connexion with engineering, and topography, or those still lighter portions which are considered as an accomplishment, necessary to add a finishing grace to a polite education. The Arts of Design in their classic character, which includes their poetic connexion with some of the highest exercises of mind, have never until now been [1–1][2] made the subject of a distinct department in any of our Universities or Colleges. The field of labor which lies before me is arduous, for it is to a great extent *new* and very *extensive,* but it is also inviting for it promises rich intellectual fruits as the reward of culture. It is an extensive field; it comprehends within its boundaries: The Arts of Design in their Nature and their principles, and their Affinity with the other Fine Arts. Their connexion with the civilization of a country, and the various Arts of Industry. Their History and their Antiquities. The Biography of Painters, Sculptors, Architects, and Engravers. The vast field of Criticism of their various products. The Studies intellectual and mechanical necessary to their knowledge, whether for the Professor, or the Connoisseur.

These and their collaterally connected subjects are some of those properly arrayed under the Literature of the Arts of Design.

In preparing the following lectures [1–2] on the Affinity of Painting with the other Fine Arts, I conceived that the demonstration of that natural affinity of the Fine Arts, or that family resemblance which marks them all, would be most acceptable to a *general* audience; at the same time, for the professional students, it appeared to be doubly important to be able to trace that resemblance which exists between the Arts they mean to profess and those other arts which have ever

1. Morse was appointed Professor of Painting and Sculpture at New York University on 2 October 1832 (Theodore F. Jones, ed., *New York University, 1832: 1932,* New York, 1933, 37–38). In 1835 his title was changed to Professor of the Literature of the Arts of Design. That the first four paragraphs of Lecture 1 were added no earlier than 1835 is indicated by the phrase "ten years since" deleted from the first sentence of paragraph three.

2. See note to Text Alterations, p. 113.

held so distinguished a place in the scale of civilization and refinement. The effect on the Artist of such a view of the other Fine Arts is to elevate his aim, and by showing him the general laws by which all these arts are alike governed, to give him more confidence in the pursuit of his studies, to open a wider range of research, and at the same time to establish a more solid foundation for his discoveries.

The Theory I endeavored to establish I then considered as a Foundation upon which I hoped to erect at a future period (should time and opportunity permit,) a larger and more complete edifice. I have since had the opportunity by a long residence in England, France, and Italy, more thoroughly to prove the soundness of the principles I had advanced.[3] With a wider range of objects of art presented for my examination, I was gratified to find that these principles stood the test to which they were submitted. I found that the most celebrated works particularly in Painting and Sculpture, in proportion too to their approach to perfectness, were consonant with these principles [1–3]. In further confirmation of their justness I ought also to add that the other Fine Arts, more particularly Music in its highest efforts, seemed completely obsequious to the same laws, and thus I found new sources of enjoyment opened, adding to the pleasure derived from the perception of the proper harmony of that enchanting Art, another derived from detecting the greater harmony of principles which bind the art itself to its kindred arts. With this general testimony of my own experience of the justness of the principles educed, I feel the more confidence in presenting them anew to you [1–4].

The plan I had proposed to myself in these Lectures I had nearly completed when [1–5] I accidently perused the following passage in the 13th Discourse of Sir Joshua Reynolds, which as it comprises in few words my general plan, I shall not apologize for quoting at length.

> To enlarge the boundaries of the Art of Painting as well as to fix its Principles, it will be necessary, that, *that* Art, and those principles, should be considered in their correspondence with the principles of the other Arts, which like this address themselves primarily and principally to the imagination. When those connected, and kindred principles are brought together to be compared, another comparison will grow out of this; that is, the comparison of them all with those of human nature, from whence arts derive the materials upon which they are to produce their effects. When this comparison of art with art and of all arts with the nature of man is once made with success, our guiding lines are as well ascertained and established, as they can be in matters of this description. This as it is the highest style of criticism is at the same time the soundest; for it refers *to the eternal and immutable nature of things.*

He adds, *"You are not to imagine that I mean to open to you at large, or to recommend to your research, the whole of this vast field of science. It is certainly*

3. He refers here to his second European trip (the first was as a student in England from 1811 to 1815). He sailed in November 1829 and returned the same month in 1832. During his return voyage on the *Sully* he had the first practical ideas for the magnetic telegraph.

much above my faculties to reach it.''[4] Appalling [1–6] as was the idea that the accomplished mind of Sir Joshua Reynolds shrunk from a task so arduous, I had the alternative at the late period of this discovery, either of abandoning my lectures altogether, or of proceeding in the path hitherto untrodden [1–7]. I have chosen the latter course, consoling myself with the reflection that if I shall fail of success in a species of Criticism so high, the candour of my audience will allow the difficulties of my plan to plead my apology.

I have said that my path is untrodden, and on this account the investigation of my subject has been attended with inconvenience. It is true writers on Painting are numerous, but Painters in the brightest periods of the Arts were less philo-sophical writers, than philosophical painters, and most of those who have written on Painting have been less painters than Philosophers. It is not surprising, therefore, that in the speculations of mere theorists many points should have been overlooked of which they could have little or no experimental knowledge. It is one thing to feel and act, and quite another to describe the process of feeling and action. "The Artist feels and produces, the philosopher thinks, analizes the production, and the faculty of producing [1–8]. The one has the instinct of art, the other the intelligence. The one creates, the other judges of the creation and calculates its laws."[5]

The few Painters who have written on the subject of Painting have addressed themselves principally to Artists. In Europe, [1–9] where every man has grown up from his infancy surrounded by the accumulated stores of the best produc-tions of art, there is much of taste that is acquired unconsciously; there is an atmosphere of art which surrounds every one and in which he breathes as in his native element.

The English [1–10] Painters in their discourses presuppose this advanced state of taste in their audience, they omit to trace rules to their source, they dwell little on first principles, contented generally if they can refer to the standard examples of Art, as authority with which their audience are familiar, and from which there is no appeal.[6] It is, therefore, no easy task to adapt a course of Lectures to the peculiar situation of our country. *Foundations* are to be laid, and that the

4. *Discourses on Art,* ed. Robert R. Wark, San Marino, Calif., 1959, 229; the italics have been added by Morse.

5. Charles Villers (1765–1815), *An Essay on the Spirit and Influence of the Reformation of Luther,* London, 1805, 351: "The Italian feels, and produces; Hemsterhusius, Kant, Burke, Goethe think, and analyze the production and the faculty of producing. The one has the instinct of the art; the other has the intelligence. The one creates; the other judges the creation, and investigates its laws." See also Text Alterations 1–8 and 1–9.

6. He refers to Reynolds, of course, but also to the lectures of Barry, Opie, Fuseli, and West. See Appendix 1, in which he discusses these English Academicians. Morse took copious notes, now at the National Academy of Design, on the published lectures of Barry, Opie, and Fuseli. Joseph Hopkinson, referring to a lecture of his own, said, "It must not be expected that this discourse will resemble those which are delivered to similar institutions in Europe. They are, generally, strictly technical and scientific, being read by a professed artist to artists" *(Pennsylvania Academy of Fine Arts, Annual Discourse,* Philadelphia, 1811, 7).

superstructure may be lasting they must be sure and solid. As in national character we combine the various traits of the many nations of which we are composed, so in regard to the Fine Arts we have as yet no decided character, no truly distinctive American school [1–11] of Art. We partake of the excellencies and defects of every foreign school. Our Artists have studied some in Rome, others in Paris, some in London, and others at home from the mingled productions of all these schools. Our commerce with the whole world, has brought from abroad many specimens of the rare and ingenious in foreign art from a madonna of Raphael to the flat and gaudy Chinese landscape.[7] These have been dispersed through the community, each specimen of art exerting an influence on the taste of those within its sphere, as diverse as the characters of the different countries from whence they came. It becomes a question of some importance whether it be not possible to lay the foundations of a just taste in the Fine Arts in our country on such principles that a substantial fabric may rise in as beautiful proportions as the temple of our political constitution.

That the foundation may be strong it should be laid not in *authority* however antient, but in the never changing principles of nature. "Authority in all its forms," says Gerard, "usurps the place of truth and reason."[8] As in religion, politics, and philosophy, there is no opinion however absurd which may not be supported by the authority of great names, so in the Fine Arts there is no departure from Taste however gross which may not be supported by the example of distinguished artists. But while authority is not to be the *foundation* of taste, it is by no means to be slightly regarded. Indeed, to the tyro in art, whether connoisseur or artist, the examples of the antients should be viewed with the greatest reverence; it is in taste as in other branches of education we must in the beginning take the word of our instructors as the ground of our belief,[9] until by this means we have attained to such a knowledge of the subject as will in the end enable us to place ourselves not on the ground of *authority* but of *principle*.

In making an appeal, therefore, to examples from the productions of the antients, in support of any opinion, it must not be forgotten that the principles upon which they executed their works are still more antient, and superior to them, and it is the knowledge of these principles alone that will enable us to be more than mere copyists, and will prepare us to enter into successful competition with them in the production of works which may deservedly lay claim to the

7. A low opinion of Chinese art was commonplace in the eighteenth century; for example: "The Chinese paintings have little other merit than the brightness of their colours. The pictures of the Chinese artists are totally deficient in drawing and perspective" (George Gregory, *A New and Complete Dictionary of the Arts and Sciences*, London, 1806–1807, 2:242). Later, Cézanne expressed the same opinion to Émile Bernard: "Gauguin n'était pas peintre, il n'a fait que des images chinoises" (quoted in John Golding, *Cubism*, London, 1959, 64).

8. Alexander Gerard (1728–1795), *An Essay on Taste*, London, 1759, 143.

9. Reynolds, note 51 in Charles Alphonse du Fresnoy, *The Art of Painting*, trans. William Mason, London, 1783: "Whoever would make a happy progress in any art or science must begin by having great confidence in, and even prejudice in favour of, his instructor."

admiration of posterity.[10] What Lord Kames says in censure of Bossu that in giving many rules of Poetry he can discover no better foundation for any of them than the practice of Homer and Virgil supported by the authority of Aristotle is equally applicable to criticism in Painting. "Strange," he says, "that he should never once have stumbled on the question, Whether and how far do these rules agree with human nature? It could not surely be his opinion that these poets, however eminent for genius, were entitled to give law to mankind and that nothing now remains but blind obedience to their arbitrary will. If in writing they followed no rule why should they be imitated? If they studied nature and were obsequious to rational principles why should these be concealed from us?"[11] To the question then What is the reason for any rule? an inquisitive mind will not rest satisfied with the answer it was the practice of the antient masters, or it was the method of the Greeks, but will search for the principles on which they founded their practice, and which known and acted upon by them are equally possible to be ascertained by us, and be made to serve as a foundation for similar if not superior excellence.

Painting is one of a family of Arts which possess many and strong features of family likeness. It is one of a beautiful group of sisters who have commanded the attention and admiration of mankind from the earliest ages. The superficial observer, indeed, can discover in them but a faint general likeness. There is to him but little resemblance among things so opposite as a page of verse, the sounds of an instrument, a colored canvas, a pile of buildings, a statue, and a decorated pleasure ground. But let him not judge too hastily from this seeming dissimilarity; more intimacy will show him many, very many traits of common resemblance, amply sufficient to authorize their customary appelation of *sister arts*.[12]

According to the plan I have adopted I shall in the first place determine What are the Fine Arts? I shall then show the principles in Nature on which they are based.

What are [1–12] the Fine Arts?

Every one [1–13] must be conscious of an indefiniteness both as to their nature and number whenever the term is used. They have [1–14] been variously enumerated as comprising Poetry, Painting, Sculpture, Architecture, Music, Oratory, Landscape Gardening, and the Histrionic Art. One ingenious writer after [1–15]

10. Reynolds, Discourse 3, 45: "But if industry carried them [the ancient sculptors] thus far, may not you also hope for the same reward from the same labour? We have the same school opened to us, that was opened to them; for nature denies her instructions to none, who desire to become her pupils." See also similar statements by Barry and Opie in *Lectures on Painting by the Royal Academicians, Barry, Opie, and Fuseli,* ed. Ralph N. Wornum, London, 1848, 91, 254. In his "remarks on Opie while reading his Lectures," Morse noted "a just remark on the proper way of studying the antique, the discovery of the *principle* on which their works were formed, which none of the moderns have yet comprehended, nor probably attempted, scarcely suspecting its existence" (National Academy of Design).

11. Lord Kames (1696–1782), *Elements of Criticism,* New York, 1833, 16.

12. This phrase is common in the eighteenth century, but its scope may vary from including all the fine arts to indicating poetry and painting only.

restricting the term to mean beautiful Arts, and confining beauty to its literal sense as applied to objects of sight reduces the Fine Arts to three, Sculpture, Painting, and Architecture.[13] Forsyth in [1–16] his work on Italy gives a singular definition and classification of them. "A fine art," he says, "appears to me to imply the faculty of inventing, and embellishing, and expressing, and imitating whatever can affect the moral or intellectual powers of man. Now as this can be done only through the medium of words or of forms or of both perhaps the Fine Arts may in relation to these media be reduced to three: 1st. Poetry including Oratory. 2nd. Painting and Sculpture as the joint Arts of Design. 3. The Histrionic Art."[14] The error of this classification will appear if we consider that by this definition numerous Arts would be included which are not here mentioned, and which no one ever thought of classing with the Fine Arts, for example, many kinds of weaving, watchmaking, and glass cutting. Another [1–17] error occurs in leaving out the whole empire of sounds, (except those that partially belong to words,) from those media by which the moral and intellectual powers of man are affected, and thus Music, one of the principal Fine Arts, is excluded from the list.[15]

Things may be [1–18] differently classed as they are considered in relation to particular qualities; there are numerous arts which considered with respect to their utility are called *useful* Arts, with respect to their necessity *necessary* Arts, with respect to their refining effect *elegant* Arts. In what sense shall we consider the word *Fine* as applied to Arts? Obviously not as meaning delicacy or smoothness, for these terms in their literal sense can scarcely be applied to Poetry or Music, but if used in this sense, the manufacture of lace, and of mathematical instruments must be called Fine Arts. The Fine Arts have [1–19] sometimes been called Polite Arts, a term evidently adopted from their tendency to polish, and to refine, and because a knowledge of their rudiments has been thought indispensible to a polite education; that this term includes too much will appear if we consider that Fencing [1–20] and Riding must then come under this head, a classification as whimsical as one to be found in the *Indiculus Universalis,* which classes under the head of Liberal Arts, Painting, Sculpture, Managing the great horse, Hunting and Hawking, printing and coining of money.[16]

13. "Definitions and Reflections," *Magazine of the Fine Arts; and Monthly Review of Painting, Sculpture, Architecture, and Engraving* 1 (London 1821): 4: "The productions of Sculpture, Painting, and Architecture, are addressed to the mind through a different sense from that which communicates the impressions derived from Poetry and Music; and this difference, affecting all the relations of these arts, is so characteristic, that it is the proper source of a generic determination. In selecting such a term, it was intended to distinguish those arts which were productions of BEAUTY, that is to say, visible beauty; for this is the original and proper meaning of the word *beauty.*"

14. Joseph Forsyth (1763–1815), *Remarks on Antiquities, Arts, and Letters, During an Excursion in Italy, in the Years 1802 and 1803,* Boston, 1818, 162.

15. Ibid., 163: "Musick, divested of poetry, is but a sensual art, and, as such, it should be classed with cookery and perfumery."

16. François Pomey (1618–1673), *Indiculus Universalis,* Lisbon, 1716, chap. 8. Morse refers

A name sometimes given to the Fine Arts designates them more accurately than any of those enumerated, to wit, the *Arts of the Imagination*,[17] and it were to be wished that this name had superseded all the others. A Fine Art [1–21] may be defined then *An Art whose principal intention is to please the Imagination*.[18] (Repeat) But why restrict the term to those that aim chiefly to please the Imagination? I answer that any other definition will include with the Fine Arts many which differ so widely in other respects that their resemblance to each other would not be recognized. And as there is a class of Arts whose highest excellence consists in this quality of aiming to give pleasure to the imagination, as in this respect they differ from all others, and as the principal Fine Arts already come under this definition there appears an evident propriety in making this intention the test of a Fine Art.

With this definition let us examine the claims of various arts to this distinction. That Poetry aims to please the Imagination it scarcely needs an argument to prove. "The primary aim of a poet," says Dr. Blair, "is to please and to move and, therefore, it is to the imagination and the passions that he speaks. He may and ought to have it in his view to instruct and to reform; but it is indirectly and by pleasing and moving that he accomplishes this end."[19] Dr. Beattie after discussing at some length what is the end of Poetry draws the conclusion that it is to please. "Verses if pleasing may be poetical though they convey no instruction, but verses whose sole merit is that they convey instruction are not poetical."[20] "Poetry," says [1–22] Quintilian,* "is calculated to strike and amaze, all its aim is to delight." Poetry, therefore, comes within this definition.

Architecture [1–23] is but partially a Fine Art. Most [1–24] professions are complex in their nature; that of an architect is composed by connecting parts of several professions. He combines [1–25] the character of a painter in the faculty of invention and designing, with that of an engineer and a builder. How common [1–26] is the error of attributing to one who possesses only a part of such combination the qualities of the whole. If a man designs a building he is miscalled an [1–27] Architect, if he draws it by rule and compass though designed by

here to what Paul O. Kristeller terms the "amateur tradition" of the classification of the arts, found in such sixteenth- and seventeenth-century texts as Baldassare Castiglione's *Courtier* and Henry Peacham's *Compleat Gentleman* ("The Modern System of the Arts," *Journal of the History of Ideas* 12 [October 1951]: 517).

17. Reynolds, Discourse 13, 229: ". . . the other Arts, which like this address themselves primarily and principally to the imagination."

18. I know of no specific source for this definition of a fine art, but Reynolds's observation that "the great end of all those arts is, to make an impression on the imagination and the feeling" is obviously close (Discourse 13, 241).

19. Hugh Blair (1718–1800), *Lectures on Rhetoric and Belles Lettres*, Philadelphia, 1833, 421. See also Abbé Du Bos, *Critical Reflections on Poetry, Painting and Music*, trans. Thomas Nugent, London, 1748, 1:63: "Poems are not read for instruction, but amusement; and when they have no charms capable of engaging us, they are generally laid aside."

20. James Beattie (1735–1803), *Essays on Poetry and Music*, London, 1778, 29.

* 1ib. 10. c. 1 [from *Institutes of the Orator*].

another, or calculates the quantity, strength, durability, and position of the materials, he is miscalled an [1–28] Architect, and even if he simply carries the design into execution he is miscalled an [1–29] Architect. This is calling one who professes a part by a name which belongs only to one who combines the whole; an accomplished architect must possess in combination the qualities of these other arts. What then in Architecture constitutes it a Fine Art, for there is nothing of intention to please the imagination in mathematical calculation, nor in the adjustment of one stone upon another. It is that part only which pertains to the design; he who can design or conceive the building in its entireness and who arranges it in all its parts to affect agreeably the imagination, though he may know nothing of the relative strength or durability of the materials, of their quantity or expense, or whether it be practicable to carry into effect his design; though he may be ignorant of the process which the builder employs; he is, in consideration of the design, entitled to rank as an Architect among the Professors of the Fine Arts. It is his to originate and arrange the parts of the object, it is for the engineer to calculate the practicability of the plan and the builder to contrive the means of execution; but without the [1–30] *Design* there is nothing for the one to calculate or the other to execute. Architecture is, therefore, classed with the Fine Arts only in respect to Design, that part in which it is the intention to please the imagination.[21]

In Music there are [1–31] sounds which make us *cheerful* or *sad, martial* or *tender,*[22] and which in the hands of a skillful composer may be made to rouze at pleasure any or all of the passions successively. He who has a sensitive ear, if he has for a moment broken from the spell by which he has been bound, while exquisite music is performing, long enough to review the operations of his mind, will be satisfied that the current of his thoughts, besides an unusual rapidity from the excitement, flows on tinged with the affections which are suggested by the sounds successively brought to his ear. A fine illustration of this effect is pictured for us in Dryden's *Alexander's Feast,* where by the skillful change of measure and of strain the spellbound monarch is made to pass from rage to love, and from cheerfulness to sadness in quick succession during the progress of the melody. If there is any art that seems particularly calculated to enchain the imagination, to lead it in a train of delightful reverie, to employ it with pleasure even when harsher passions are called into exercise, it is Music, and its claim, therefore, to rank with the Fine Arts on the ground of its principal aim to please the imagination is indisputable.

Landscape Gardening, an art in its perfection [1–32] in England, and which is

21. Morse seems to contradict himself here, for see the preceding paragraph, where he says, "If a man designs a building he is miscalled an Architect. . . . This is calling one who professes a part by a name which belongs only to one who combines the whole."

22. James Harris (1709–1780), *Three Treatises; The First Concerning Art; The Second Concerning Music, Painting, and Poetry; The Third Concerning Happiness,* London, 1772, 92.

recently both studied and practised in our country, [23] is the Art of arranging the objects of Nature in such a manner as to form a consistent landscape and requires in the professor a knowledge of all those qualities of objects which give pleasure or pain to the imagination through the sense of sight. He must to a certain extent possess the mind of the Landscape Painter, but he paints with the objects themselves. His is the art of hiding defects by interposing beauties; of correcting the errors of Nature by changing her appearance; of contriving at every point some consistent beauty so that the imagination in every part of the theatre of his performance may revel in a continual dream of delight. His main object is to select from Nature all that is agreeable, and to reject or change every thing that is disagreeable. Landscape Gardening is therefore a Fine Art; and here there is the same distinction between the mechanical and intellectual operation which exists in Architecture; it is not the laborer who levels a hill, or fills a hollow, or plants a grove that is the landscape gardener, it is he alone who with the "prophetic eye of taste," sees prospectively the full grown forest in the young plantation, and selects [1–33] with a poet's feeling passages which he knows will affect agreeably the imagination.

Oratory has for its principal aim to persuade and this is accomplished by *proving* by *painting* or *describing* and by *moving* the passions. It is not according to our definition a Fine Art in its principal aim, but in looking at the means by which it accomplishes its end, we find that the two last mentioned have as an object the pleasing of the imagination, and rousing the passions. Oratory, therefore, in consideration only of these qualities partakes of the nature of a Fine Art.

We come now to consider the Histrionic Art. There [1–34] seems more justice in the first view in classing the profession of an actor with the Fine Arts according to our definition than will be warranted on closer scrutiny, for although the principal aim of an actor is to please the imagination, when we consider that he accomplishes it not so much by a distinct art as by the assistance of a combination of the Fine Arts, each of which has been brought to its result by the Poet, the Painter, and the Musical Composer respectively, and that it is their works which operate upon the imagination, it is necessary to make some abatement in an unqualified admission of it to a place among the Fine Arts. Take from the actor the sentiments indited for him by the poet, the scenic illusion furnished by the painter, and the charm of sounds furnished by the musical composer and there is left but the modulation and gesture of the orator. An actor is but the instrument by which the dramatic poet speaks. Is he then an Orator? [1–35] The difference between the Actor and the Orator is strongly marked in this: the actor assumes a character while the orator appears in his own. The actor is supplied with his

23. Andrew Jackson Downing expresses similar sentiments in *A Treatise on the Theory and Practice of Landscape Gardening Adapted to North America*, New York, 1844, 27–29.

51

matter by another, the orator supplies himself. The attitudes, [1–36] and gestures, and expression of the orator must be chastened and subdued even in the highest state of feeling to a more temperate and dignified condition, for that which in an actor would appear just and proper, and but a forcible expression of feeling, would in an Orator be deemed extravagance and grimace. The Actor and the Orator in the mechanical operation of delivering an address differ in degree rather than in kind, but while the *Orator* feels *naturally* in expressing his *own* sentiments the *actor* feels *artificially* in expressing those of *another*. The Actor is allied to the Orator only in the single quality of pronouncing a speech. That which [1–37] is distinctive in his art is the modulation of voice and modification of features and gesture to suit the sentiment not his own, to give it its full impression on the imagination. With these deductions and qualifications the Histrionic Art is classed with the Fine Arts on the ground of its principal aim to please the imagination. The fleeting, temporary nature of this art strongly distinguishes it from all the rest. *Poetry* when once it has embodied its conceptions kindles by words the imagination to the end of time; *Music* through its notation may sing forever; *Painting* on the wall or canvas through ages transmits her vivid thoughts; *Sculpture* and *Architecture* write theirs in stone; Cicero and Demosthenes still speak in words of living eloquence; and Time but slowly obliterates the deep and characteristic expression of the artificial landscape; but where are the memorials of the Art of Garrick and of Kemble![24] While all the other arts live and speak when their professors are mute in death, the Histrionic Art perishes with the individual nor leaves a trace behind.[25]

We have thus examined the claims of six different arts to the title of Fine Arts on the ground of their principal aim to please the Imagination. These are *Poetry, Music, Landscape Gardening, Architecture, Oratory,* and the *Histrionic Art.* Of these the first three may be styled *Perfect,* and the last three from possessing some peculiarities which prevent their unqualified admission may be styled *Imperfect Fine Arts.*

24. David Garrick (1717–1779) and John Philip Kemble (1757–1823), celebrated English actors.

25. Morse is at pains to diminish the stature of the histrionic art. As a student in London, under the stimulation and encouragement of Charles Robert Leslie (who described himself as "passionately fond of the theatre" in his *Autobiographical Recollections,* Boston, 1860, 20), Morse often attended the theatre, and even wrote a farce. But this was certainly contrary to the views of his parents; his mother wrote him in 1813, "I hope you do not attend the theatre, as I have ever considered it a most bewitching amusement, and ruinous to both soul and body" *(Letters,* 1:118). His parents' opinion on this matter was, despite youthful deviation, ultimately Morse's own; in an 1833 letter to William Dunlap, for example, he described himself as "conscientiously opposed to the Theatre" *(Diary of William Dunlap,* New York, 1930, 3:662–63).

One must give Forsyth's view of the histrionic art and its components, for Morse was at once contesting and using it: "From Poetry it borrows words; from the arts of design, decoration. Its own vehicle is motion and speech. Motion connects it with dancing (in the latitude which Lucian gives to this art;) speech, with musick. But dancing and musick appear only as accessories to the histrionic art, and derive all their dignity from that connexion" *(Remarks,* 163).

Some of [1–38] the Fine Arts are classed together under other names. *Painting, Sculpture, Architecture,* and *Engraving,* are called the *Arts of Design; Sculpture* includes within it many kinds under the name of *Plastic Arts;* and *Painting* and *Engraving* compose another class denominated *Graphic Arts.*

From restricting the definition of a Fine Art to the quality of aiming principally to please the imagination, an important result is noticeable. A difference is made between the mechanical and intellectual operations of all these Arts and it furnishes a test by which not only to distinguish them from all others but also to fix the rank of any of their professors; it is he alone who aims in the practice of them to please the imagination, who is truly entitled to the name of an Artist.[26] And just so far as his work accomplishes this end, so far only is it a production of the Fine Arts. I have been led into a longer discussion of this part of my subject from having myself felt that indefiniteness of which I have spoken as to the nature and number of these Arts, in which I am persuaded I am not singular. There seemed to be a necessity for settling their nature definitely on some quality common to all of them, that by light reflected from each might be concentrated on Painting a lustre which should render its nature and rank clear to all.

If the Fine Arts are all [1–39] united in one common aim, it is natural to suppose that their principles are similar, that a knowledge, therefore, of the principles of one art may be useful in the discovery of the principles of another, that

> Verse and Sculpture may bear an equal part,
> And Art reflect its images to art—— [1–40]
> > Pope[27]

We have shown that to excite the *imagination* agreeably is the common aim of all the Fine Arts. What is the Imagination? It is the most restless of all our

26. There is no single source for this opinion, but it was a common one. For instance, throughout the *Discourses* Reynolds contrasts an exact imitation of nature, which he calls the "mechanical parts" of art, to that higher form which at once appeals to and is the product of intellect and imagination; see, for example, Discourse 3, 43, and Discourse 4, 57. See also Reynolds's comments in his *Literary Works* 2:127. Similar sentiments are expressed by others.

27. *Epistle to Mr. Addison, Occasioned by his Dialogue on Medals:* "The verse and sculpture bore an equal part, / And Art reflected images to Art." Gerard, Reynolds, and Beattie had similar ideas. Gerard: "As the fine arts are truly sisters, derived from the same common parent Nature, they bear to one another, and to their original, various similitudes, relations, and analogies As one science, by supplying illustrations, makes another *understood;* so one *art,* by throwing lustre on another, makes it more exquisitely *relished*" (*Essay on Taste,* 85).

Reynolds: "It is by the analogy that one art bears to another, that many things are ascertained, which either were but faintly seen, or, perhaps, would not have been discovered at all, if the inventor had not received the first hints from the practices of a sister art on a similar occasion. The frequent allusions which every man who treats of any art is obliged to make to others in order to illustrate and confirm his principles, sufficiently shew their near connection and inseparable relation" (Discourse 7, 133).

And Beattie refers to "that strict analogy which all the fine arts are supposed to bear to one another" (*Essays,* 128).

faculties, it sleeps not when we sleep,[28] but delights and terrifies us with dreams; it is perpetually on the wing collecting from the four corners of the earth its materials to combine in picturing scenes of bliss or of misery, it suffers itself not long to be confined by attention without fatigue, and throws around the realities of life a charm or a gloom which do not naturally belong to them, and which sober judgment cannot always dissipate.

It is part of Taste to select and arrange such objects of Beauty and Sublimity as shall agreeably exercise this faculty. The generally [1–41] received definition of Taste is, "that faculty of the mind by which we perceive and enjoy whatever is beautiful or sublime in nature or art."[29] If taste is compounded of *sensibility* and *judgment,* of which there is little doubt, it is dependent on nature for the former, and culture for the latter.[30] In this it is analogous to an ear for music. As no art can bestow an ear for music but it is the peculiar gift of nature, so that sensibility which lies at the foundation of taste can never be acquired. It is this sensibility that Quintilian intends when he says,* "Non magis arte traditur quam gustus aut odor." "It is no more to be acquired by art than *taste* or *smell*."[31] But while it cannot be acquired the least degree of it is capable of high culture.[32] On the other hand the most delicate sensibility is of little avail if it receive not a proper education. Hence it has been well observed that† "a refined taste depends upon sensibility for its acuteness, and judgment for its correctness, and its progress towards refinement is exactly in proportion to the activity of the mind, the extent of its observation, and the improvement of general knowledge."

28. Similar ideas can be found in Beattie, *Dissertations Moral and Critical,* London, 1783, 78; William Thomson, *An Enquiry into the Elementary Principles of Beauty, in the Works of Nature and Art,* London, 1798, 61; and William Cullen Bryant, "Lectures on Poetry," in *Prose Writings of William Cullen Bryant,* ed. Parke Godwin, New York, 1964, 1:6. Bryant's lectures on poetry were delivered in 1826 as part of the same series of Athenaeum lectures as Morse's. Morse painted Bryant's portrait in 1825 (see fig. 3).

29. Archibald Alison (1757–1839), *Essays on the Nature and Principles of Taste,* Edinburgh, 1811, xi. Preceding Alison's definition of taste, Morse, in his reading notes (National Academy of Design), wrote Blair's: "The power of receiving pleasure from the beauties of nature & art" (*Lectures,* 16).

30. See Gerard, *Essay,* 90, and Blair, *Lectures,* 21.

* 1ib. 6. cap. 5.

31. Morse knew Charles Rollin's *The Method of Teaching and Studying the Belles Lettres* and probably took this from it: ". . . Rules and precepts may be laid down for the improvement of [taste]; and I cannot conceive why Quintilian, who justly sets such a value upon it, should say that 'tis no more to be obtained than taste or smell; Non magis arte traditur, quam gustus aut odor" [Rollin's note: Lib. 6 cap. 5] (London, 1734, 1: pt. 2, 2). Morse referred to Rollin's *Method* in his reading notes (National Academy of Design).

32. Morse wrote earlier: ". . . Taste is altogether acquired, it is never natural, any man of good common sense, who will interest himself in the thing and study, may in a short time become a man of taste, be able to discover the different kinds of excellence in art, to separate the real from the fictitious, and justly to appreciate merit" (SFBM to his parents, London, 1 March 1814; Morse Papers, Library of Congress).

† Kett's Elements [Henry Kett (1761–1825), *Elements of General Knowledge,* Philadelphia, 1805, 2:150; Morse conflated two sentences from the same page.]

The productions of any of the Fine Arts equally require taste in those who produce and in those who examine them. For of what use is it for the Artist to cultivate his own taste if those around him are incapable of feeling and appreciating the beauties which are spread before them. There is a habit, very prevalent among many who pretend to taste, of extravagant censure and extravagant praise, the sure indication of false taste, and which arises not so much from deficiency in native sensibility to beauty and defect, as from real ignorance of *how much* to blame, and how much to applaud. Ignorance is sure to use superlative or general terms; every thing that offends is odious, abominable, execrable; every thing that pleases is wonderfully fine, most superb, most elegant; it knows no gradations of epithets, no classes of beauties or faults, it deals in round numbers, and scorning to arrive at deliberate conclusions by a just balance of beauties and defects, hurries at once to a violent and irrational extreme.[33] The Artist in any of the Fine Arts finds one of his principal excitements in the discriminating applause of the public; I say *discriminating* applause, for that ephemeral praise which originates in caprice, or fashion, or sympathy, however it may for the moment excite a feeling of pleasure, loses its power on reflection, and leaves in its place a disheartening weight upon the spirits, worse in its effects than total neglect. It cannot but be discouraging to hear *inferior*, extolled beyond *superior* beauties, and to be conscious of possessing an excellence which is not perceived, and therefore not appreciated, and to know that inferior talent may by slighter efforts attain to the same elevation in the eyes of mankind. The man of ardent genius must have an object above him at which to aim; he seeks for distinction by reaching upward to that which is unattainable by others; he looks for much of his reward in the praise of those who can estimate his success. If, then, there is no distinction between a low and a high state of proficiency, if inferior are permitted to usurp the place of superior attainments, or those who are just entering on the course are applauded with the same praises as those who are far advanced in the race, what but discouragement must ensue. It is equally injurious to the older and the younger artist; there can be no inducement in the one case to proceed when that superlative praise has been received in the beginning which should have been reserved as the reward of later and superior merit; nor in the other when excellences already attained have outstripped their comprehension. It is the part of true taste and sound criticism to graduate every quality and every beauty, and thus by presenting to aspiring genius the successive steps to perfection, lead it forward and onward to higher and still higher

33. Pope: "Avoid extremes; and shun the fault of such, / Who still are pleas'd too little or too much." *(An Essay on Criticism,* 1709). Note also Kett, whose "man of taste" dislikes "equally to express himself in the language of high panegyric, or illiberal censure" *(Elements,* 2:190), and Gerard, who said that extravagance "both in liking and disliking . . . proceeds much less commonly from excess of sensibility than from a defect in the other requisites of fine Taste; from an incapacity to distinguish and ascertain, with precision, different degrees of excellence or faultiness" *(Essay,* 113).

excellence. But every thing is at the mercy of caprice if there are no settled principles to govern our judgment concerning objects of Taste. Where shall we look then for a standard of Taste? "De gustibus non est disputandum," is a common remark. Is there then no criterion of right or wrong in taste? Is it sufficient that a man be pleased in order to put an end to any dispute concerning the merits of any work of nature or art? A sentiment so full of anarchy cannot be adopted. The general sense of mankind has been held up as the standard by many writers, and with limitations in some and extension in other particulars it is doubtless the most rational.[34] But how can this be ascertained; can it be decided by vote and that too on the principle of universal suffrage? However well this may be in Politics, it can scarcely be admitted in matters of Taste. "Interdum vulgus rectum videt," says Horace, but he very justly adds, "est ubi pecat."[*] "Sometimes the public see correctly, but there are cases where it errs." In taking the vote then there must be some exclusions. Lord Kames excludes from this right "all who depend for food on bodily labor; these," he says, "are totally devoid of taste, such at least as can be of use in the Fine Arts."[35] With these he places another class the members of which will be more ready to dispute their proscription than the first but whose exclusion from a vote on Taste is undoubtedly as just [1–42] as theirs. These are "the voluptuous, those who inflamed by riches vent their appetite for superiority and respect upon the possession of costly furniture, numerous attendants, a princely dwelling, sumptuous feasts, and every thing superb and gorgeous to amaze and astonish all beholders."[36] To these may be added another and smaller class, composed of those who want that native sensibility of which we have spoken.[37] These being excluded there is left a class composed of the intelligent and well educated in all countries and ages whose province it would seem to be to decide on the objects of Taste. But why is their opinion to be undisputed? If this opinion were arbitrary, and simply tradition-ary, it would still be an uncertain and fluctuating standard, and this must be the

34. These ideas closely echo Blair, *Lectures*, 22, 24, and Kames, *Elements*, 471.

* lib. 2. Epis. 1. [The same phrase is cited in *The Polite Arts, or, A Dissertation on Poetry, Painting, Musick, Architecture, and Eloquence*, London, 1749, 4: "This is the Progress of Taste: By little and little the Publick are caught by Examples. By seeing, they (even without taking notice of it) insensibly form themselves upon what they have seen. Great Artists produce in their Works the most elegant Strokes of Nature: Those who have had some Education, immediately applaud them; even the common People are struck; *Interdum Vulgus rectum videt.*"]

35. Kames, *Elements*, 471.

36. Ibid., 471–72: ". . . Voluptuousness never fails, in course of time, to extinguish all the sympathetic affections, and to bring on a beasting selfishness, which leaves nothing of man but the shape: about excluding such persons there will be no dispute. Let us next bring under trial, the opulent who delight in expense: the appetite for superiority and respect, inflamed by riches, is vented upon costly furniture, numerous attendants, a princely dwelling, sumptuous feasts, every thing superb and gorgeous, to amaze and humble all beholders."

37. Morse noted, "A third class may be those who want native sensibility, like those who have no ear for music" (National Academy of Design).

case, unless we go one step further and suppose that their decisions are founded on principles in the constitution of human nature, hidden, indeed, from the classes we have excluded, but discoverable to an enlightened philosophy; we must suppose that human nature being the same in every age what has moved the intelligent in all countries alike, and in all ages, will find within the human breast some chord, attuned to the same note, ready to vibrate when touched by the same magic power.

While, therefore, the best models in the Arts and the opinion of the best critics are to be studied to know what has pleased the intelligent and refined in former ages, the lights of philosophy and science must lend their aid in the discovery of those principles in nature on which the works of the Fine Arts are founded.[1–43]

To these principles I shall direct your attention in my next Lecture.[1–44]

Lecture 2

In my last [2–1] Lecture, I ascertained what the Fine Arts are, classing them on the quality of their principal aim to please the imagination. I brought to this test, Six Arts, viz., *Poetry, Music, Landscape Gardening; Architecture, Oratory*, and the *Histrionic Art*. The first three, we proved to be *Perfect*, and the last three *Imperfect* Fine Arts.

Painting and Sculpture were left to be proved Fine Arts, as an inference from the whole course. I shall [2–2] in the present lecture proceed to an examination of the principles on which the Fine Arts are founded.

All the Fine Arts refer to Nature as the source whence they draw their materials, and the Imitation of Nature is always recommended to the student in any of these Arts. But there are two kinds [2–3] of Imitation which should not be confounded: a copying exactly any object just as it is, with every beauty and defect, and an Imitation of the rules or methods according to which that object is constructed to serve a particular purpose.

A part of the subject affecting the Fine Arts so essentially, and one on which there exists so much erroneous impression, allow me more closely to analyze. In looking [2–4] abroad over the works of Creation our thoughts are naturally carried up to the great first cause, the Creator of all. An unperverted taste must discern traces of the Deity in every thing: not a leaf, or an insect but speaks the language "the hand that made me is divine."[1] Now there is in man [2–5] a spark of this Divinity, a portion of the thinking, contriving principle, the *immortal mind*. It is [2–6] reasonable to suppose that the mind in its essential nature, (whatever that nature may be,) is the same in the Deity and in Man, like those images of the Sun, which are seen during the progress of an eclipse, marking the intervals between the shadows of the foliage of the trees, multiplied infinitely, but resembling each other and their great original in all their parts, differing indeed in size and lustre from their Parent in the heavens, and being but twinkling images of his brightness; the resemblance to each other which is here observed is also seen in the minds of men. All are similar to each other in their essential nature, however they may vary in proportion or strength of parts. It is not presuming too much to suppose that the Deity, the great source of mind, while possessing in their perfection all the ingredients of this mysterious essence, still has them in

1. In Reason's ear they all rejoice,
 And utter forth a glorious voice,
 For ever singing as they shine,
 "The Hand that made us is Divine."

(Addison, *The Spectator*, no. 465, 23 August 1712)

resemblance to those emanations from himself, with which he has enlightened man. My inference from this reasoning is, that man being mentally formed in the image of his Creator, possesses among other resemblances the desire and faculties of contriving with design. In the loftiest exercise of these faculties, he should create a work not like one already made, but an original work on similar principles. An Imitation of nature is not necessarily the mere copying of what is created, but includes also that more lofty imitation, the making of a work on the Creator's principles. A work of Art thus constructed stands among those of the Creator like one of his own, and it is not surprising that in an age when the Deity was known only as the God of Nature, such works should obtain the appellation of Divine and their authors be reverenced as Demigods. In his Imitative efforts, however, man differs from his great original in this important point, he cannot create *something* out of *nothing;* in his humble creative attempts he must use materials already produced. His imitation is confined to the *combination* of these materials. He may combine them infinitely, but he is restrained within the limits of things already created.[2] By way of illustration, take the quality of *Contrast.* By *Contrast,* certain peculiar effects are produced in Nature. Qualities brought into contrast with each other are rendered more obviously and distinctly different. The opposition of the essential ingredients of each is made more palpably apparent. Qualities which may be contrasted, are indiscriminately scattered through nature and the Poet or the Painter can select and combine in contrast at will, virtue with vice, beauty with deformity, youth with age, light with dark to suit his purpose.

There is [2–7] then an Imitation which copies exactly what it sees, makes no selections, no combinations, and there is an Imitation which perceives principles, and arranges its materials according to these principles, so as to produce a desired effect. The first may be called *Mechanical* and the last *Intellectual Imitation;* let me illustrate this distinction by another example. Watt, the celebrated inventor of the improved steam engine,[3] produced this masterpiece of mechanism by an application of certain laws that govern the mechanical powers and the operations of steam. Mr. Watt's engine may be imitated in two ways: another engine may be made exactly like it, or the principles on which it was made may be variously modified and applied to the construction of other ingenious instruments. To the first kind of Imitation the ordinary and illiterate mechanic, as is well known, is perfectly competent, while the latter requires genius and mental cultivation similar to those of the inventor himself.

A distinction so obvious one would suppose would have been readily made by a philosophical mind. But even Plato according to Sir Joshua Reynolds speaks only of mechanical imitation, attributing to it an excellence which it does not

2. Similar thoughts are expressed by Reynolds in Discourse 2, 27, and Discourse 6, 99, and by Fuseli in his *Lectures,* 408–9.

3. James Watt (1736–1819), whose improved steam engine was patented in 1769. Over "engine" is the notation "en-gin."

possess; and Cardinal Bembo in his eulogiums on Raphael fixes on this quality as constituting the chief excellence of the painter, one which by no means belonged to him in a remarkable degree. And Pope in his praises of Sir Godfrey Kneller takes the same mistaken view of Imitation.[4] Harris also in his "three treatises," in drawing the comparison between Poetry, Painting, and Music, seems to have no other idea of Imitation than this inferior and purely mechanical kind.[5] Still, as we have seen, there is a well marked difference between them leading to results as diverse as the operations of mechanical and mental effort. While [2–8] we acknowledge, therefore, the necessity of Mechanical Imitation to the successful demonstration of Intellectual imitation, let it take its proper place as subordinate to a great end. It is not the end itself any more than the exact fitting of valves and levers in a steam engine, however necessary, is the ultimate object of that mighty instrument.

But why are the Fine Arts called Arts?

Every work of *Art* proposes some end, is made to accomplish some definite purpose. It is not only proper but necessary to enquire, what is the intention of any such work, and it may be considered in regard to this intention or the success with which it has been accomplished. If, for example, it is the intention of a painter to make an exact representation of any object then so far as his picture resembles such object does he deserve praise for attaining his end; and the character of the picture is determined from the character of the intention and the importance of the object copied.[6] If it is to copy an apple with exactness, the aim

4. Discourse 13, 232: "When such a man as Plato speaks of Painting as only an imitative art, and that our pleasure proceeds from observing and acknowledging the truth of the imitation, I think he misleads us by a partial theory. It is in this poor, partial, and so far, false, view of the art, that Cardinal Bembo has chosen to distinguish even Raphaelle himself, whom our enthusiasm honors with the name of Divine. The same sentiment is adopted by Pope in his Epitaph on Sir Godfrey Kneller."

The epitaph, given in vol. 2 of *The Works of Alexander Pope* (London, 1735), reads:

> Kneller, by Heaven, and not a Master taught,
> Whose art was nature, and whose pictures thought;
> Now for two ages, having snatch'd from fate
> Whate'er was beauteous, or whate'er was great,
> Lies crown'd with Princes' honours, Poets' lays,
> Due to his merit and brave thirst of praise.
> Living, great Nature fear'd he might outvie
> Her works; and dying, fears herself may die.

5. "Discourse on Music, Painting, and Poetry," in *Three Treatises*.

6. Reynolds, Discourse 3, 51–52: "The painters who have applied themselves more particularly to low and vulgar characters, and who express with precision the various shades of passion, as they are exhibited by vulgar minds, (such as we see in the works of Hogarth,) deserve great praise; but as their genius has been employed on low and confined subjects, the praise which we give must be limited as its object. . . . Even the painter of still life, whose highest ambition is to give a minute representation of every part of those low objects which he sets before him, deserves praise in proportion to his attainment"; Discourse 5, 82: "We ought not to expect more than an artist intends in his work." And Beattie, in *Dissertations*, 178, says, "Every work should be good in its kind; but every kind of work has a sort of goodness peculiar to itself."

is not very elevated, nor the object of much individual importance, however well it may be copied; and it must rank accordingly. If a man is the subject of representation, the subject increases in importance, while the design to make an exact resemblance and the success with which it is accomplished remain as before. Let the aim now be to represent passion, exemplified in two animals; the intention becomes of a higher character, mind begins to show itself, something is to be represented with which mind can sympathize, even displayed in inferior animals; the intention being higher, the object selected in which to embody passion furnishes another point in fixing the character of the picture. It is still low compared with others. Instead of two animals, substitute two men; the character of the picture is still more elevated.[7] It is in this way we might proceed to graduate the works of Painting from the lowest kind of Mechanical to the highest point of Intellectual Imitation, to that which Fuseli in his peculiarly strong language styles *"the sublime allegory of maxim."*[8] But, it may be asked, is not Mechanical Imitation in Painting a necessary excellence through every step even to the highest grade of epic? I have allowed that it is, and to a greater degree than Sir Joshua Reynolds is disposed to admit. There is no reason why every thing that is selected to be represented should not be imitated exactly. In the epic, which is the highest class of Painting, the effect is produced by a more severe selection and rejection of objects, and parts of objects, but having made the selection, down to the minutest fold of the drapery, I can perceive no reason why all that is adopted should not be mechanically imitated with exactness.[9] From what I have observed of the two kinds of imitation, it will be seen that Mechanical Imitation requires in the Painter merely such an acquaintance with the visible qualities of objects as will enable him to copy with exactness whatever he sees, while Intellectual Imitation requires a knowledge of those principles on which the Creator has made objects agreeable or disagreeable, or expressive of Sentiment.

7. See André Félibien, Preface, *Conférences de l'Académie Royale de Peintre et de Sculpture,* 1669, in Lee, *Ut Pictura Poesis,* 19, for the academic classification of subject-matter reflected here.

8. *Lectures,* 438.

9. Reynolds, Discourse 4, 58: "I am very ready to allow that some circumstances of minuteness and particularity frequently tend to give an air of truth to a piece, and to interest the spectator in an extraordinary manner"; Discourse 11, 192: "He that does not at all express particulars, expresses nothing."

Morse found support for this belief in the daguerreotype: "How narrow and foolish the idea which some express that it will be the ruin of art, or rather artists. . . . One effect, I think, will undoubtedly be to banish the sketchy, slovenly daubs that pass for spirited and learned; those works which possess mere general effect without detail, because forsooth the detail destroys general effect. Nature, in the results of Daguerre's process, has taken the pencil into her own hands, and she shows that the minutest detail disturbs not the general repose" (SFBM to Washington Allston, undated, in Prime, *Life,* 405).

One of William Hazlitt's chief objections to Reynolds was his theory of the ideal or General Nature, which favored the general over the particular: "Greatness," wrote Hazlitt, "consists in giving the larger masses and proportions with truth;—this does not prevent giving the smaller ones too. The utmost grandeur of outline, and the broadest masses of light and shade, are perfectly compatible with the utmost minuteness and delicacy of detail, as may be seen in nature" ("On the Fine Arts," in *Criticisms on Art,* ed. W. Hazlitt, London, 1843, 208).

I now come to the consideration of those *principles* in the works of the Creator which serve as the common basis of the Fine Arts.

Lord Kames lays the *foundation* of the principles on which the Fine Arts raise their structure, in that succession or train of ideas which is constantly passing through the mind, and on the relations which connect these ideas together. Every one is conscious of this continual flow of thought, and Locke well observes "The mind can by no effort break off the succession of its ideas, nor keep its attention long fixed upon the same object."[10] The mind in this seems to be subject to that universal *law of Change* which governs all things, that law by which all earthly things proceed forward from their present mode of being to another mode of being. Inanimate nature, rocks and earth, though slower in the process still are subject to this law. The Sun never declines to the West but he has passed over a world of objects advanced a day further in this march of everlasting mutation. The vital principle in animal existence seems but the action of continual change, it is a process which never remits but steadily pursues its revolutions till it ends in extinction. It is an absorbing thought to contemplate this vast movement of all created things, this untiring procession of a universe of materials pouring onward to an obscure and mysterious consummation.

The first and most obvious principle proceeding from this law is *Motion,* or the progress of change. Motion in external objects has a powerful effect in retarding or quickening the natural progress of our ideas; this is abundantly seen in nature. Slow and even motion lulls to repose; if it be very slow, there is a corresponding sluggishness in our ideas with a sense of weariness and impatience. If it is rapid our thoughts flow rapidly, we are conscious of unusual excitement.[11] Some of its varied effects on the imagination may be illustrated in the progress of a fleet of vessels. We shall observe also its effects if we examine our sensations while looking at a passing procession, or the flowing of smoke, or the driving of clouds across the moon, or the waving of grain by the wind, or the flight of birds in the air. Nature is full of examples. But it [2–9] is not in the larger and more palpable objects of nature that the effects of motion in retarding or accelerating the train of thought are felt. It may be marked in the features of an expressive face as they change with the sentiment; or it is still more beautifully illustrated in the face of a sleeping infant, where smiles and frowns alternately change its features each into their own peculiar expression. As motion is capable of modification in degree from the swiftest to the slowest, as it is even or uneven, continued or broken, its power and use in exciting the imagination are apparent. The effects produced by motion are not confined in the world of visible objects to those that move, for I must draw your attention to a fact which I have never seen alluded to by any writer, a fact which is nevertheless of so much importance that it lies at the basis of all the Arts of Design. It is this. *There is* [2–10] *a motion of the eye as it travels over objects in a state of rest, which affects the imagination in a similar manner to*

10. Kames, *Elements,* 152. See also Kames's ideas on this in ibid., 19.
11. Ibid., 94.

the motion of objects passing in review before it and according to the order in which they are surveyed. The eye while in the act of perception cannot keep its attention long fixed upon a single point with more facility than the mind can keep its attention fixed upon a single idea; if our eye is at any time fixed it is *when it does not perceive,* when we are absorbed in thought; and if we observe another with his eye rivetted to a particular spot, we conclude without hesitation that he is in deep thought. The circle of motion may be confined indeed to a small space, as in the examination of some microscopic object, but it is no less certain that in scrutinizing the minutest object the eye travels from point to point with more or less rapidity through the whole process of perception.

The law of *Order* governs all our perceptions and sensations, it regulates the progress of motion, and is necessary to the permanence of any impression; we naturally survey a whole before its parts, a larger before a smaller, a brighter before a duller object; we hear a louder, before a lower, an acuter before a graver, a shriller before a softer sound.[12] The natural love of order is consulted in the classification of the various objects of science into genera and species, in the organization of a government or an army.

Another principle in the works of the Creator is *Novelty.* It seems to result naturally from the law of change, for as all things proceed in conformity to this law, new situations, new appearances, new combinations must constantly occur; the moon that rose last night, rises to night with diminished disk, and even the Sun, apparently so unchangable, moves not to-day in the same path that he travelled yesterday. From infancy to manhood, and in all circumstances of life, something new is forever attractive; it matters not whether the object be beautiful or deformed, the simple fact that it is *new* excites our wonder and calls forth curiosity. It is a question, which time will not allow me here to discuss, whether in the examination of any object the pleasure of Novelty does not accompany us through every part, and whether when the emotion produced by Novelty is gone, our pleasure has not departed with it.[13]

Connexion is another principle which pervades the Universe.[14] Every thing is bound together with a mysterious chain; no object seems so insulated as not to bear some relation to another, none so feebly related that it will not be found difficult to separate it from all others.[15] All the Arts and Sciences arbitrarily separated by man depend so absolutely on each other, run so imperceptibly into

12. Ibid., 21.
13. Novelty is discussed by several writers—including Kames, Burke, and Addison—but always as a quality of art to be distrusted as fleeting and superficial.
14. On the facing page is the note: "Connection (see Butler's Analogy, p. 195)." Morse probably refers to the following passage: ". . . As it is obvious that all events have future unknown consequences, so if we trace any as far as we can go into what is connected with it, we shall find, that if an event were not connected with somewhat farther in nature unknown to us, somewhat both past and present, such event could not possibly have been at all" (Joseph Butler [1692–1752], *The Analogy of Religion,* London, 1809).
15. Kames, *Elements,* 19: "Taking a view of external objects, their inherent properties are not more remarkable, than the various relations that connect them together: cause and effect, contigu-

one another, that no one can be pursued to any great extent without having encroached into the territory of its neighbor. Dr. Burney in his researches into Music found it "so intimately connected with Poetry, Mythology, Government, Manners, and Science in general" that he says "wholly to separate it from them" seemed to him "like taking a single figure from a group, or a single character out of a drama."[16] Hence it is very common for the Professors of any Art or Science, who have pursued their investigations to any extent, to believe that this Art, or this Science comprehends all others. What but this persuasion could have dictated to Vitruvius that catalogue of studies which he has given as necessary to form an Architect. Not only must he be well educated, docile, and ingenious but he must be acquainted with Designing, Geometry, Optics, Arithmetic, History, Philosophy, Music, Medicine, Law, and Astronomy;[17] appalling as this list may seem, had he still proceeded on the principle of selecting such of the Arts and Sciences as were more or less related to Architecture, he would not have stopped until he had numbered them all. But it is not in Arts and Sciences only that connexion is seen. In the works of creation we perceive connexion binding the various parts of animal existence together. Man himself in exterior appearance stands not insulated and distinct from the animal world; witness the negro, the ouran outan, the baboon, the monkey by gradual and downward steps blending the human face divine, with the unseemly visage of the brute.[18] Where is the line that severs the connection between beasts and birds, while the bat still holds his midway parley between them? The vegetable, animal, and mineral kingdoms themselves, distinct as they appear from each other, have had their limits the subject of dispute among the ablest naturalists, nor can they be clearly defined. The sea anemone may well connect the vegetable with the animal, while the arborescent coral, at the same time *stone, plant,* and *animal,* embodies in itself the three kingdoms of nature, an illustrious example of the universal principle of *Connexion.* It will not I trust be considered a digression here if I allude to a recent discovery in N[orth] C[arolina] of a vegetable insect, which is indeed a striking example of the undefinable limits between vegetable and animal existence.

ity in time or in place, high and low, prior and posterior, resemblance, contrast, and a thousand other relations connect things together without end. Not a single thing appears solitary and altogether devoid of connection."

16. Charles Burney (1726–1814), *A General History of Music,* London, 1776, 1:xx.

17. *On Architecture,* bk. 1, chap. 1. Morse's source was the article on architecture in Ephraim Chambers, *Cyclopedia,* London, 1791, vol. 1. Reynolds also mentioned this passage in Vitruvius (Discourse 7, 117).

18. "Human face divine" is from *Paradise Lost* 3.32. Benjamin Haydon wrote of his "belief, founded on physical construction, that the negro was the link between animal and man" *(Auto-biography,* Oxford, 1927, 162). This belief was expressed and attacked in a series of letters to the *Examiner,* 1, 15, 22, 29 September 1811 (Haydon's were signed "An English Student"). Morse knew Haydon at this time (Mabee, *American Leonardo,* 29), and this belief may have been fortified, if not implanted, in Morse by this public debate involving an acquaintance and fellow artist. Haydon's views on this subject are also found in his diary *(The Diary of Benjamin Robert Haydon,* ed. W. B. Pope, Cambridge, Mass., 1960, 1:208–10).

When the insect [2–11] has obtained its growth, it disappears beneath the surface of the ground, and dies. Immediately after its death, the two posterior legs begin to sprout or vegetate. These two shoots soon appear above the earth, and the insect-plant attaines [*sic*] the hight [*sic*] of about six inches.——It puts forth branches and leaves, resembling trefoil.——The extremities of the branches bear a bud, which contains in embryo neither leaves nor flowers—but an insect! As the insect developes itself and grows, it either falls to the ground, or turns upon its mother plant, feeding on its leaves until the plant is exhausted, when the insect returns to the earth again, and again the plant shoots forth!

The writer adds

it may be supposed [2–12], that nature has invested this specimen of existence with attributes the nearest possibly assimilated to those of both the vegetable and animal kingdoms, yet belonging not exactly to either, nor entirely to both. It may seem to be the hinging point at which the animal kingdom mergoes [*sic*] into the vegetable, and the vegetable into the animal kingdom.[2–3][19]

Objects [2–14] are connected by various relations some of which we will now consider.

On *Contiguity* [2–15], the first and most common, I shall not dwell; it appears to be the most *accidental* of all *relations,* objects being seen contiguous to each other without evincing any design.[20]

Variety and *Uniformity* appear every where and intimately blended. The members [2–16] of the animal frame exhibit variety in relation to each other, while the two sides of the same animal show their uniformity; the millions of human faces possessing the same features and these uniform on either side, still differ so widely that two persons are seldom mistaken for each other.[21] Observe this union in the movements of the heavenly bodies, each of the planets moving with a different velocity and different time, and yet completing their revolutions with a uniformity and regularity that human mechanism in vain attempts to equal.[22]

mazes intricate,
Eccentric, intervolv'd, yet *regular*
Then most, when most irregular they seem.

Milton[23]

19. For the remainder of this article, see Text Alterations 2–11, 2–12, and 2–13. The clipping, which is pasted into the text, is from an unidentified newspaper no earlier in date that 1840, for the original article appeared in the *Family Magazine; or Monthly Abstract of General Knowledge 5* (1840): 257.
This notion of connection is intimately tied to eighteenth-century thought. See above, n. 15, and Arthur O. Lovejoy, *The Great Chain of Being,* Cambridge, Mass., 1957, chap. 8, wherein he cites Oliver Goldsmith (1763): "The gradation from one order of beings to another, is so imperceptible, that it is impossible to lay the line that shall distinctly mark the boundaries of each."
20. Kames wrote that contiguity is "a relation . . . of the slightest kind" (*Elements,* 25).
21. Ibid., 163.
22. Kames discusses mechanisms—human, animal, vegetable, and solar (ibid., 162).
23. *Paradise Lost* 5. 622–24. The same lines appear in Hogarth's *Analysis of Beauty,* ed. Joseph Burke, Oxford, 1955, 160. Morse consulted Hogarth's *Analysis* in the preparation of the lectures. One of its central issues was the "Line of Beauty"; Morse spoke of arguing with Leslie and

Nothing [2–17] in Nature is so uniform but some variety may be discovered in it, and nothing so varied but in relation to some of its parts it shows uniformity. Uniformity is seen in the Genera and Variety in the Species. There are more than 500 species of flies so different from each other as not to be confounded, and yet possessing so much uniformity as properly to be classed one genus.

The relation [2–18] of *Resemblance* furnishes the foundation for that extensive comparison which enables the natural philosopher to classify the objects of nature, and it is the basis of all Analogy.

The relation of *Gradation* is one of the strongest that belongs to Connexion. It is that imperceptible change which conceals the steps of its progress even in passing from one extreme to the other. How beautifully it is seen in the evening sky, the brilliant yellow light melting away into the deep azure proceeding from warmer to cooler, and at the same time from lighter to darker, by such evanescent degrees that before we are aware we find ourselves at another extreme. The rainbow embodies the perfect gradation of colors. Sound on a stringed instrument, or in the human voice, is capable of the most perfect gradation from the highest to the lowest note, or on almost every instrument from the gentlest breath of sound to the loudest, or from the softest to the shrillest. All extremes may be united by *Gradation,* whether old or young, cold or hot, light or dark, beautiful or deformed.

Another relation, and the very opposite of *Gradation,* is *Contrast.* It is that quality which by its contiguity to its opposite marks most decidedly the differences of each. All that is united by gradation may also be contrasted; the effect of Contrast in strengthening the impression of two extremes, is a subject of common and daily observation. The cloudy day makes the succeeding sunshine the more welcome, the charms of spring are heightened by the glooms of the preceding winter, the morning is more beautiful for the darkness of the preceding night, all the pleasures of life are felt more keenly by being contrasted with antecedent afflictions and privations,[24] and to the Christian the darkness, and the gloom, and the privation that concentre in the night of death will but render him more exquisitely sensible to the lustre of an eternal day. The mixture of contraries, of light and dark, of cold and hot, of dull and bright, and even of concord and

Coleridge "about certain lines of beauty" (James Wynne, "Samuel F. B. Morse," *Harper's New Monthly Magazine* 24 [January 1862]: 231).

24. Beattie, *Essays,* 154: ". . . Health is doubly delightful after sickness, liberty after confinement, and a sweet taste when preceded by a bitter." Morse had intimate experience of this principle of contrast, as he told Thomas Cole: "I sincerely pray, my dear Cole, that whatever now be your trouble, may, by the blessing of our Heavenly father, be changed into permanent profit to you. It is indeed good to trust in Him, for in the darkest, most lowering moments, there springs up light, as if He intended to heighten our pleasure by the contrast. . . . It is in the moral world as in the material world, sunshine follows close upon storms and clouds, and how much more delightful are the beams of the sun by the contrast; what a lessening of our griefs, my dear Sir, there would be, if we could persuade ourselves that however threatening and seemingly permanent is the present affliction, a purer and more beautiful atmosphere is at that very moment preparing to break and disperse the clouds, and give fresh elasticity to our spirits" (SFBM to Cole, Paris, 25 August 1832; Cole Papers, New York State Library, Albany).

discord to form one consistent and harmonious whole, is abundantly seen in Nature. "By admitting every Nature, and every fortune," says Aristotle,* *"One disposition is formed out of many dispositions, and of dissimilar ones, Similar. Perhaps Nature herself also has an affection for Contraries, and chooses out of these to form the consonant, and not out of those things similar. Music by mixing together sounds that are sharp and flat, long and short, out of different voices produces one harmony."*

The relation of *Congruity* is next to be noticed. It is a consistency or propriety of objects or circumstances with each other; we feel its power when in a church, for example; every thing accords with the solemnity of the occasion, the silence of waiting worshippers, the scarcely audible voice of prayer, the murmurings of the popular response, the deep peal of the organ, and I will add, the "dim religious light" of a Gothic interior,[25] all accord with the sentiments of devotion which should pervade the place.

Incongruity is the basis of the ridiculous. Much of wit depends upon it, and it lies at the foundation of caricature. Suppose [2–19] for a moment that in the midst of such a place and such solemnity as has been mentioned there should suddenly appear one with a violin dancing to a lively tune in one of the aisles; it would give a shock to our feelings, and in spite of the place, laughter would scarcely be restrained. But what [2–20] would produce this effect? For the same man may perform the same action in a ball room, and no such effect be produced. It is its incongruity with the other objects which surround us.

We notice also the effect of *Congruity* when agitated by any great emotion such as extreme grief or joy. Objects, or sentiments, or circumstances which are not of the same kind are not only disagreeable, but they are often changed from their natural character into that of the emotion that absorbs the mind. For example, the loss of a friend occupies with its intenseness of grief our whole soul, and the dawn of day presents itself with all its interesting associations, a scene naturally calculated in a high degree to inspire gladness, what is the language of the sickened heart? "Oh! when will it dawn on the night of the grave"![26] And how congenial to such an one, and I had almost said delightful, is the storm and the rain and the howling winds and the sad countenances and tears of friends. These are in unison with our feelings while the sight and sound of pleasure comes to us like mockery and contempt of our sufferings.[27]

We come next to consider the relation of a *whole and its parts*. All objects in Nature may be arbitrarily divided into a whole and parts, and each may change

* Treatise Περί χοσμδ, quoted by Harris in his 3 Treatises. [Aristotle, "De Mundo," in *The Works of Aristotle*, ed. W. A. Ross, Oxford, 1914, 3:391ᵃ–401ᵇ. E. S. Forster, who translated the treatise for this edition, wrote, "This interesting little treatise has no claim to be regarded as a genuine work of Aristotle," and it was apparently so regarded in Morse's lifetime. I was unable to find it cited or quoted in any editions of Harris's *Three Treatises*.]

25. Milton, *Il Penseroso.* The same single line was quoted by Francis Hutcheson, *Inquiry into the Original of our Ideas of Beauty and Virtue*, London, 1729, 81.

26. James Beattie, *The Hermit*; the original reads, "O when shall it dawn."

27. This moving passage must certainly be read in the light of the sudden death of Morse's wife

its relation. The whole may become part of a greater whole and a part become a whole in relation to smaller parts. We take a leaf from a tree, we survey its general shape, and size, and color, we proceed to examine its stalk and its fibres; by itself it is a whole. But the single leaf taken from a tree of leaves is but a part of a greater whole; the tree again with its countless leaves belongs to a forest of trees; the forest to a wide extended landscape of forests, rivers, cities, mountains, these again to a world of landscapes. Nor can we stop here. The world itself in the system of our Sun takes its station with the other worlds merely as a part; nor even here does the wonderful progression end. "Our Sun," to use the language of the eloquent Chalmers, "may be only one member of a higher family, taking his part along with millions of others in some loftier system of mechanism by which they are all subjected to one Law and one arrangement, describing the sweep of such an orbit in space, and completing the mighty revolution in such a period of time as to reduce our planetary seasons, and our planetary movements to a very humble and fractionary rank in the scale of a higher Astronomy."[28]

The habit of the mind to divide the objects of its consideration into whole and parts, is necessary to fix the attention, and make permanent impressions on the memory; around every object of its thought it throws a circle of exclusion to all others, and secure in its temporary ramparts pursues undisturbed its quiet investigations.

The comprehension of a whole has ever been considered a mark of Genius. Horace condemns the Sculptor who could attend only to the finish of minute parts.

> Infelix operis summâ, quia ponere *totum*
> Nesciet. (Art. poet. ver. 32.)
>
> Defective in the chief part of his work, because
> he knows not how to compose a whole.

But if, to hold in its comprehension a mighty whole, discovers a mind superior to that which attends only to minute parts, it doubtless indicates a still greater mind while comprehending the entire whole, to be able to contemplate without distraction the smallest parts of its composition, and to assign to each its place in the great arrangement; it is an indication of greatness when the mind's eye cannot only dilate to take in immensity but can contract its vision to regard the least of the parts. It is in this that the mind of man discovers its strong analogy to its great Source; it is the Divine mind alone that grasps in its full extent the stupendous whole of a vast creation, and at the same time regards with undiminished attention the less than microscopic atom.

in February 1825, the tragic effects of which he still felt keenly when preparing the lectures for their first reading in 1826.

28. "Discourses on the Christian Revelation Viewed in Connexion with the Modern Astronomy" (1819), *The Works of Thomas Chalmers,* Philadelphia, 1833, 73.

The universal propensity to observe a whole before its parts may be illustrated by a single example. In visiting the interior of some splendid building, we first naturally turn suddenly about and give a hasty glance above, below and on all around, dwelling on no particular part; to this succeeds a more deliberate survey; the eye selects that which is most obtrusive. Objects are soon classed according to their superficial importance, whether rendered so by light or dark, size, form, or color. We then consider particulars; each object is successively made a part and a whole until the examination is completed.

From what we have observed on *Connexion*, particularly in its various relations of *Uniformity* and of *whole* and *parts*, it might be expected that *Unity* would constitute an essential ingredient in the works of Nature. Indeed we should expect that the Deity would stamp this attribute of himself on all his works. Without Unity in design no impression would be felt but that of confusion. We accordingly see Unity illustrated in every thing. How various soever the offices of different parts in any work of Nature they are all directed to one end. For example, the weights [2–21], valves and levers of the Steam engine differ widely in their character and office; each is perfectly adapted to perform its separate functions, yet all unite to produce one result. One great operation is often but a part made up of other smaller parts each of which performs its different subordinate action; thus in the engine, the weight by its gravity operates continually to depress one end of a lever, it is an action complete in itself; the depression of a lever lifts a valve, another complete action; the united action of the weight, the lever, and the valve effect one operation, the opening of a passage for the steam; but this also is not the ultimate design of the whole machine; it constitutes but one movement among a thousand others, which go to produce the final result.

I shall [2–22] mention at present but one more universal principle which is *Mystery*. It is a quality in the works of Nature which by exciting the curiosity keeps alive the attention in investigating them. It lies at the threshold of all philosophical inquiry; it accompanies the naturalist in his laborious arrangements of genera and species; the chemist in his subtle analyses; and the moral philosopher in his more intricate researches into the operations of mind. Mystery is an ingredient in the Sublime:[29] Imagination clothes all things mysterious with a largeness and importance which do not belong to them. A cannon heard at a distance is sublime from the mystery that attends it,[30] from the various conjectures we immediately form of the intention of its discharge. It may be the signal of an enemies [*sic*] approach or for assistance in distress, or a friendly salute, or a trial of skill at a target,[31] or many other intentions which will readily suggest themselves, in most of which instances were the mystery dispelled by certain

29. Burke in *The Sublime and Beautiful* makes numerous references to the power of obscurity, darkness, confusion, incompleteness, infinity, and so forth, in producing the emotion of sublimity.
30. "The noise of an engagement heard from a distance is dreadfully Sublime" (Alison, *Essays,* 195).
31. Over the *g* in "target" is written "hard."

knowledge of the cause of discharge the emotions of sublimity would also be dissipated. The universal fondness for Mystery is strongly evinced in the partiality every where existing for all such amusements as are tinctured with it. The whole family of puzzles and riddles depend on Mystery for their principal charm. It also constitutes the chief fascination in all works of fiction. A character is introduced, around whom is thrown some circumstances of deep interest, perhaps a female in distress made more interesting by beauty, youth and virtue; our interest is at once engaged, and curiosity is excited to know who she is, and by what unhappy circumstances she has thus been rendered miserable. Imagination is busy with conjectures and ready to seize on the first hint that is given to explain the mystery. The author has now the reader in his power; by the introduction of another character, perhaps between whom and the first there appears no palpable connection, imagination is employed in creating a thousand fancied relations. If he be a young man, it may be the lover or the brother, if an old man, the Father, or the guardian; as more characters are brought forward, the mystery increases; imagination still labors to connect, while the author still endeavors to increase the difficulty of connection. Were this process too long continued the imagination, fatigued by its fruitless toil, would give over the pursuit in despair; but here the judicious author knows how to entice it onward. By clearing up some minor mysteries he partially satisfies the craving curiosity, only to strengthen it for fresh enterprizes, until the web of Mystery is completely woven. He now commences his means of relief to the excited curiosity, not by a sudden, but gradual development, still creating lesser mysteries to exercise it to the end of the story.

The mystery which is gathered around the writer of the letters of Junius has given them a reputation to which they are not entitled by their intrinsic merit;[32] and the author of the Waverly novels knew how to take advantage of this universal passion, by enveloping himself for a time in a cloud of Mystery, an artifice for exciting attention certainly not necessary to add interest to the writings of Sir Walter Scott.[33]

I have thus given a glance at most of the principles in Nature upon which the Fine Arts are based. They are the general principles to which Poetry, Painting, Sculpture, Architecture, Music, Landscape Gardening, Oratory, and the Histrionic Art, are alike subservient. As each of the Fine Arts employs a different machinery by which it avails itself of these principles, they may not always be obvious to a casual student, but more profound study of any one of these Arts will assuredly demonstrate that it appeals for its efficiency to the same general laws.

In my next Lecture I shall illustrate by examples in the various Fine Arts the principles in Nature which I have this evening demonstrated.[2–23]

32. These letters were originally published between January 1769 and January 1772 in the London *Public Advertiser* and were reprinted into the nineteenth century.
33. Scott was technically anonymous from 1814 (when *Waverly* was published) to 1827.

Lecture 3

In my last lecture I endeavored to show that the true Imitation of Nature consists, not in the mere mechanical copying of what is created, but in making something on the Creator's principles. These principles I referred to one general law, the *law of change* which governs all created things. Among these principles I enumerated *Motion* or the progress of change, producing *Novelty; Connexion,* by the various relations of *Contiguity,* of *Variety* and *Uniformity,* of *Resemblance,* of *Gradation,* of *Contrast,* of *Congruity,* of *Whole and Parts,* and the principles of *Unity* and *Mystery.* I am aware that this enumeration is incomplete. I have attempted to construct a complicated instrument, the *many stringed instrument of the Fine Arts,* naturally tuned to many a sweet concord, and some harsh discords too. It is, indeed, as yet but rudely and imperfectly strung, and many of its chords are still to be supplied; I am admonished, however, that so much time may be bestowed in constructing the instrument, as to infringe on that which is necessary to try its power. Imperfect as it is, enough perhaps is already finished to show that the sister arts perform each in her own peculiar way upon the same harp of Nature.

Why are the Fine Arts called Arts? There is a propriety in the term which may not be immediately obvious. There are certain methods in Nature by which many operations are performed which are too slow to suit the necessities, the convenience, or the wishes of man. It is here that Art comes in and by its mechanism helps to quicken the sluggishness of a natural process. The tide or wind will naturally move a boat without the assistance of Art, but Art constructs the sail and the rudder and gives it additional velocity and any desired direction. Art improving on art applies the steam engine to the more rapid accomplishment of the same original and natural movement. To apply this analogy to the Fine Arts, Nature is full of objects that naturally affect the imagination; some making but a faint and evanescent, some a strong and lasting impression. The mere mechanical imitation or copying of some of these striking objects will excite strongly the same emotions as their originals. For example, the mere unadorned description of some natural scenes have all the effect on the imagination of fine poetry. Whately thus describes the rocks of Dovedale:*

> The forms and situations of the rocks are not their only variety, many of them are
> perforated by large natural cavities; some of which open to the sky, some terminate
> in dark recesses; and through some are to be seen several more uncouth arches, and
> rude pillars, all detached, and retiring beyond each other, with the light shining in

* Whately on Gardening (p. 117.) [Thomas Whately (d. 1772), *Observations on Modern Gardening,* London, 1793. Whately is quoted several times by Alison, but none of his selections are the same as Morse's.]

between them, till a rock far behind closes the perspective. The noise of the cascade in the river echoes amongst them; the water may often be heard at the same time gurgling near, and roaring at a distance; but no other sounds disturb the silence of the spot.

Here is not poetic embellishment, it is the simple description of the scene itself and language must indeed be badly chosen to deprive it of its poetic effect. So of some sounds in music, the imitation of the soft notes of the English nightingale, or the endless variety in those of our Southern mockingbird, must naturally excite the imagination without the assistance of art, and in Painting too there are many scenes which require only the mechanical imitation of the Painter to give them their poetic effect on the imagination. But all incidents accurately described, all sounds successfully imitated, all scenes perfectly delineated, will not produce the poetic excitement of the imagination. It is here then that art comes to the aid of nature and by her philosophical selections and combinations quickens the sluggish emotion; here an Intellectual Machinery is brought into operation to produce that effect which the objects themselves unassisted by art could not produce. Hence it is that Poetry has been said to * "wing notions to a flight above the low and muddy conceptions of ignorance and dullness." "Res vivunt, et plane spirant." (Things live and seem to breathe).

"From Poetry" says Quintilian, "we learn to give *animation* to circumstances, sublimity to *words,* every emotion to *passions,* and every grace to *character.*"[1]

The Fine Arts then are strictly arts having their peculiar *end* to attain, and *means* to accomplish that end. The mechanical arts employ as their means the mechanical powers to accomplish purposes of *utility;* purposes as varied as the wants of man, but all effected by modifications of the same general principles. So also the Fine Arts propose as their end the pleasing of the imagination, each of them accomplishing this end by different instruments but on the same general principles. The Fine Arts comprise the rules by which any emotion may be excited in its fullest power; they are accompaniments by which an excited emotion may be strengthened in its impression; the Intellectual Machinery by which the imagination is aided in its efforts.

We will now direct our attention to the *materials* and *methods* which the Fine Arts employ in accomplishing their common end to please the imagination, and show their accordance with the principles of nature.

We commence [3–1] with *Poetry.* Its first materials are words. The various properties of language are consequently the subject of the strictest analysis by the poet. Not only does all that belongs to the construction of sentences become important, but whatever pertains to *words,* to *syllables,* and even *letters.* As Poetry addresses itself to the imagination through the ear, the properties of sound are also a necessary part of study. Letters may be *rough* or *smooth,* syllables are

* (Whitlock's Ζωοτομία). [Richard Whitlock (1616?–ca. 1675), *Zootomia, or Observations of the Present Manners of the English,* London, 1654, 468–69. The two phrases are quoted by Morse in reverse order.]

1. *Institutes,* bk. 10, chap. 1, sect. 3.

long or *short* and according as they are composed of different kinds of letters will be harsh or soft. *Words* as they are composed of syllables *rough* or *smooth, long* or *short,* may be made to partake of various characters. So also by the mixture of words the character of *sentences* may be modified.

The arrangement of these properties of language as far as they regard Poetry belongs to *Versification,* which comprehends the division of words into long and short syllables, the collection of these into feet, and these again into metre. Rhythm, that which regulates the degrees and arts of motion, has been the subject of accurate determination; and the various kinds of verse, were by the Greeks adapted each to the expression of the different kinds of sentiment.

Every one is familiar with the variety that exists in the different measures of poetical lines in our own language, which by the collocation of syllables of different lengths, are capable of producing either gaiety or gravity. Some writers may have carried their analogies on the subject of correspondence of sound and sense to fanciful extremes, but there can be no doubt that to a certain extent such correspondence is accordant with rational principles.[2] If what we have said of motion be correct, then it is natural that *long* syllables should produce slowness and *short* syllables quickness in the succession of our ideas. The aid derived to gay or melancholy sentiments by the employment of these two kinds of syllables is therefore obvious.

The sprightliness of the Anacreontic stanza in which Cowper addresses the cricket, must strike every one with its suitableness to the subject.

> Little inmate, full of mirth
> Chirping on my kitchen hearth
> Wheresoe'er be thine abode
> Always harbinger of good.
> Pay me for thy warm retreat
> With a song more soft and sweet
> In return, thou shalt receive
> Such a strain as I can give.[3]

On the contrary, the subject of the minstrel of Dr. Beattie, plaintive and melancholy, demanded a different metre and arrangement of pauses.

> Ah! Who can tell how hard it is to climb
> The steep where Fame's proud temple shines afar.
> Ah! who can tell how many a soul sublime
> Has felt the influence of malignant star
> And wag'd with fortune eternal war,
> Check'd by the scoff of Pride, by Envy's frown,
> And Poverty's unconquerable bar

2. Morse wrote *"rashional"* in the text and above it the correct spelling.
3. William Cowper (1731–1800), "The Cricket," in *Poems by William Cowper* (London, 1782).

> In life's low vale remote has pined alone
> Then dropp'd into the grave unpitied, and unknown.[4]

Again, the din of battle, and the conflict of passions require the irregularity and roughness expressed in the following choice of lines, and words.

> Arms meet with arms, falchions with falchions clash
> And sparks of fire, struck out from armour flash.

Why does Poetry employ all this apparatus for governing motion, with such accuracy that any degree of slowness or rapidity can be given to verse? Does it not accord, as we have just hinted, with principles noticed in the works of Nature? We have seen that Motion by its different modifications of slow and quick, regular and irregular, even or uneven, sensibly affects in a particular way the succession of thought;[5] and poetry, therefore, by her quantities, and numbers, by appropriating to her use those determinate properties of language, is enabled to construct a series of words in artificial composition which shall imitate the same effect. Nor is motion the only principle observed in this apparatus, *Variety* and *Novelty* are also obviously produced. The Greeks could vary the single property of quantity an hundred and twenty four different ways by composition and transposition; how then is the regular stanza, which is divided into a certain definite number of feet, and more especially, how is the constant recurrence of rhime, consistent with this variety? On referring to our principles, we perceived that in Nature *Uniformity* is blended intimately with *Variety;* so far, therefore, is this artificial regularity from contradicting nature, that a well constructed verse is a beautiful example of the union of *Variety* and *Uniformity.*

The disposition of words in connection by *Gradation* gives to numbers that easy flow which is abundantly seen in Poetry, and which is effected by the placing together more long syllables than short, or soft ones than hard, as in this line of Virgil.

> Lŭctăntēs vĕntōs, tĕmpĕstātĕsquē sŏnōrăs.[6]

Or in this, copied from a sundial at Worms, on the Rhine.

> Horas non numero nisi serenas

the gradual full flow [3–2] of which could never be confounded with the harsh abruptness of the following line.

> Hăc ĭn rē nōs hĭc nŏn fĕrĭt.

From the qualities of *long* and *short,* of *smooth* and *rough* &c. which belong to words and to metre, it will be seen that *Contrast* is capable of being used with effect whenever the emotion requires it. Thus we [3–3] perceive that Poetry has

4. James Beattie, *The Minstrel,* bk. 1, sect. 1, 1–11.
5. See Lecture 2, pp. 62–63.
6. *Aeneid* 1. 53.

mechanical means to assist the imagination even in its words; that by artificially dividing language into feet and metre it can produce [3–4] the effects of *Motion,* of *Variety* and *Uniformity,* of *Connexion,* by the various relations of *Gradation, Contrast* &c., it has the means for an Intellectual Imitation of nature. But we have as yet taken but a very confined view of the means which Poetry possesses to affect the imagination. In so copious a field, time will not permit me to show to any great extent the same principles some in a greater, some in a less degree, in operation in all its numerous kinds. One thing is common to every species of Poetry, from the simple epigram to the most complicated dramatic or epic poem; each proposes some one end, by which the whole work is regulated. Aristotle makes *unity* in the action essential to the Epic poem; it must lie in the subject itself and growing up from all the parts combine into one whole. Milton's subject is the ejection from Paradise of our first Parents; Virgil's the establishment of Aeneas in Italy; Homer's in the Odyssey the return of Ulysses and his re-establishment in his own country. The action in each is *one* and its *unity* is constantly regarded by the poet. Whatever is introduced must have reference to the one great result. This unity, as Dr. Blair justly observes, does not exclude from the Epic poem episodes, but the episode must be connected with the subject of the poem. It is an inferior part belonging to it and not a mere appendage; it must present objects of a different kind from what precedes or follows in the narrative.

But why is one principal action made a rule in the contrivance of an Epic or Dramatic poem? Because we have seen that in the works of Nature one principal end is always proposed. Why must *unity* be so strictly observed, and lie in the subject itself, and growing up from all the parts combine into one *whole?* Because the same Unity, the same relation of *whole and parts,* the same *connexion* is observed in the Creator's works of design. Why is the complex fable considered more perfect than the simple? Because by its complication there is more room for the introduction of that *Mystery* and *Contrast* which in objects of Nature so powerfully rouze the curiosity. Why in the management of his subject must the poet so contrive his plan as to introduce a great variety of "affecting incidents," "sometimes dazzling," "sometimes touching," "now awful and august," "now tender and pathetic"? Obviously that his work may possess that variety and novelty which occupy so great a space among the qualities of all created things. But there is a part of the fable which must be involved in perplexity. The nodus or intrigue is the part which comprizes the dangers to which the hero is exposed; the poet must create difficulties for his hero, and make them "grow and thicken 'upon us by degrees' until after a season of suspence he winds up the plot in a natural manner."* These rules we refer without hesitation to the principle of *Mystery* in the works of nature; and on this ground perhaps may be defended what is called the Machinery of the poem, the introduction of Supernatural

*Blair [Much of the preceding two paragraphs has closely paralleled Blair, *Lectures,* 474–78. This passage is quoted from ibid., 477.]

beings. All the *characters,* all the *sentiments,* all the *incidents* of a poem are in the same manner regulated by those principles of nature to which we have referred. But I must close this part of my subject with a few examples from the poets.

In Atherstone's *Last Days of Herculaneum*[7] is a beautiful illustration of *Contrast;* the dark, dry, noxious, atmosphere produced by the volcano which destroyed that ancient city is thus described:

> —Not a breath [3–5]
> Of air was felt:—the thick hot atmosphere
> Came on their parching lips, as from the mouth
> Of opening furnace. Darkness, like a pall
> Of deepest shade, hung o'er:—no heaven, no earth,
> No faintest outline of the temple's form
> Against the sky:
> .
> How drear the night! [3–6]
> Oh! when will morning come?—the tapers all
> That measure out the hours are long since spent
> But yet there is no day.—
> .
> slowly yielding now, the pall of night [3–7]
> Changed to a dingy red:—like a vast arch
> Of iron look'd the heavens when first the heat,
> Deep penetrating, to a lurid tinge
> Begins to turn its blackness;—redder now—
> And redder still the awful concave grows—
> Till in its bloody, but uncertain glare,
> The bolder may walk forth.—Man meets with man,
> And starts as at a fiend:—for from the hot
> And fiery sky all things have caught their hue.

Observe the contrast of images and of scene which immediately succeeds:

> No sweet varieties of colour here
> As in the blessed sunshine:—no soft tints
> Like those of sweet May-morn,—when day's bright god
> Looks smiling from behind delicious mists;
> Throwing his slant rays upon the glistening grass,
> Where 'gainst the rich deep green, the cowslip hangs
> His elegant bells of purest gold:—or the pale
> Sweet perfumed primrose lifts its face to heaven
> Like the full, artless gaze of infancy.

7. Edwin Atherstone (1788–1872). The poem was published in 1821 and never reprinted. Morse cut his selections from an unidentified newspaper.

Or where

> The little ray-crown'd daisy peeps beneath
> When the tall neighbour grass, heavy with dew,
> Bows down its head beneath the fresh'ning breeze;—
> Where oft in long dark lines the waving trees
> Throw their soft shadows on the sunny fields:—
> Where in the music-breathing hedge, the thorn
> And pearly white May blossom full of sweets,
> Hang out the virgin flag of spring, entwined
> With dripping honeysuckles, whose sweet breath
> Sinks to the heart—[3–8]

Who does not feel in the *"delicious mists,"* and *"glistening grass heavy with dew,"* and the *"dripping honeysuckles"* how much more intense is rendered the *"thick hot atmosphere,"* *"from the mouth of opening furnace,"* the *"iron looking heavens,"* the *"hot and fiery sky."* Who does not perceive in the *"varieties of color,"* the *"soft tints of May,"* the *"rich deep green,"* the *"cowslip's bells of purest gold,"* the *"soft shadows of the trees,"* the *"pearly blossom,"* how much the dismal dreariness of the *"pall of deepest shade,"* of *"dingy red,"* the *"lurid tinge,"* the *"bloody glare,"* the *"fiery hue"* is heightened, and how the sulphurous and noisome vapors of such an atmosphere are made to be felt by the description of the *"sweet perfumed primrose,"* the *"blossom full of sweets,"* the *"sweet breathed honeysuckles"*?

But I pass to consider an example of the effect of *Mystery* in poetical productions. Byron understood its power and uses it abundantly in his works. I shall produce from his *Lara* an example of the happy effect of simple Mystery in creating interest in a character. He is describing Lara:

> ————oft in sullen mood for many a day
> From all communion he would start away
> And then, his rarely call'd attendants said,
> Through night's long hours would sound his hurried tread
> O'er the dark gallery ·
> ·
> They heard, but whispered that must not be known—
> The sound of words less earthly than his own
> Yes, they who chose might smile, but some had seen,
> *They scarce knew what,* but more than should have been,
> Why gazed he so upon the ghastly head
> Which hands profane had gathered from the dead
> That still beside the open'd volume lay,
> As if to startle all save him away?
> Why slept he not while others were at rest?
> Why heard no music, and received no guest?

All was not well they deem'd—but where the wrong?
*Some knew—perchance—*but 'twere a tale too long,
And such besides were too discretely wise
To more than hint their knowledge in surmise,
But if they would—they could—around the board
Thus Lara's vassals prattled of their lord.[8]

How full of Mystery is this whole passage, the hearing of words that must not be known, the seeing of an indefinite Something; the suspicion that all was not well, yet *where* the wrong; the knowledge of a secret known to some, but involving a long story, the revealing of which might be attended too with danger, and the hint that if they would they could reveal a tale of wonder; all throws around the character of Lara a deep interest, and excites our curiosity to discover what these matters of mystery are that are so cautiously concealed.

I will give one example of the effect produced by the relation of *Congruity.* Shakespeare wishes to excite the imagination and to impress the mind of his readers with horror at the murder of Duncan. He does not by a cold relation of a plot between Macbeth and his spouse tell his readers that the King was a guest in their house and that as he was asleep at night he was murdered by Macbeth; this is the whole fact, it is all the information which he gives us, and shocking as murder is, had he merely given us the simple narrative of it, there are few that would read it with emotion. But how does the poet bring the machinery of his art to bear upon this emotion to quicken it into vigorous life? He assembles a host of images from nature related by congruity to the passion he wishes to raise; the time of midnight is chosen, the fittest to conjure up every species of horror; the phantom of the air-drawn dagger is introduced; now "witchcraft celebrates pale Hecate's offerings," and the wolf howls on his watch; "the owl screams;" "Twas a rough night;" "chimneys were blown down;" "Lamentings were heard in the air;" "strange screams of death,"

And prophesying with accents terrible
Of dire combustion, and confus'd events.
———The obscure bird
Clamor'd the live-long night;" "the earth
Was feverous and did shake.[9]

These are a few only of the images that this great master of human nature clusters round the deed to raise the passion strongly which the mere narration would but faintly have excited.[3–9]

Music has for its means of affecting the imagination all the qualities of sound. Sound may be *loud* or *soft, harsh* or *sweet, quick* or *slow, grave* or *acute.*

8. George Byron (1788–1824), *Lara*, 1814, canto 1, verse 9.
9. Act 2, scenes 1, 2.

It is by the varied combination of these few qualities that the musical composer produces all his effects. From the nature of these materials, it is readily perceived that by the variation of sound from quickness to slowness, from even to uneven, from continued to broken, he can give the effects of *motion*. From the number of these qualities he can produce *variety* and *novelty*. Sound is susceptible of the most perfect *gradation*, either from loud to soft, from harsh to sweet, from quick to slow, or from grave to acute; and as we have heretofore noticed, the power of contrast is peculiarly within the province of sound. But there is a species of *Contrast* in music called *Dissonance* to which we must advert, the mixture of Discord with Concord.

That discord should be an ingredient in harmony seems a paradox, but from the known effects of Contrast in increasing the qualities of its opposite the propriety of such mixture is readily seen. Dr. Burney calls it the *"Dolce piccante"* of music and compares its effect on the ear to that of a poignant sauce on the palate,[10] a zest without which the auditory sense would be as much cloyed as the appetite if it had nothing to feed on but sweets.[11] Mason, in his *Caractacus*, notices its effect in the address of the chorus to the bards.

> Wondrous men
> Ye whose skilled fingers know how best to lead
> Through all the maze of sound the wayward step
> Of harmony; recalling oft, and oft
> Permitting her unbridled course to rush
> Through *Dissonance,* to *Concord, sweetest then*
> E'en when expected harshest.[12]

In music the relation of Congruity is particularly observable. Not only are the tones of the various sentiments of joy and grief and other passions expressed by the voice but the great variety of Instruments which music can command, by their natural consistency with various emotions are made to help out any particular sentiment.* The Greeks fixed also with the greatest accuracy their numerous modes and genera, each adapted by its congruity to the same purpose. The Phrygian mode was that in which enthusiasm and fury were best expressed and in their excitement were employed all the noisy instruments.

10. Over "poignant" is written "poé-nant."
11. This is a common observation; see Burney, *History of Music,* xiv; Beattie, *Essays,* 154; Gerard, *Essay,* 63; and Hutcheson, *Inquiry,* 28.
12. William Mason (1725–1797), *Caractacus,* London, 1759. The same lines were quoted by Thomas Twining, "On Poetry Considered as an Imitative Art," *Aristotle's Treatise on Poetry,* London, 1789, 12. There are several references to Twining in Morse's notes (National Academy of Design).
* Gillies Greece Vol. 1. p. 182 [John Gillies (1747–1836), *The History of Ancient Greece,* Philadelphia, 1822, 1:182.]

Some strike the Drum, with loud resounding roar
Some through the taper trump shrill clangors pour
These the hoarse horn, while those discordant strain
The shrieking pipe, till every nerve complain.

Catullus[13]

On the other hand, the Lydian mode was suited to the expression of the more tender emotions; Dryden alludes to both these modes in his *Alexander's Feast*, where Timotheus rouzed the Macedonian monarch to madness by the Phrygian mode and suddenly changed the strain.

Softly sweet in Lydian measures
Soon he sooth'd his soul to pleasures.[14]

But can Music be said to have *unity?* If indeed we consult our feelings after hearing much of the music in popular use, I know not what single impression would remain from it but that of confusion.

That Unity of effect can be produced by Music is certain. The sound of the Halleluiah Chorus of Handel performed by 300 instruments and voices has not faded from my memory after the lapse of twenty years. It has left one abiding impression of sublimity, for as the voices mingled at the close into one vast volume of harmonious sound, the very air seemed buoyant and the spirit itself was lifted up as if it could with ease rise and float away towards heaven, and the lingering silence that succeeded among the auditors gave proof of the power of music to produce one all absorbing emotion.

I am at present prevented from illustrating by examples from musical composition. Description alone can scarcely define what can be expressed only by sound. It is my purpose at some future season to demonstrate by musical selections the perfect consonance of this enchanting Art with the principles to which the other arts are obsequious.

The materials which Landscape Gardening possesses for pleasing the imagination are ground, wood, water, rocks, and buildings.[15] Ground in all that relates to this art is convex, concave, or plane; that is, a swell, a hollow, and a level.[16] Trees and shrubs, which are what is meant by wood, are divided into shapes, colors, and growths. In shape some trees are thick and solid, others light and airy; some are conical, others swell in the middle and diminish at both ends; the base of some

13. *On the Nuptials of Peleus and Thetis,* 64. 261–64:

Plangebant aliae proceris tympana palmis,
Aut tereti tenuis tinnitus aere ciebant;
Multis raucisonis efflabant cornua bombos,
Barbaraque horribili stridebat tibia cantu.

14. Lines 79–80.
15. Whately, *Observations,* introduction (unpaged).
16. Ibid., 3.

is large, of others small in proportion to their height; some have branches growing upwards, others horizontally, others hanging directly down with many more varieties. As to colors, some are dark green, others light green, some tinged with brown, others with white, and in growth every variety is seen in the size of trees and shrubs.[17] Water is either running or stagnated; running water is a brook, a river, or a rill; stagnated water is a lake or a pool.[18] Every kind of building as far as it regards exterior appearance belongs also to this Art from the simple outline of a rustic arbour to the splendid form of a palace.

These are the means in the possession of Landscape Gardening by which it aims to please the imagination. Some of its rules gathered from Whately, an accomplished writer as well as gardener, I will now compare with the principles of nature; "Small portions of large circles blended together; lines gently curved which are not parts of any circle, a hollow sinking but little below a level, a swell very much flattened at the top are commonly the most agreeable shapes of ground, whilst a plain is in itself not interesting."[19] Why are the former agreeable and this latter disagreeable? In the first there is variety, in the last it is wanting. "In made ground the connexion is perhaps the chief consideration, a swell which wants it is but a heap, a hollow but a hole, the one seems placed on a surface which does not belong to it, the other dug into it."[20] In this rule the principle of *Connexion* is expressly recognized. "When ground changes its direction there is a point where the change is effected and that point should never appear; some other shapes uniting easily with both extremes must be thrown in to conceal it."[21] Connexion by Gradation is the principle to which this is referred. The effects of *Motion* in its various kinds as exemplified in water and consequently the suitableness of water to inspire and sustain any emotion from cheerfulness to melancholy, and even to terror, is beautifully illustrated in the following description by Whately.

> So various are the characters which water can assume that there is scarcely an idea in which it may not occur or an impression which it cannot enforce; a deep stagnated pool dank and dark with shades which it dimly reflects befits the seat of melancholy, even a river if it be sunk between two dismal banks and dull in motion and color, is like a hollow eye which deadens the countenance, and over a sluggard silent stream creeping heavily along all together, hangs a gloom, which no art can dissipate, nor even the sunshine disperse. A gently murmuring rill, clear and shallow, just gurgling, just dimpling, imposes silence, suits with solitude and leads to meditation; a brisker current which wantons in little eddies, over a bright sandy bottom, or babbles among pebbles, spreads cheerfulness all around; a greater rapidity and more agitation to a certain degree are animating, but in excess instead

17. Ibid., 26–29.
18. Ibid., 64–65.
19. Ibid., 7.
20. Ibid., 8.
21. Ibid., 11.

of awakening they alarm the senses, the roar and the rage of the torrent, its force, its violence, its impetuosity, tend to inspire terror, that terror which whether as cause or effect is so nearly allied to sublimity.[22]

The analogy here is very perceptible between the degrees of Motion which Poetry and Music employ to awaken the same sentiments.

As an example of *Congruity* in the choice of objects a spot on the grounds of the Marquis of Buckingham at Stowe, described by the same writer, happily illustrates this relation; after describing a scene of gaiety and sprightliness he says,

> Close by this spot, and a perfect contrast to it is the alder grove, a deep recess, in the midst of a shade which the blaze of noon cannot brighten, the water seems to be a stagnated pool, eating into its banks, and of a peculiar color not dirty but clouded, and dimly reflecting the dun hue of the horse chestnuts and alders, which press upon the brink; the stems of the latter, rising in clusters from the same root, bear one another down and slant over the water: misshaped elms and ragged firs are frequent in the wood which encompasses the hollow; the trunks of dead trees are left standing amongst them; and the uncouth sumach, and the yew, with alder, nut, and holly, compose the underwood; the wood is in general of the darkest greens; and the foliage is thickened with ivy, which not only twines up the trees, but creeps also over the falls of the ground, which are steep and abrupt; the gravel walk is covered with moss; and a grotto at the end, faced with broken flints and pebbles, preserves in the simplicity of its materials and the duskiness of its colour all the character of its situation; one building is sufficient for such a scene of solitude as this, in which more circumstances of gloom concur than were ever perhaps collected together.[23]

But I will close what I have to say on this interesting Fine Art by giving an example of its transforming power.

(show example)[24]

In this example you perceive one of those buildings and its mode of embellishment which those who have travelled, I will not say in what direction in the country, will bear me witness is not caricatured.

Observe its finical, patchwork fence, half rail, half stone wall; its four poplars trimmed up lest any part of the house should be concealed, and on the left two unsightly unconnected woodsheds.

Dividing the green area into two equal parts is a straight walk to a meagre pair of steps, leading upon the platform of a low straddling portico.

Observe the house with its three monotonous rows of windows; its bare roof without eaves or balustrade; its four equi-distant chimneys and its abortive pediment,[25] altogether appearing as if the Genius of Desolation had been the

22. Ibid., 63–64.
23. Ibid., 226–27.
24. Morse's illustrative examples have not survived. One listener, who found them "highly interesting" but indistinctly visible, described them as "sketches." See Introduction, n. 67.
25. Morse describes a New England house of the Federal period.

Architect, and had planned it for his own residence. Such is the scene of Art to which the landscape-gardener is introduced. He surveys the whole place and finds the house situated on rising ground; behind it a level piece of meadow without a tree or shrub stretching to the river, which is disclosed to view in its whole passage. The river is the boundary of the land on which he can operate. Beyond the river is a flat open country with two or three villages scattered in the distance, the whole bounded by a long straight line of horizon, with no mountain to break its monotony.

With such an unpromising spot how does he proceed?

(Show 2d example.)

In this example you will observe the result of his labor. What has he done to effect this transformation? He has taken away the fence and substituted a green hedge; he has cut down the poplars; and instead of a straight path has turned the approach into a semicircular form enclosing the area making one beautiful lawn; the unsightly woodsheds are masked by an ornamental connected front of blind arches. He has not built here a new building, neither has he built a new house; it is the same house, not a window nor door is removed or changed in number or situation. Even the form of the pediment is preserved. He has concealed the bare roof by a balustrade; broken the insipidity of the front by bringing forward the pediment to be supported by four columns whose bases rest on a broad flight of steps, thus giving by its shadow a variety in its appearance which is obvious. Between each of two of the four windows on either side of the portico he has placed pilasters, and also at the corners; and a pilaster between each of the windows under the portico, thus producing in the whole front a union of *uniformity* and *variety*. From each end a platform for flowerpots and flowers is made connecting by *gradation* the house with the shrubbery introduced on the brow of the hill.

Beyond the house is seen the same level meadow and the same river as before; but the meadow is enclosed as a lawn by the trees and shrubs; and the river, concealed in some parts only, is suffered to sparkle here and there through the underwood; and by leaving the imagination to supply its course *Mystery* is created to whose pleasing effects we have often alluded. But we have now arrived at the boundary of the spot which is within the landscape gardener's immediate control; how is the flat country beyond, and particularly the unvarying line of horizon, to be deprived of its dreary insipidity? He cannot create hills and mountains, and if he could, he may not intrude upon the territory of others. He has his remedy in the size of his trees; by planting such as when grown will rise above the horizon and break it at such places as he may wish, hiding the most barren parts of the distant country and leaving any more interesting spots to be seen between the various openings, as in the case of the small villages in this example.

Thus we perceive, in the judicious removal and planting of a few trees, and a slight and by no means *expensive* alteration of the exteriors of the buildings, a

space which seemed so desolate is by the landscape gardener made to appear not only tolerable but even fascinating.

I have now compared three of the perfect Fine Arts with those principles in nature which I gave in my last lecture; they would each bear a much more enlarged comparison and the analogies perceived between the rules of these arts and the principles of nature would multiply on further research; but time will not allow me further to pursue them. I must also omit for the present the comparison of the Imperfect Fine Arts.

Enough has already been shown I trust to prove to you that the rules of these Arts are not arbitrary nor dependent on mere authority, but that they have their origin deeply rooted in the principles of nature. It now remains for me, according to my original plan, to show that *Painting* is entitled to a rank among the Fine Arts; that it possesses materials for affecting the Imagination; and that its rules are also founded on the same solid basis of nature.

This shall be done in my concluding Lecture.

Lecture 4

Having in my previous lectures settled definitely what are the Fine Arts on the quality common to all, of their principal intention to please the Imagination; having given the principles of Nature on which they are based; and demonstrated the agreement of the rules of Poetry, Music, and Landscape Gardening with these principles, we are prepared according to the plan adopted in these Lectures to examine the claims of *Painting* to a rank among the Fine Arts.

What is *Painting?* The name [4–1] Painting confines the attention to the grosser ideas connected with the Art, leaving not indicated the Intellectual part which must be discovered only by a more intimate acquaintance with the thing and not the name. This defect, it is true, is not confined to Painting; Poetry is conceived by many to consist in the mere mechanical construction of verse, and Music in the production of harmonious sounds, and Architecture in the mechanical construction of a building. Nothing can be inferred from the names of any of these arts but their *modus operandi.* Painting in its literal sense signifies but the mechanical operation of the Painter in producing his results. Thus confining themselves to the literal signification of the word, many writers on the Art of Painting seem not to have considered that it had a higher and nobler end than the mere mixture and spreading of pigments; hence it is not a little mortifying to an artist, in his researches among the writings of such men, instead of finding principles illustrated, to be cheated, as is often the case, with a definition that places his art on a level with any ingenious mechanical employment, followed up by a series of receipts, a pharmacopoeia of curious mixtures, as if painting were but a part of Pharmacy and operated on its devotees by some Circean compound. Thus Painting has been defined by an English writer to be "the Art of imitating the appearances of natural objects by means of artificial colors spread over a surface;"[1] and a French Lexicographer defines it to be "the Art which by lines and

1. I am unable to locate the precise source, but the implication to which Morse objected is found in many similar definitions:

"The function of the painter is to render with lines and colours, on a given panel or wall, the visible surface of any body, so that at a certain distance and from a certain position it appears in relief and just like the body itself" (Leone Battista Alberti, *Della Pittura,* in Anthony Blunt, *Artistic Theory in Italy 1450–1600,* Oxford, 1940, 14).

"The essence and definition of painting is, the *imitation of visible objects* by means of form and colours" (Roger de Piles, *The Principles of Painting,* London, 1743, 2).

Painting is "the art of representing all visible objects by lines and colours, on an even and uniform surface" (Chambers, *Cyclopedia,* 1791, vol. 3).

"*Peindre,* c'est imiter les objets visibles par le moyen des figures qu'on trace & des couleurs qu'on applique sur une surface" (M. Watelet, *Dictionnaire des Arts de Peinture, Sculpture et Gravure,*

colours represent on an equal and uniform surface all visible objects."[2] This is as correct as if he had defined Poetry to be the Art of delineating on paper by means of pen, ink, and words, the signs of our ideas. The error of these distinctions consists in giving a part for the whole, and, while professedly treating of Painting as a Fine Art, in leaving out the essential quality which distinguishes it from Painting as a mechanical art.

In Poetry, Music, and Landscape Gardening the distinction is obvious between the *thought,* and its dress. It is the sentiment to be excited which is the principal end in all; and while the machinery employed in bringing out a given emotion in its full power may be well adopted for that purpose, in admiring the beauty of its construction we should not lose sight of the end of the whole apparatus. This is by no means an uncommon error; there is an analogous style in writing which critics have denominated the "ambitious style," and have defined it to be "an unnatural and artificial sustainment of the language and imagery when neither the warmth of the author's mind prompts it nor the elevation of his thoughts demands it; this error arises from considering the qualities of diction distinct from those of *matter,* the mode of *expression* from the thing *expressed.*" (Quart. rev. 1816. p. 70.)[3]

From the same cause Painters and connoisseurs often lose sight of the senti-ment in a picture and devote all their attention to the mode of expression or machinery. And in Painting the temptation is greater to this error from the superior splendor of the vehicle of a painter's thoughts; this is richer and more varied and has, therefore, more of fascination than the media of other arts; even the dress without the thought produces exquisite pleasure: delighted with the gorgeousness of the dress some artists forget that it was made only to adorn the thought. There are very many pictures, and these too of the first masters, that seem painted only to display ostentatiously the resources of the painter; they may be compared to the voluntaries of one skilled in playing on an instrument; they are pleasing idlings, momentary reveries, a playing with the means without realizing their adaptation to a noble end. A painter may learn all these artifices as a man learns a language, but if he does not employ them to convey thought or sentiment they are but an unprofitable accomplishment.

It is the principal aim of Painting to *excite the Imagination* by visible repre-

Paris, 1792, 4:45).

"Painting is the art of representing all objects of nature visibly, by lines and colours on a plane surface" (Gregory, *Dictionary of the Arts and Sciences,* 2:327).

"PAINTING comprises all methods of producing a representation of objects by lines, light and shade, and colour, on a plane surface" *(Magazine of the Fine Arts* 1[1821]: 5).

2. Jacques Lacomb, *Dictionnaire portatif des beaux-arts,* Paris, 1753: ". . . un Art qui par des lignes & des couleurs, represente, sur une surface égale & unie, tous les objets visibles." This definition comes from André Félibien: "La Peinture est un Art qui par des lignes, & des couleurs represente sur une surface égale & unie tous les objets de la nature" *(Des principes de l'architecture, de la sculpture, de la peinture,* 3d ed., Paris, 1699, 288).

3. From a review of *Judicam Regale* and *Fazio; a Tragedy,* in *Quarterly Review* 15 (1816): 70.

sentations of natural objects.[4] Its intention is to produce a sympathetic emotion in the spectator similar to that produced by their archetypes in nature, either in their original states or under any of their modifications. In accomplishing this end it does it by materials peculiarly its own, but analogous to the materials of its sister arts. Every object in nature produces some definite emotion. There are few, however, that produce an unmixed emotion, few, that by the addition or subtraction of some qualities, may not produce a given emotion more distinctly. Almost all beautiful objects have, combined with them, some qualities which if removed would make them more beautiful; the *perception, selection,* and *arrangement* of such only as are necessary to an agreeable result, belong to the man of genius in any of the Fine Arts; the *perception* and *relish* of them belong to the man of Taste. The Painter surveys the objects of nature as they pass in succession before his eye, and what on the minds of others would leave no impression, he stores in his memory, he feels as it were intuitively what strengthens and what weakens any particular sentiment, and although he may not always be able to tell what it is, nor where it is, yet in the language of Painting, and with his own peculiar pen and ink, he can show that a Poet's mind has perceived it, and a philosopher's mind has analyzed it. The power of certain qualities of objects to raise particular emotions is therefore an interesting study for the painter. The visible signs of all the passions in the animal but especially the human frame; the visible qualities of inanimate nature, the gorgeousness of the setting sun, the calmness of the unruffled lake, the deepening shadows of the thick forest and the countless beauties of the close of day; the storm and the hanging cliff, the tower, and the torrent, have all visible qualities which produce the milder or stronger emotions, and which, therefore, may be observed and copied by the painter.

Painting may be considered

>as *a Mechanical Art,*
>as *an Accomplishment,*
>as *an Intellectual Art.*

As a Mechanical Art is comprehends all those numerous branches in common use as *Sign painting, Standard, Heraldic,* and all *Ornamental painting,* imitations of marbles, mahogany, and other woods, the embellishment of furniture, &c.

As an *accomplishment* it comprehends such a knowledge of its rudiments as will enable any one to draw with tolerable facility an object from a model or print and sometimes from nature, and to color generally in the manner of the teacher. It is seldom carried as an accomplishment beyond these; in this respect it is on a level with other accomplishments; a knowledge of music, for example, is seldom pursued to such an extent as to enable the learner *to compose,* nothing more is attempted than the teaching of the mechanical means of producing harmonious

4. Morse noted, "Painting may be defined as the Art of exciting [pleasing] the imagination, with a representation of visible objects on a plain [*sic*] surface by means of lines, lights, darks, and colors" (National Academy of Design).

sounds. Language, Chemistry, Botany, and most of the sciences taught as accomplishments pretend merely to superficial knowledge, and indeed, from the diversity of studies requisite in a polished education, most if not all of them must necessarily be superficial. It is to Painting as an *Intellectual Art* that I wish now especially to direct your attention.[5] *Poetry*, as we have seen, embodies its conceptions in *words*, *Music* in *sounds*, *Landscape Gardening* in the *various objects of nature;* what materials has Painting at command to excite the imagination in a similar manner? As we have noticed the first materials in the other Arts, we will now consider what are the materials of Painting. As Painting is addressed to the eye, it is apparent that those objects alone which are visible are within the province of the Painter. All objects as addressed to the eye are composed of *Lines, Forms, Lights, Darks,* and * *Colors.*[6]

(See example 1st (Lines) & 2nd (Forms) & 3rd (Colors)).[7]

There are three primary colors and three only: B[lue]. Y[ellow]. R[ed]. This [4–2] is the Artist's Theory and opposed or apparently opposed to that of the Natural Philosopher. It is an error, notwithstanding it is sanctioned by the name of Newton, that there are *seven* primary colors. These are stated to be Violet, Indigo, Blue, Green, Yellow, Orange, and Red.[8] That these are not all primary is perfectly demonstrable. It will be admitted that that color cannot be primary whose elements can be separated into two others, or which can be compounded by the mixture of two others. Let us examine, then, these seven alleged primaries. The first, Violet, is a bluish purple, compounded of red and blue; Indigo is merely a dark blue; *Blue is a primary;* Green is compounded of Blue and yellow; *Yellow is a primary;* Orange is compounded of yellow and Red; and *Red is a primary.* Thus, *Blue, Yellow,* and *Red* are the only colors not compounded. An illustration by an experiment which I had prepared, but which requires daylight to exhibit, proves beyond question the fact of the existence of three, and three only, primary colors.

5. "I am not happy unless I am pursuing the intellectual branch of the art" (SFBM to his parents, London, 2 May 1814, in *Letters*, 1:132). In a draft of this lecture Morse here included a disquisition on the dignity of painting (National Academy of Design).

6. The asterisk refers to the passage on color (the following seven paragraphs) added to the manuscript.

7. None of the examples referred to in this lecture survive, but see Appendix 3 for possibly comparable diagrams.

8. Morse noted, "Sir I. Newton as quoted by Priestley says 'There are also two sorts of colors, the one original and simple, the other compounded of these. The original or primary colors are red, orange, yellow, green, blue, indigo, and a violet purple, and an indefinite variety of intermediate gradations' " (National Academy of Design).

According to Field, "Newton considered the simple originality of . . . these colours . . . to be demonstrated, because, after having produced them from a beam of light analytically, by prismatic refraction, he could not farther resolve either of them into other colours by passing them through a second prism; for though variously dispersed, each colour retained its original line" (George Field, *Chromatography; or a Treatise on Colours,* London, 1835, 257n). Field's *Chromatography* also influenced another American artist about 1840, Morse's friend Thomas Cole (see William I. Homer, "Thomas Cole and Field's 'Chromatography,' " *Record of the Art Museum, Princeton University,* 19 (1960): 26–30).

The rainbow, then, whatever difficulties may exist in the analysis of its compounded colors, is a combination of but *three* and not of *seven* colors. This error, it would seem, is of modern date for Homer speaks of

> Jove's wondrous bow, of *three celestial dyes*
> Placed as a sign to man amid the skies.[9]

And here allow me to ask whether this philosophical error of *seven* primary colors has not been suffered to obscure, if not entirely to conceal, one of the most beautiful natural examples of a Trinity in Unity. It is a Philosophical truth that the existence of a Trinity in mysterious connexion with Unity is not an absurdity. This single fact, were there no others, of the existence of one entire perfect essence, *Light*, yet in mysterious union with *three* distinct essences, constantly separable in their nature from it into *three*, and three only, and resoluble again into perfect *oneness*, is such an example in nature of a mysterious union of *three* and *one*, as forever to forbid cavil at the Theological doctrine of the Trinity as unphilosophical and absurd.[10] Nor am I certain that in the light of this philosophical truth there may not be seen to exist a significance hitherto unnoticed in the Rainbow, that "sign to man amid the skies." I would not dare to say that that gorgeous bow, set with such pomp and solemnity after the deluge upon stormy cloud by the hand of omnipotence, was not intended to be a perpetual, splendid, and most significant type of himself. I must contend at least that it is neither irrational nor merely fanciful to suppose that the Diety has painted upon his bow in the cloud, in never-fading triune colors to be seen and read by all generations, an everlasting *emblem*, (I do not say an explanation,) but an everlasting *emblem* of his own mysterious existence.[11]

"And God said, This is the token of the covenant which I make between me and you and every living creature that is with you, for perpetual generations.

"I do set my *bow* in the cloud, and it shall be for a token of a covenant between me and the earth.

"And it shall come to pass when I bring a cloud over the earth that the bow shall be seen in the cloud."[12]

9. *The Iliad*, trans. Alexander Pope, bk. XI. On primary colors, see Field, *Chromatography*, exp. 2, 225–26; Barry, *Lectures*, 210–11; A. R. Mengs, *The Works of Anthony Raphael Mengs*, London, 1796, vol. 1, pt. 1, 11; and John Galt, *Life of Benjamin West*, pt. 1, 18.

10. The Reverend Jedidiah Morse, Samuel's father, was a bitter opponent of Unitarianism. His son shared his orthodox beliefs, which he defended in this demonstration of Trinitarian doctrine.

11. Field, *Chromatics*, 56–57: "Dull of consciousness therefore will be the mind that in contemplating a system so simple, various, and harmonious, as that of colours, should not discover therein a type of that TRIUNE ESSENCE WHO COULD NOT BUT CONSTRUCT ALL THINGS AFTER THE PATTERN OF HIS OWN PERFECTION. For this reason, the Divine Wisdom that framed the world, gave *His image* not to man alone, but according to the oracle, *He filled the world with symbols of Himself.* And since of all sensible things colour is pre-eminent, for it gives value and distinction to whatever is visible, we may wonder the less that the perfection of form and system belongs supereminently to colours, or that they constitute a type of Universal Intelligence Himself."

12. Genesis 9:12–13.

But to return, White and Black are not properly colors, they are *light* and *dark*, each containing the primary colors in a state of perfect neutralization.

Colors [4–3] are modified by *light* and *dark*, e.g.; by *warmth* and *coldness*, e.g.; by *opacity* and *transparency*, e.g.; by *Dullness* and brightness, e.g.

These constitute the physical materials of painting. Let us next examine whether like the first materials of the other Arts they possess qualities for affecting the imagination, and first of *Lines*. In Nature we have seen how powerful is the effect of *Motion* on the Imagination, and that Poetry, Music, and Landscape Gardening each have an apparatus for producing the effect of Motion. Painting, you will say, is precluded from any advantage from this source. But I would remind you of what was said in regard to the motion of the eye as it travels over objects at rest, producing an effect similar to the real motion of objects;[13] if the eye in perception passes from point to point with more or less rapidity according to the order in which objects are presented, then is Motion evidently within the power of Painting. (See example 4th. & 5th.)

We will next notice the properties of *Light* and *Dark*. A preliminary remark is necessary on the use of terms. *Chiaroscuro* is the Italian term to express the *lights* and *darks* of a picture; it has been translated *Light and Shade*, and *Light and Shadow*; neither of these terms expresses what is intended in the original. By the Lights and Darks of a picture I mean something different from the Light and Shade; this difference I will illustrate. (See example 6th.)[14] This is a distinction of practical importance. I have chosen, therefore, to use the term Light and Dark in preference to Light and Shade which does not give the idea.[15] *Light* and *Dark* being extremes capable of union by imperceptible degrees, *Gradation* is of course producable. (See example.) In this example is seen *Gradation* from Light to Dark in a perfect manner. *Contrast*, and all the degrees of Contrast of which light and dark is capable. Light and Dark have the power of producing *Mystery* in a peculiar degree, both of them by absorbing lines, forms, and colors, and consequently rendering them indistinct, and *dark* particularly in being the natural representative of *darkness*.

Colors [4–4] can be arranged so as to produce motion; our eye naturally follows the same color, and quietly passes through its gradations into others.

Color is connected by the various relations: *Gradation* is beautifully illustrated, (as was observed in a former lecture,) by the rainbow and prismatic

13. See Lecture 2, pp. 62–63.

14. In a draft, Morse described his sixth example as follows: "In this example of a black and white cube, if I speak of the light and shade, I call this (see *black* example) the light, and this the shade; and in this (see *white* example) this is the light and this the shade; but if I speak of the lights and darks, (this whole object [black]) light as well as shade classes with the darks of the picture, (and in this [white],) the shade as well as the light, classes with the lights of the picture" (National Academy of Design).

15. See Barry, *Lectures*, 176–77.

90

spectrum.[16] In this diagram also, (show example,) is seen not only the *gradation of color,* but each color modified by *gradation of light and dark.*

Contrast is perfectly exemplified in color; there being three perfectly distinct colors, any *two* of them equally combined are the exact contrast to the *third;* in this Diagram the *contrast* of each color is seen directly opposite. Colors are also contrasted by *warmth* and *coldness;* Blue is the extreme of *cold* color, and orange of *hot;* here they are in direct opposition, and were a line drawn at right angles (here) it would divide nearly into equal parts the cold from the warm colors; Blue and orange, therefore, may not inaptly be called the *poles of color.* Colors are also contrasted by brightness and dullness, and by light and dark. The power [4–5] of producing *variety,* therefore, by natural *form, light* and *dark,* and *color* is infinite.

Thus we have shown that the first materials of Painting each possess separately qualities similar to the other Fine Arts for affecting the imagination. Without *light* and *dark* and *color* Painting may by lines and forms alone excite the imagination; hence the beauty of a picture in outline. If to these be added light and dark, there is brought to bear upon the effect another element possessing the same qualities as lines and forms; it is to this extent that Engraving goes; all prints and drawings in one color employ the 3 elements of lines, forms, and light and dark. If Color be now added bringing in support of the effect its infinite combinations, it will be perceived how abundant and diversified are the means which Painting has at command even in its elements to affect the imagination.

If Poetry then has its long and short syllables, its feet, its metre, and its rhime; if Music has its notes of various lengths, its soft and harsh sounds, its gay and sad tones; if Landscape Gardening has its ground, and trees, and water, and buildings all adapted to aid the imagination in its efforts, and employed by the *Poet,* the *Musical composer,* and the *Gardener* respectively with effect; is it reasonable to suppose that an apparatus, similar in its powers, fitted to accomplish the same end, and completely within reach of the Painter, is without use to him? We will [4–6] endeavor to show that Painting is not regardless of her advantage in this respect. The principles [4–7] of Nature, as we have seen, apply to *each* of the Elements of Painting. I must confine myself at present to but one of them for the purpose of illustration: the application of these principles to *Lines* being more subtle and not so well adapted to explanation in this place, and *Colors* requiring day-light for a clear understanding of them, I have chosen the element of Light and Dark for this purpose.

With respect to the illustrations generally that I am about to use in this lecture, I have to ask the indulgence of my audience. Although they explain the points to

16. In Lecture 2 he mentions the rainbow, but there is no reference to the "prismatic spectrum" as an example of gradation in any of the lectures. See Kett, who said of the "seven primogenial colours" separated by prismatic refraction, that they "appeared not strongly contrasted with each other, but melted by gentle gradations into the neighbouring tints" *(Elements,* 2:86).

be illustrated, yet many of them are so small that I am aware they can not be seen by all in the room, nor in the hasty selection of examples I was under the necessity of making, could I choose larger. I was compelled to take these as they are or copy them of a proper size, a labor of many months. To remedy this evil, I will accompany such with a fuller description.

We have, heretofore, remarked that we naturally survey a *whole* before its *parts*. In this respect there is a difference between the arts addressed to the eye, and those addressed to the ear; in Poetry and Music we comprehend a *whole* after having considered the *parts;* while in Painting, Sculpture, Architecture, and partially in Landscape Gardening, we proceed from the impression of a whole to examine the relation of parts. In a picture, therefore, the first thing that strikes us is the general effect. Having given a hasty glance at the whole, we at once fix our eye on the most prominent part which is rendered so in various ways by *size,* by *light,* by *dark,* or by *color:*

In this Example it is by *size* and *dark:* Paestum.[17] In these (Sleeping Girl by Sir J[oshua] R[eynolds], Our Savior in the Garden, Coregio [*sic*], A Pieta, Spagnolletto [*sic*])[18] it is [4–8] by *light.* It is accordant with the law of *order* that every picture should have some part which attracts the eye first, whether in Portrait, Landscape, Historical, or Epic painting, one principal spot around which all that is introduced must rally. It answers to the principal end of every work of Nature, of every Poem, of every piece of Music; the mind must not be left in doubt, which of two parts is most important; Painting has diversified means of distinguishing any object; it can arrange its materials in such an order that the eye may be carried from part to part according to their several degrees of importance. Without such a method all would be confusion. But the difference between a picture that has a

17. See fig. 16. Morse was at Paestum in the late summer of 1830 and wrote, "I need not describe these temples to you, even if I now had the time. The few hours that I can spare in this most interesting spot, I must employ in observing and sketching" (Letter of 7–14 August, *New York Observer,* 27 November 1830). Morse's illustration was a print, not one of his own sketches, but the use of one of the temples of Paestum as an example may have been inspired by this visit. The print Morse used was probably one he himself owned, for among the items in his "List of articles sent in a box to America, 1831" were "2 Prints of Pestum [*sic*]" (Morse Papers, Library of Congress).

18. See figs. 17, 18, and 19. E. Hamilton, *A Catalogue Raisonné of the Engraved Works of Sir Joshua Reynolds,* London, 1884, lists *The Girl Sleeping,* painted in 1788 and engraved by John Jones, published in 1790.

Correggio, *Christ in the Garden of Gethsemane,* engraved by Volpato in 1773 (C. Ricci, *Antonio Allegri da Correggio,* New York, 1896, 232ff.). The painting is now in the Wellington Museum, Apsley House, London.

Ribera, *Pietà,* Naples, San Martino (A. L. Mayer, *Jusepe Ribera, "Lo Spagnoletto,"* Leipzig, 1908, 104ff., pl. 31). Morse greatly admired this painting: ". . . I am quite inclined to say that it is the finest picture that I have yet seen. There is in it a more perfect union of the great qualities of art,—fine conception, just design, admirable disposition of *chiaroscuro,* exquisite color,—whether truth is considered or choice of tone in congruity with the subject's most masterly execution and just character and expression. If any objection were to be made it would, perhaps, be in the

proper arrangement, and one which wants it, will best be illustrated by examples.

<p style="text-align:center;">(Example of battle)[19]</p>

In this picture of a battle, the eye wanders in vain in search of a principal object. Lights and darks equal in size and degree are scattered throughout. No definite impression is left but that of painful confusion. This you will say accords with the sentiment of the picture, but what would be thought of the poet who, to impress the idea of confusion, should describe the incidents of a battle without any regard to order and by expressions which rendered his language and meaning unintelligible. There must be *order* in describing or depicting *disorder.*

In this print, on the contrary (Show example, Bunker's hill),[20] representing incidents quite as numerous as the other, the eye is drawn at once to *this spot.* It examines what is there, and then passes to the consideration of the next most important part. In this place, then, should be the principal action.

In the first example [of a battle] (show example) it is difficult to say which is the principal action or who is the principal figure. In the other (show example), *this person* and *this action* are the principal parts of the picture, from *this* place the eye departs, and to *this* it will constantly return.

In some pictures there is but one overpowering mass of light, all other parts being kept obscure; such are most of the pictures of Rembrandt (The Presentation in the Temple, The Aged Dutch Woman, The Holy Family, all by Rembrandt. The Sleeping Girl by Sir J[oshua] R[eynolds], Our Savior in the Garden, Correggio, also illustrate this point).[21]

In others [4–9] there are two or three masses all of which differ from each other in size, form, and degree. (Full length Portrait of Gen. Graham by Sir. J. R. Full length Portrait of S. Harmer, Esq., [by]Opie. Beggar Boy, by Murillo.)[22] In each of

particular of character, which, in elevation, in ideality, falls far short of Raphael. In other points it has not its superior" (European journal, 6 September 1830, in *Letters,* 1:370).

19. For similar comments by Reynolds on the painting *The Battle of Constantine* by Giulio Romano (fig. 20), see Discourse 7, 125–26. Morse's idea is the same and he may have used the same example.

20. See fig. 21. Trumbull, *Death of General Warren at the Battle of Bunker's Hill, June 17th, 1775,* 1786, engraved by Müller, published by De Poggi, London, 1788 (Theodore Sizer, *The Works of Colonel John Trumbull,* rev. ed., New Haven, 1967, 95, fig. 145).

21. See figs. 22 and 23. Rembrandt painted several versions of all of these subjects; it is therefore uncertain which version Morse used. The *Presentation in the Temple* may be the one of 1631 now in the Mauritshuis, The Hague, engraved by J. De Frey (John Smith, *A Catalogue Raisonné of the Works of the Most Eminent Dutch, Flemish, and French Painters,* London, 1836, vol. 7. He also lists another version formerly owned by Reynolds and engraved by Earlom, and a third engraved for the LeBrun Gallery by Wiesbrod).

Only one of the Holy Families (that of 1640 in the Louvre) listed by Smith was engraved (by P. M. Probst, De Frey and Devilliers, Martini, Le Bas).

There are, of course, many paintings and prints of aged Dutch women, so it is impossible to be sure which Morse used.

22. See figs. 24, 25, and 26. Morse refers to the portrait of General Sir Thomas Graham, Lord

Figure 16. Giambattista Piranesi, *Temple of Neptune at Paestum.* Etching. From *Différentes vues de quelques Restes de trois grandes Edifices de ancienne Ville de Pesto,* plate 10. Print Collection— Art, Prints and Photographs Division, The New York Public Library. Astor, Lenox and Tilden Foundations.

these there is a principal mass of light and a subordinate second and third.

The works of *Rubens* are excellent examples of *order* in the arrangement of light and dark.[23] Observe it in this (example), *Mary Magdelene Washing the Feet of our Savior in the House of the Pharisee.*[24] *This* is the spot to which the eye is first directed and *here* is found the principal action.

This excellence of arrangement, the pictures of West eminently possessed, and

Lynedoch, by Sir Thomas Lawrence, not Reynolds. It was exhibited in the Royal Academy in 1813 (when Morse was in London) and engraved the same year by Cook (Kenneth Garlick, *Sir Thomas Lawrence,* London, 1954, 48). An 1817 version is now in Apsley House, London.

Samuel Harmer was speaker of the Common Council of Norwich. His portrait was painted for the council about 1798 and hangs in the Guildhall, Norwich. It was engraved by S. W. Reynolds in 1805 (J. J. Rogers, *Opie and His Works,* London, 1878, 105; and A. Earland, *John Opie and His Circle,* London, 1911, 282).

The *Beggar Boy* is probably the one that Morse painted in replica for his *Gallery of the Louvre* in 1832 (fig. 8).

23. Contrast Reynolds's reference to Rubens's "florid, careless, loose, and inaccurate style" (Discourse 5, 86).

24. See fig. 27. Mezzotint by Earlom, published by Boydell, 1797 (Max Rooses, *Rubens,* trans. H. Child, Philadelphia, 1904, 1:287–89).

Figure 17. Engraving after Sir Joshua Reynolds, *The Sleeping Girl*. British Museum.

Figure 18. Engraving after Antonio Allegri da Correggio, *Christ in the Garden of Gethsemane.* British Museum.

Figure 19. Engraving after Giuseppe Ribera, *Pietà*. British Museum.

Figure 20. Engraving after Giulio Romano, *Battle of Constantine.* British Museum.

Figure 21. Engraving after John Trumbull, *Battle of Bunker Hill.* Museum of Fine Arts, Boston. Harvey D. Parker Collection.

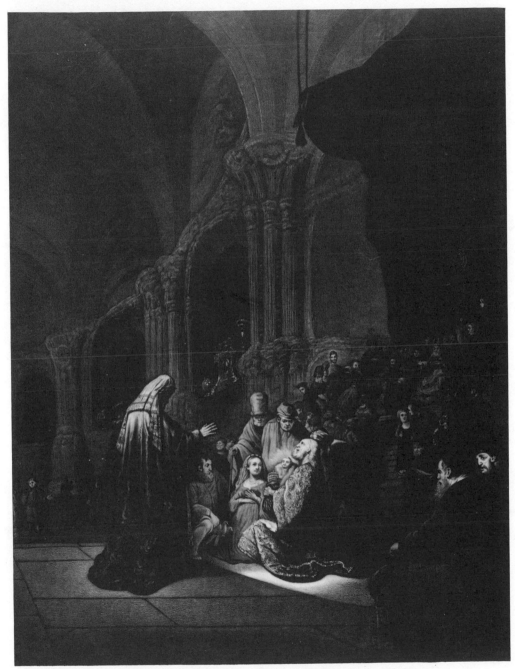

Figure 22. Engraving after Rembrandt, *Presentation in the Temple*. British Museum.

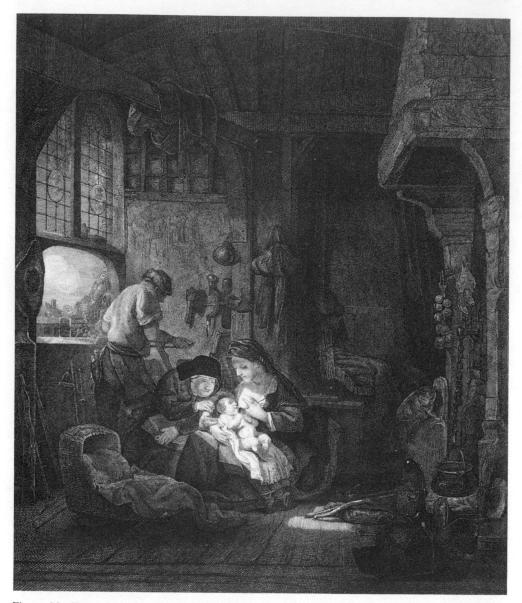

Figure 23. Engraving after Rembrandt, *Holy Family*. British Museum.

Figure 24. Engraving after Sir Thomas Lawrence, *General Graham*. British Museum.

Figure 25. Engraving after John Opie, *Samuel Harmer*. British Museum.

Figure 26. Engraving after Bartolomé Esteban Murillo, *Beggar Boy*. British Museum.

Figure 27. Engraving after Peter Paul Rubens, *Mary Magdalene Washing the Feet of Christ in the House of the Pharisee.* The Hermitage, Leningrad.

it is one also which distinguishes strongly the works of the present English School from the Continental Schools.[25]

We now give you an example of *Gradation.* It is perceived in this same picture. *This spot* is not surrounded by dark, otherwise the eye must jump to the next important part, creating an agitation which does not belong to the subject; but the eye is led by imperceptible degrees to the face of the *Savior,* where the light, being stronger than in the intermediate degrees, detains it for a moment, (as it should,) to examine the expression: from thence it passes easily onward to the *faces* of the rest, losing itself in *mystery* by the indefinite blending of *this* face with the sky beyond. Reviving again on the forehead of the same face, the eye is carried onward till it arrives at *this point.* We will here stop. You will now perceive that by the simple gradation and continuity of light you have naturally been led to the examination *first* of every important *head* in the picture; all the rest are the

25. "[West's] principal excellence is considered composition, design, and elegant grouping; and his faults were said to be a hard and harsh outline and bad coloring" (SFBM to his parents, London, 25 March 1812, in *Letters,* 1:68).

servants of the table. For the perfection of *Gradation* the works of Corregio [*sic*] are celebrated; he was the inventor, or discoverer, of Chiaroscuro.[26] (Mother, and Infants Savior and St. John, Corregio).[27] *Ostade, Mieris, Gerard Dow* [*sic*] and many painters of the Dutch school have applied the same perfection of Chiaroscuro to inferior subjects.[28]

Contrast is also seen in this picture, the principal light is contrasted in one part with the principal dark (See example, Rubens' Magdelene)[29] and in this print also (See example, Paestum)[30] the violent contrast of *this dark* pillar with the bright sky makes the one *lighter* and the other *darker.*

According [4–10] as *Gradation* or *Contrast* prevails in a picture its character will be *mild* or *rough*. Most of the pictures of Claude are characterized by *Gradation*. (Picture by Claude, [*Morning?*], Mr. Coit's).[31] I have an opportunity of showing this quality in a good copy from Claude politely loaned me by a friend from his collection. The almost imperceptible blending of the sky with the distance shows the gradation of light which, on each side of the dark mass of trees in the centre, expands and becomes darker and darker until it is lost in the deepest shadows of the foreground. Claude was not merely master of gradation in light and dark, the gradation of lines, and of color; he also thoroughly understood uniting, or interchanging, their powers as circumstances made it necessary. This picture illustrates gradation in lines, lights, darks and colors. Contrast is [4–11] here also, in the mass of trees dark against the sky, but it is used to prevent unvarying gradation from degenerating into *insipidity;* it is the single *passage of discord* which gives vivacity to the whole.

Salvator Rosa [4–12], *Carravaggio* [*sic*], *Guercino, Spagnioletto* [*sic*], and *Titian* also were [4–13] distinguished for violent *Contrasts.* Claude [4–14], from the prevalence of *gradation* in his pictures, is no less celebrated for the serenity of

26. See Opie, *Lectures*, 304; Fuseli, *Lectures*, 488; and West to John Singleton Copley, London, 6 January 1773, in *Life & Papers of John Singleton Copley and Henry Pelham 1739–1776*, Boston, 1914, 196.

27. There are several versions of this subject attributed to Correggio.

28. For Morse's low opinion of Dutch painting, which was a common one in the eighteenth century, see p. 110.

29. On the facing page is the note: "Rubens, Magdalene, again, blue paper."

30. On the facing page is the note: "Paestum again, tea colored paper."

31. D. Coit was a lender to the American Academy of Fine Arts exhibitions of 1817 and 1833, but he never lent a Claude. Morse stayed with a Mr. Coit on visits to New York in 1810 and 1811 (SFBM to his parents, 29 May 1810 and 11 June 1811, Morse Papers, Library of Congress). He proposed a Daniel Coit for Honorary Membership in the National Academy of Design in 1831 (SFBM to John L. Murray, Florence, 18 April, National Academy of Design).

A loose sheet in Lecture 4, to be inserted four sentences after this reference, contains a description of the Coit painting:

Gradation (See example, Claude's Morning)

Observe in this picture of morning how gently the eye is led through every part.

The sky imperceptibly blends with the distant mountains.—The mountains with the water;—the dispersing mist marks the course of the hidden river, spreading the light which glances on the foliage and declivities

Figure 28. Engraving after Claude Lorrain, *Landscape with the Father of Psyche Sacrificing at the Milesian Temple of Apollo.* British Museum.

his atmosphere, and the quiet repose of his subjects than these latter[32] are for their stormy vehemence.

We will now notice the relation of *Congruity.* In this picture of a storm by Poussin (see example)[33] the Painter like the Poet has assembled a number of incidents, related by Congruity to the passion of terror which he wishes to excite; besides the usual effects of tempest, in the foreground is introduced *one who has*

of its banks; leading the eye unconsciously onward until at length it expands upon the river which reveals itself from the arches of a bridge.

For the continuation, see Text Alteration 4–11.

Coit's painting was a copy of Claude's *Landscape with the Father of Psyche Sacrificing at the Milesian Temple of Apollo* (see fig. 28), 1663 (The Lord Fairhaven). It was frequently mentioned when it hung in the Altieri palace, Rome, and was one of Claude's most famous works, known through Woollett's engraving of 1760. It was in England, in private hands, since 1799 (Marcel Rothlisberger, *Claude Lorrain: The Paintings,* 1:370–73; 2, fig. 259).

32. He refers to Salvator Rosa and Guercino.

33. See fig. 29. In a deleted passage (4–10) Morse referred to "this print by *Gaspar Poussin.*" It is the *Landstorm,* the story of Pyramus and Thisbe, painted in fact by Nicolas Poussin. The painting, of about 1651, is now in the Staedelsches Kunstinstitut, Frankfurt am Main. It was engraved by Chatelain and Vivares and published by Boydell in 1769 (Anthony Blunt, *The Paintings of Nicolas Poussin,* London, 1966, no. 177).

106

Figure 29. Engraving after Nicolas Poussin, *Landscape with Pyramus and Thisbe*. British Museum.

committed suicide; in the middle ground *a horse attacked by a Lion* has thrown his rider while men and cattle are seen flying in every direction; farther in the distance is a group of *cattle fighting,* and upon the mountain is *a castle on fire.*

I must advert to one example of *Congruity* of form (see example, Bunker's hill). It is in the general shape of this whole group. It is that of *a falling Pyramid,* a form perfectly congruous with the sentiment of the subject.

In this picture (the Two Disciples at Emmaus) by Titian,[34] is an example of *Incongruity.* For with all their many excellences no artists at times sinned more grossly against the principle of *Congruity* than Rubens, Paul Veronese, and Titian; here is a *dog gnawing a bone,* an incident to which he seemed partial, wholly incongruous with the subject, and giving an air of ludicrousness to his most serious compositions; in the *Magdalene and Savior* by Rubens is the same *Incongruity* (see Magdalene).[35]

34. See fig. 30. There are two versions of this subject, one in the Louvre, the other at Brocklesby Park, Earl of Yarborough (Harold Wethey, *The Paintings of Titian,* London, 1969, vol. 1, nos. 142, 143). Morse knew the Louvre version, of which he painted a miniature replica for *The Gallery of the Louvre* (fig. 8).

35. What Morse calls incongruity was a violation of the aesthetic principle of decorum, which Titian's *Supper at Emmaus* was often said to offend.

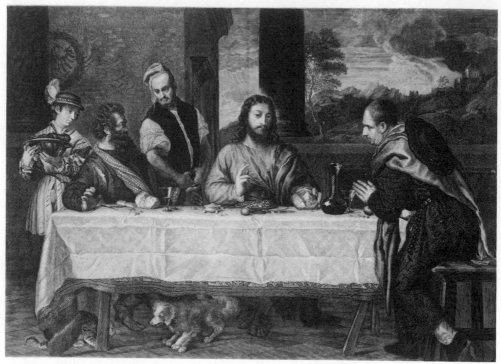

Figure 30. Engraving after Titian, *Supper at Emmaus*. British Museum.

The relation of *Whole and Parts* is strictly observed in a good Picture. Titian illustrated this principle happily from a *bunch of grapes* (see example). Light and Dark, says Fresnoy,

> Are only justly spread, when to the sight,
> A breadth of shade pursues a breadth of light,
> This charm to give, great Titian wisely made
> The *cluster'd grapes* his rule of Light and Shade.[36]

While the whole bunch may be divided into a single mass of light and shade, each grape has also its own particular light and shade, but in subordination to the whole. If, therefore, any part of a picture is ever so well finished in itself considered, if it bear not its proper relation to the whole it is a transgression of this principle.

I revert, once more, to these two battle pieces (see examples), as well illustrating the defect here spoken of and the opposite excellence. In this example (see confused battle) the separate figures are for the most part *finely conceived, justly*

36. Charles Alphonse du Fresnoy, *The Art of Painting*. The original Latin version was published in Paris in 1667. Morse used the popular verse translation by Mason, annotated by Reynolds (see Appendix 1, n. 4). Titian's bunch of grapes (see fig. 31) are also mentioned in Reynolds, *Art of Painting*, n. 40, and in Piles, *Principles*, 222.

drawn, and in *spirited action;* but from the total neglect of their relation to a whole, their beauties are lost like diamonds among a heap of unarranged minerals. In this, on the contrary (see Bunker's Hill), each part has its own light and shade, but strictly subordinate to the whole.

Unity is [4–15] the next principle we will illustrate. It is strictly regarded in this picture of the *Crucifixion* by *Rubens* (see example).[37] The *group* is *one,* the *light* is *one,* the *action* is *one,* the *time* is *one;* every figure has something to do with the *one action.*

Here is its opposite. It is too confused, and the figures too small to be seen at any distance. It is by a distinguished master, *Albert Durer.*[38] There are here no less than five distinct *actions, five* different *times,* and the same place delineated at least three times in different parts of the picture. Our Savior is five times introduced:

Here, mocked by the soldiers sitting on the cross.

Here, disrobed, buffeted, and *scourged.*

Here, bound to be *crucified.*

Here, again, *crucified;* and *here* coming from the gates of the city, with the multitude bearing his cross. Such a treatment of the subject speaks its own absurdity.

Mystery is the last principle I can now allude to. It is seen in every picture where there is indefiniteness. Were every part so palpable to the eye that it could be seen at a glance much of that interest would be lost which the painter as well as the poet has it in his power to create. The Painter accordingly blends or melts away some parts of his objects into those that surround them, leaving their limits to be discovered by closer scrutiny, or filled up by the imagination of the spectator.

I have [4–16] now completed what I dare not call more than an unfinished sketch of an interesting subject; I have time for but a few, very brief, remarks.

If the view I have taken of Painting be correct, what rank is to be given to that *deception* or *accurate likeness of objects* which is so commonly supposed to be the end of Painting? It takes a *subordinate* station among the *means* for attaining a *far more exalted end.* This *naturalness of resemblance* undoubtedly possesses merit, because it is to a certain degree necessary; in many subjects in painting it is a great beauty, in many it is their principal beauty, but it is a common and deeprooted error that Painting in attaining this has attained every thing.

Such an estimate would exclude from the list of Painters Raphael, Michael Angelo, Poussin, Rubens, and indeed all the most distinguished, and place at the head of the list all those artists of the Dutch and Flemish schools, who, however excellent in this part of the art, have ever been considered as belonging to the

37. There are several versions of this subject.

38. See fig. 32. Morse describes the grisaille *Calvary* in the Uffizi, mistakenly attributed to Dürer. It was engraved by Jacob Matham of Haarlem in 1615 (*The Dürer Society,* 10, no. 8, London, 1908).

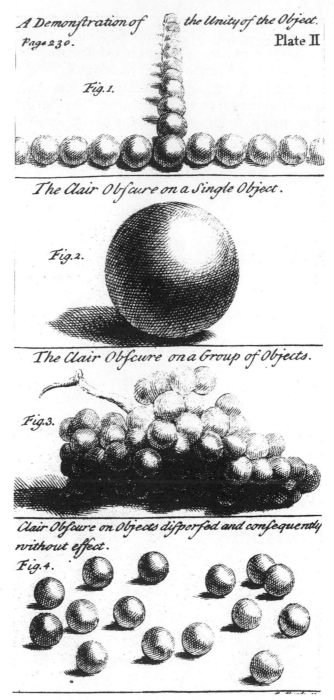

Figure 31. *Titian's Bunch of Grapes*. From Roger de Piles, *The Principles of Painting* (London, 1743). Library of Congress.

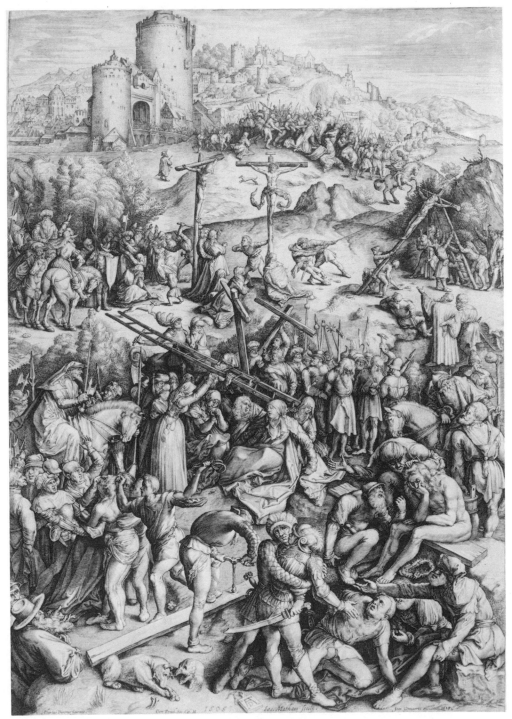

Figure 32. Engraving after Albrecht Dürer (wrongly attributed), *Calvary*. British Museum.

lowest school of Painting. I am not singular in giving a low place to this quality; hear what Sir Joshua Reynolds says. "When the Arts were in their *infancy,* the power of drawing the *likeness* of any object was considered as one of its greatest efforts. The common people, ignorant of the principles of art, talk the same language to this day."[39]

Again, in directing the student to aspire to a high standard, he says, "He will leave the meaner artist servilely to suppose that those are the best pictures which are the most likely to deceive the spectator."[40] And again, in another place, "I have only to add a word of advice to the Painters, that however excellent they may be in painting *naturally,* they would not flatter themselves very much upon it; and to the Connoisseurs that when they see a *cat or a fiddle* painted so finely, that as the phrase is, it looks as if you could *take it up,* they would not for that reason compare the painter to Raphael or Michael Angelo."[41]

A *picture* then is not merely a copy of any work of Nature, it is constructed on the *principles of nature.* While its parts are copies of natural objects, the whole work is an artificial arrangement of them similar to the construction of a *poem* or a *piece of music.*

If in our estimate of any thing, we put for the *end* of the work, that which is only a subordinate *means,* all beyond that subordinate part is not appreciated and will soon cease to command both the attention of him who forms it, and of him for whom it is formed. A false estimate of the *end* of the Fine Arts, then, as it lowers the standard of merit, must necessarily lower the aim of the Artist; having attained so low an aim, he must remain idle, or multiply mediocrity; instead of complaining that [4–17] *"life is too short for art,"* it is his to lament that *"art is too short for life."*[42]

It is [4–18] for the public, therefore, to fix a high aim for the Artist in any of the Fine Arts. What they wish he will be compelled from necessity to perform; if in Poetry he finds that they have no higher views than *smoothness of versification* and *accurate description,* or in *Music* than *simple concord and mimickery of sound,* or in *Gardening* than *straight rows of regular formed trees,* or in *Painting* than *smoothness of surface and mere naturalness of objects,* to these minor parts will his attention be confined, and feeling it to be in vain to aspire to a height which he can see, and to which he might attain, but where he can find no sympathies to support him, he wastes his energy and his spirits in unavailing efforts to rise.[4–19]

39. Discourse 6, 96.
40. Discourse 3, 50.
41. *The Idler,* no. 79, 1759 *(Literary Works,* 2:130).
42. "The pursuits of an Artist have their pleasures, indeed, and of the highest refinement, but they have also their pains, felt most keenly by those most susceptible of these pleasures. They are not arts acquired in a year, or in many years, and with ordinary industry; they require unremitting attention during a whole lifetime. 'Ars longa, vita brevis' is indeed too true. Life is too short for Art" (Morse, "Address to the Students [of the National Academy of Design]," in Cummings, *Historic Annals,* 45).

Text Alterations

At every point in the text where a significant revision was made by Morse, a number appears in brackets. The first part of that number gives the number of the lecture, while the part of the number after the dash indicates the listing of that alteration within the lecture. For instance, [2–12] would refer to the twelfth alteration in Lecture 2. A stroke between words (for example, required / is well) indicates that the discontinuity is due to a discarded page. For passages altered more than once, italicized lowercase letters are used to indicate the succeeding corrections, so that *a.* represents the first version and so on as needed. It is often impossible to define stages of correction; such instances are noted.

Text Alterations—Lecture 1

1–1. never been

1–2. *a.* preparing and delivering the following lectures ten years since, *b.* lectures some years since

1–3. principles, which also by their application to some phenomena in criticism afforded an early and obvious explanation.

1–4. anew to you, in the following discourses, which must be considered as Introductory to that course which at a future period I hope gradually to complete under the liberal auspices of the University.

1–5. *All of the preceding material was added to the original manuscript of Lecture 1. The original beginning of the first lecture was as follows:*

If those of your Lecturers who have been in the habit of addressing a popular assembly have felt a diffidence in appearing before so refined and intelligent an audience as I now have the honor to address and have claimed your indulgence, well may I feel a diffidence in submitting to you the composition of one more accustomed to address the public through the eye than through the ear, and consequently inexperienced in the facilities of arranging a written discourse. But a double disadvantage operates against me. I had adopted a plan of illustration and a train of speculation on the subject of *Painting in its affinities with the other Fine Arts,* which, until nearly the completion of my third Lecture [illegibly deleted line and a half] I accidentally

1–6. *it.* "It is to this latter observation I alluded in speaking of a double discouragement. Appalling

1–7. path already begun

1–8. "The Italian," says Villers, "feels and produces, Hemsterhuys, Kant, Burke, Goethe think, analyze the production, and the faculty of producing.

1–9. laws. These two functions equally presuppose genius. The first displays it externally in visible forms, the second in the depths of the understanding."[1]

1. Villers, *Essay,* 351.

Most of the writings and the paintings of the ancients are known to us only by name; Pamphilus, Parrhasius, Apelles, and Metrodorus, were painters who left writings illustrative of their principles, but they are no longer[2] / of all the writing I have enumerated that they have been addressed, especially the Lectures, principally to Artists. It is my lot to address an assembly of a different character, composed not of artists only, but of those who are to be the connoisseurs and patrons of Art; of those who with knowledge and refinement and discrimination in literature and science have from the necessity of circumstances been without the means of acquiring to any great extent a knowledge of the principles of Painting. In Europe

1–10. Knowing or rather feeling this to be the case the English

1–11. no great distinctive mark that characterizes us as a school

1–12. based and their common agreement with these principles, that in the last place I may the better demonstrate the nature and rank of Painting.

What are

1–13. *a.* excellence.

Before we enter on our investigations of the principles of Painting, let us inquire what are those Arts which have been denominated Fine Arts to which Painting belongs; and this will be the more necessary as I shall have occasion to call in the aid of the other Fine Arts to illustrate the principles and nature of Painting.

Every one

b. Before entering on our investigation of the principles of Painting, I propose to determine definitely what are those Arts which have been denominated Fine Arts to which Painting belongs; and this will be the more necessary as according to the plan proposed I shall call in the aid of the other Fine Arts to illustrate the principles and nature of Painting.

Every one

1–14. used. They are generally understood to be those Arts which require refinement and ingenuity in the practice of them and which have for their principal object the pleasing of the imagination. They have

1–15. Oratory, and Landscape Gardening; and Lord Kames in speaking of music incidentally puts the Histrionic Art among them.[3] Mr. Forsyth in his work on Italy gives a singular definition and an ingenious writer in the 1st No. of the Magazine of the Fine Arts after

1–16. Architecture, and the able author of the article Fine Arts in the Supplement to the Encyclopedia Brittanica applies the term to those that give pleasure to the mind through the eye, viz. Painting, Sculpture, Engraving, and Architecture and by way of eminence to the two first. Mr. Forsyth in[4]

2. See Appendix 1.

3. Kames, *Elements*, chap. 2, pt. 4, "Coexistent Emotions and Passions."

4. William Hazlitt (1778–1830), "Fine Arts," in *Supplement to the 4th, 5th, and 6th Editions of the Encyclopedia Brittanica*, Edinburgh, 1824: ". . . the *Fine Arts*, including Poetry, Eloquence, Painting, Statuary, and Architecture. The term, in its widest application, would also embrace Music, Dancing, Theatrical Exhibition; and in general, all those arts, in which the powers of imitation or invention are exerted, chiefly with a view to the production of pleasure, by the immediate impression that they make on the mind. The phrase has of late, we think, been restricted to a narrower and more technical signification; namely, to Painting, Sculpture, Engraving, and Architecture, which appeal to the eye as the medium of pleasure; and by way of eminence, to the first two of these arts."

1–17. The error of this definition of Mr. Forsyth's will be felt if we consider that it must include numerous Arts which he has not mentioned, and which no one has ever thought of classing with the Fine Arts, for example many kinds of weaving, watchmaking, glass cutting, and even straw bonnet making would equally be subservient to the same definition. Another

1–18. list.

Amidst this variety of classification is it not possible by classifying on another quality to bring out a definite result and one which will be less liable to contradict public opinion respecting that than any other. In classification it is legitimate to arrange under one general name things that agree in any one or more qualities and things may be

1–19. Fine Arts. The term Fine Arts is translated, and is adopted into English from the French *Beaux Arts* and literally signifies Beautiful Arts, but should we adopt this signification we are again under the necessity of including many which by common consent would be refused such a place. The Fine Arts have[5]

1–20. that Dancing, Fencing

1–21. money.

There is another name sometimes given to the Fine Arts, which marks the line of distinction between them and other Arts more accurately than any of those enumerated, viz., the *Arts of the Imagination,* and it were to be wished that this name had superseded all the others; but the term Fine Arts is so universally adopted that the substitution of a more logical name which should generally be recognized would be very difficult if not impossible; fortunately the difficulty may be surmounted without changing the name by defining and restricting it to signify so much as shall include what are called the Arts of the Imagination. A Fine Art

1–22. poetical." An example of the latter occurs in the well known verses for finding the number of days in each month:

> Thirty days hath September
> April, June, and November, &c.

In these verses, instruction is conveyed, but no one will call them poetry. "Poetry," says

1–23. definition. That Painting is also a Fine Art will be shown more completely in the progress of these lectures, and Sculpture also, connected as it is with Painting, will be shown in the sequel to be also a Fine Art.

Architecture

1–24. Art. Forsyth questions whether it in any degree belongs to them. This is, however, too sweeping a declaration. Most

1–25. nature; they are made up of an assemblage of parts of others; an architect combines

1–26. builder. Now an architect is neither of these professors singly but by a combination of parts of each he composes his own profession. How common

1–27. is called an

5. "Definitions and Reflections," *Magazine of the Fine Arts* 1 (1821):2, 4: ". . . the generic denomination, FINE ARTS, which is an imitation of the French term, *Beaux Arts.* . . . It is to be regretted that the first English writers who paraphrased the French expression *Beaux Arts,* did not accept the word *beautiful* instead of *fine,* as the translation of *beaux;* by which means, all ambiguity and confusion would have been avoided."

1–28. is called an

1–29. execution by a neat and orderly arrangement of parts he is called an

1–30. execution; he may make his design and call in the aid of an engineer to calculate and a builder to execute; not so with the engineer or builder. Without the

1–31. imagination.

Music has for its object in a peculiar manner the pleasing of the imagination. There are

1–32. Gardening, as yet but little known or practiced in our country, an art in perfection

1–33. taste," sees where and how to correct and selects

1–34. Art which Forsyth classed with the Fine Arts. The Histrionic Art is the profession of an actor, and there

1–35. the poet speaks. What is it that pleases in a dramatic representation? Is it the scenery and decorations? In this you admire painting. Is it the harmony that proceeds from the orchestra or a fine voice on the stage? In this you admire music. Is it the heroic sentiment or just delineation of character? In this you admire the skill of the poet. Is it the judicious management of the voice giving effect to every part by proper inflections; is it the skillful adaptation of the gesture to the sentiment? In this you admire the mechanical part of oratory. The histrionic art stripped of the ornaments borrowed from other arts has nothing of its own but modulation of voice and modification of features and gesture which it has in common with oratory. It may be asked, then, is not the actor an Orator?

1–36. himself. The manner of the actor admits of a wider range upon the stage and a greater diversity of attitude, and of gesture, by mobility of feature: the orator is limited to a single spot as a rostrum or pulpit or at most to a place of a few feet in dimensions; while the attitudes

1–37. speech; so far then as the qualities above mentioned, modulation of voice, and modification of gesture and features, affect the imagination as far as the actor and the orator assimilate to each other. What claim then has the Histrionic Art to be called a Fine Art?

We find it indebted for the greater part of its effects to other Fine Arts and these completed in their results before they are used by it. That which

1–38. *Arts.*

The right of *Painting* and *Sculpture* to a rank among the Fine Arts will be made evident in the progress of these Lectures; and *Sculpture*, intimately connected with Painting, will be more clearly shown to be a Fine Art after we have established the claims of Painting to that rank.

Some of

The following passage was temporarily added here:

There remain to be considered *Painting* and *Sculpture.* Their claims to be ranked in the number will be shown in the [two illegibly deleted words] result of the investigations in these Lectures.

1–39. to all.

"To illustrate one thing by its resemblance to another," says Johnson, "has been always the most popular and efficacious art of instruction," a method which is naturally suggested from the view we have taken of the Fine Arts; if they are all

1–40. "Each from each contract new strength and light."

idem.[6]

1–41. *a.* faculty. On this part of the subject it will not be necessary largely to dilate after the full and clear discussion it has lately received in your hearing from the able Lecturer on Taste.[7] I shall, therefore, notice it no further than its necessary connection with my subject requires.

The generally

b. has at a former season received

1–42. Taste is perhaps as just

1–43. founded. *Two illegibly deleted lines follow.*

1–44. *These last two lines were added to the original. Also added is the note,* "See 2nd Lecture."

Text Alterations—Lecture 2

2–1. That those of my audience who were not at my first Lecture may be able to follow me, I will in a few words present the general outline of the plan I have adopted. My subject is not Painting in the abstract, but *Painting in its affinity with the other Fine Arts.* I was led to choose this plan from knowing that the other Arts of the Imagination have hitherto been more cultivated in our country than Painting, and I presumed that the latter would be better understood by showing it in its connexion with the former. For this purpose, in my last

2–2. course. I treated cursorily of the Imagination as the faculty excited and of Taste as the faculty judging and selecting objects of Beauty and Sublimity to excite it, showing also that a sure foundation of Taste could only be found in the universal principles of Nature. I shall

2–3. Arts. What then is Nature; and what is the Imitation here recommended? The term Nature is often used ambiguously; there are two meanings generally confounded; it may mean the *Creator,* or the works of the Creator. It needs no argument to show that a confounding of the Creator with the thing created cannot result in any clear deduction. In using the word Nature, therefore, I wish to be understood as intending the works of the Creator. Imitation is also vaguely used; there are various kinds *This passage was so altered that it is virtually impossible to define the stages its alterations went through.*

2–4. allow me to dwell a moment. That art justly claims the highest rank which requires for its successful prosecution the greatest intellectual powers. In looking

6. *Epistle to Mr. Jerves, with Du Fresnoy's Art of Painting, Translated by Mr. Dryden,* 1716.

7. The "able Lecturer on Taste" was Prof. John McVickar of Columbia College. His lectures were presented on 17 and 24 February and 3 and 10 March 1826, and were entitled "On Taste and Beauty, as Applied to the Fine Arts" (see M. J. Lamb, *History of the City of New York,* 2:705–6; John B. Langstaff, *The Enterprising Life: John McVickar 1787–1868,* New York, 1961; and daily advertisements in the *New-York American*). McVickar's lectures were neither published nor reviewed.

2–5. divine." The invisible things of him are clearly seen being understood by the things that are made.[1] Now as there is in every man

2–6. *mind.* For that Man was made in the image of his Creator we know from the best authority and we also know that the resemblance is not in the body, but in the mind. It is

2–7. Demigods. I would not here be understood as discarding altogether Mechanical Imitation from any share in the production of the Intellectual kind. This would be carrying the argument too far; for Man differs from his great original in this important point; he cannot create *something* out of *nothing*. In his humble creative attempts he must use materials already made; his efforts are for the contemplation of his fellow men, not for the Deity, and must consequently be intelligible to them; he may combine these materials indefinitely but he is confined strictly within the limits of created things. To make this point clear I will anticipate a part of my subject which will be treated of more at large in its place in another part of this Lecture. As we have just observed, man cannot create *something* out of *nothing,* but he must produce his effect by combining materials already made. Among the works of creation he observed, for example, *Contrast* in its various applications pervading every thing; he finds its effect to be to render the contrasted qualities more distinct than in their separate situation; this is one of the methods by which the Creator produces certain effects; man cannot create these qualities but he has at command materials already created; these exist scattered abroad indiscriminately through creation and he can contrast these with each other. If he draws a character in writing, or in Painting, he can place virtue in contrast with vice, beauty with deformity, youth with age; these extremes exist scattered abroad indiscriminately in creation; beauty is / There is then

2–8. operations of body from those of mind. / effort. While

2–9. vessels, how enchanting the effect is of this different motion, here one with every sail spread to the successful breeze glides majestically onward, there another, with diminished canvas struggles with the adverse wind, dipping and leaping in her baffled course, while a third in all the boldings of conscious strength rushes by us like a meteor across the sky. But it

2–10. move. *There is*

2–11. *Though he pasted in the entire article, Morse used only part of it. The remainder is as follows:*

A NEW CURIOSITY IN NATURAL HISTORY

A natural production, was shown to us a few evenings since, that is neither fish nor flesh, nor beast nor fowl,—animal,—vegetable,—nor mineral! It was procured in Plymouth N.C. and brought to this city in a glass of alcohol. The *thing*—for it is without a name—is both entomological and vegetable.—When its entomological nature ceases, its vegetable nature commences; and when its vegetable character has arrived at maturity, its entomological character developes itself, and its vegetable existence disappears. In other words, it is alternately a plant and an insect.

1. Romans 1:20: "For the invisible things of him from the creation of the world are clearly seen, being understood by the things that are made." The same passage is quoted in George Field, *Chromatics*, London, 1817, 57.

118

As an insect it is perhaps about one inch in length and three-fourths of an inch in circumference. It is of a brownish color, shaped like a wasp, destitute of wings, head similar to a beetle, with two antennae or horns; has near his head on either side, a short leg, shaped like those of a mole, with broad, serrated extremities, and intended doubtless, like those of the mole, to assist the insect in penetrating the earth. It also has two posterior legs,—the purpose of which shall be seen.—When the insect

2–12. shoots forth!

The true nature of the insect-plant, or vegetable-insect—we know not what to call it—is entirely inexplicable to us. It may be surmised that an insect has here associated itself with the seed of a plant, in such a manner, that they reproduce and nurture each other, or it may be supposed

2–13. *The following material was at one time added to the end of the quotation:*

It is certainly a wonderful curiosity, and we believe that it is not only entirely unknown to naturalists, but has never before been publicly described.

We understand that a gentleman in Philadelphia, of whom the specimen we saw was procured, is cultivating a quality [*sic*] of them, which he has obtained from North Carolina, for the purpose of furnishing the Museum. We hope to be able to furnish a more particular account of this insect-vegetable hereafter. In the specimen we saw, the plant had grown about three inches, and the insect was yet preserved in its original and nearly perfect state.

Family Magazine.

2–14. Connexion. Objects

2–15. consider: / of the *Relations* by which objects are connected. On *Contiguity*

2–16. blended; the forest that bears its countless leaves, produces no two kinds alike, while the parts of every leaf are uniform. The members

2–17. equal. Nothing

2–18. Species. / of the *Relations* by which objects are *connected*. On *Contiguity* the first and most common relation that connects objects together we shall not dwell; it appears to be of all the most *accidental,* objects being seen contiguous to each other without evincing any design. The Relation of Variety and Unity appear &c. (insert here) The relation

2–19. place. Suppose

2–20. aisles you would at once be struck with the incongruity. But what

2–21. end. In a bird, for example, we observe its wing and its bill; no two things can be more unlike, the one a hard unyielding substance, the other soft and pliable, the one used in gathering its food, the other in flying; but they both unite by their various offices to support and [illegible word] the animal; the weights

2–22. result. The progress of any article of manufacture illustrates the same point; each workman performs his individual labor, insulated from the rest; the product of the labor of several is combined in forming one main part, many such parts are again combined to form one whole, to complete the Unity of the Design.

I shall

2–23. *The last two paragraphs of summation were added to the original manuscript.*

Text Alterations—Lecture 3

3–1. / Something on the principles of the Creator, and not in the mechanical copying of any work. And we have endeavored to establish these principles by searching into the works of nature. Having done this we come to consider the Fine Arts, as Arts having an end to attain, and having means to accomplish that end. We commence

3–2. sonoras.
 the gradual flow

3–3. requires it. Instances are so obvious I shall not detain you by illustration. Thus we

3–4. can, as is done in the works of nature, produce

3–5. A night of gloom and horror!—Not a breath

3–6. sky: the uplifted hand was viewless:
 How drear the night!

3–7.
 no day.—Is the great sun,
 Consum'd too, or darkened? is this the time,
 So oft foretold, when nature shall expire,—
 The heavens be blotted out, and earth in flames
 Shall pass away?
 Such thoughts on many came
 As slowly yielding now, the pall of night

3–8. heart—recalling with a sigh
 [illegible line]
 Of youth and early love.

3–9. *Barely and incompletely legible is this passage from "Macbeth," act 1, sc. 6:*
 Duncan. This castle hath a pleasant seat, the air
 Nimbly and sweetly recommends itself
 Unto our gentle senses.
 Banquo. This guest of summer,
 The temple-haunted marlet, does approve,
 By his loved mansionry, that the heaven's breath
 Smells wooingly here: no jutty, frieze,
 Buttress, nor coign of vantage, but this bird
 Hath made his pendant bed and procreant cradle:
 Where they most breed and haunt, I have observ'd
 The air is delicate.

Text Alterations—Lecture 4

4–1. *Painting?* In calling a man a painter, no definite idea is conveyed of the particular department which he pursues among the numerous branches which have the same general name, and what is more to be regretted the name

4–2. only. This

4–3. neutralization.

> The prism separates from Dark as well as Light all the colors.
> Colors

4–4. *darkness.*

> Light and Dark compose forms independent of the real forms of objects. (See example.)
> Colors

4–5. dark.

> What was observed with respect to light and dark, that they compose forms independent of the real forms of objects, is true in as great a degree of colors which make forms not only independent of the real forms of objects, but also of the forms of light and dark. (See example.)
> The power

4–6. him? The presumption at least is opposed to such a supposition. We will

4–7. respect. I do not propose to treat of Painting methodically in its different branches; my object is attained if I can demonstrate such points of resemblance between it and the other Fine Arts, as shall give some just idea of its nature and rank. The principles

4–8. In this (Taking down from the Cross by Rubens) it is[1]

4–9. Rembrandt; an example is seen in this (the Sleeping Girl) by Sir Joshua Reynolds. Any good portrait illustrates this, as in those by Sir Thos. Lawrence.

> In others

4–10. *darker.*

> In this print by *Gaspar Poussin* (see example, "a land storm") Contrast is used with effect to create that hurry and agitation so natural to a storm; the eye is hurried from light to dark in quick alteration in no less than twelve different places along the horizon only: and the abrupt clashing of Light and Dark is *here* and *here.*
> According

4–11. colors. / reflecting on its bosom the bright sky; from this place the eye glides easily over the rich champaign country, and enjoying the sparkling of the light through the dark underwood, it rests upon the group of devotees who are preparing the sacrifice to Apollo, the god of morning. Contrast is

4–12. whole.

> *a.* In the other (Poussin) also there is *Gradation* necessary to prevent Contrast from degenerating into *harsh discord.*
> *Salvator Rosa,*
> *b.* In the last example of a storm where contrast predominates (Poussin) there is also Gradation necessary

4–13. *Guercino,* and *Spagnioletto* [sic], and *Velasquez* were

4–14. *Contrasts.* Observe the wildness of this of Salvator Rosa (see example); the subject is the exposure of the infant Oedipus upon a desolate mountain; observe the wild flashing of lights and darks and the sudden contrast of the limbs and foliage of these trees. In this of Guercino (see example), the *Raising of Lazarus,* Contrast is

1. This is probably the painting in Antwerp Cathedral, 1613 (see fig. 33). Smith (*Catalogue,* London, 1830, 2:13) lists an engraving by Vosterman and a mezzotint by Valentine Green.

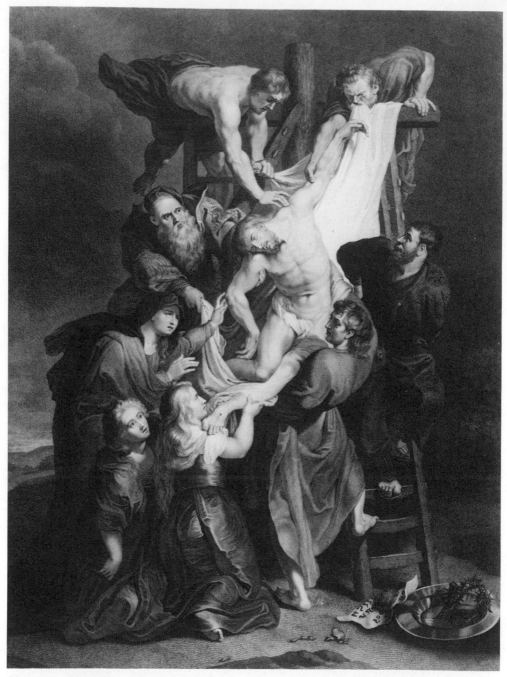

Figure 33. Engraving after Peter Paul Rubens, *Descent from the Cross*. British Museum.

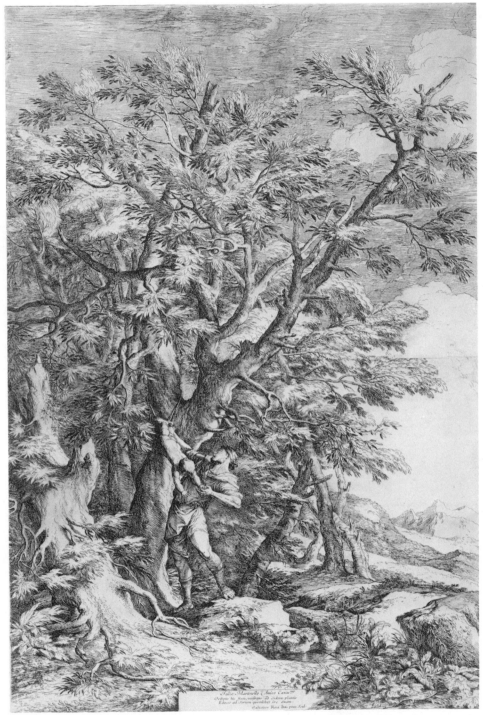

Figure 34. Salvator Rosa, *The Rescue of the Infant Oedipus.* Etching. Courtesy, Museum of Fine Arts, Boston. Katherine Eliot Bullard Fund.

Figure 35. Engraving after Guercino, *Raising of Lazarus.* British Museum.

Figure 36. Jacques Louis David, *Coronation of Josephine (Le Sacre)*. Replica. Musée de Versailles.

predominant to a painful degree, and misapplied to the subject which is not of *wildness*, but of *mysterious solemnity*. Claude[2]

4–15. *a.* whole.

I will also refer you to the great picture of the Coronation of Josephine by David as illustrating the want of this relation; for with all its numerous beauties, there is the capital defect of a disregard to proper subordination of parts; each part is carefully and beautifully wrought; but each solicits to be examined first. The most accurate delineation of parts will scarcely compensate for this neglect of a whole.

Unity is

b. David, which many of my audience may remember to have seen, as illustrating[3]

4–16. spectator.

But he can use mystery on a more extended scale. Observe it in this picture by Fuseli, who was perfect master of this principle. It is the scene between Macbeth and Banquo, and the *"wierd sisters"* upon the heath; observe how indefinite are all the forms, even the most prominent figures are lost in the surrounding darkness, and the

2. Perhaps the Rosa is the large etching, *The Rescue of the Infant Oedipus* (see fig. 34). The Guercino is probably that at Marseilles (see fig. 35). There is an etching by De Non and an anonymous engraving *(Intorno alla vita e alle opere di Gianfrancesco Barbieri, detto il Guercino da Cento*, Rome, 1861, 129).

3. Jacques Louis David, *The Coronation of Josephine by Napoleon (Le Sacre)* (see fig. 36). Morse refers to the replica of 1821 (Musée de Versailles), which was twice exhibited at the American Academy of Fine Arts in New York, in the spring of 1826 and again in 1827 (Theodore Sizer, "History of the American Academy," in *American Academy of Fine Arts and American Art-Union 1816–1852*, ed. Mary B. Cowdrey, New York, 1953, 44, 91, note 89). One reviewer said, ". . . The critic must be fastidious who does not derive much pleasure from the contemplation of most of the parts; but the *whole* is flat, and in general the effect far from agreeable" *(The New-York Review and Athenaeum Magazine* 2 [April 1826]: 371).

Figure 37. Engraving after Henry Fuseli, *Macbeth, Banquo, and the Three Witches*. British Museum.

three witches vanishing into air lose their forms in the mysterious cloud of light which flashes in the midst of the gloom that fills the rest of the picture.[4]

I have

4–17. complaining with an ancient artist that

4–18. *life;"* or if with the aspirings of real genius, he stretches his pinions like our own eagle for a flight into those pure regions which he alone has daring to attempt; like him he finds his food is on the earth, he must stoop from his towering height and contract his vision to the dimension of an earthly valley.

It is

4–19. *The last page of the lecture, which consists of the entire last paragraph, is pasted over another, which reads:* Let not then the vigorous vine to climb a sapling; it will soon reach up its tendrils far beyond its diminished top, and entangled in its own luxuriance sink to the ground under the weight of accumulated perplexity. Plant it at the foot of a *tall oak*, and it shall rise from limb to limb, and spread its foliage higher and higher, and at length shall hang its clusters on the topmost branch.

4. Probably the painting at Petworth House (Sussex) (see fig. 37), engraved by J. Caldwell, published by Boydell (see *The Boydell Shakespeare Prints*, New York and London, 1968, pl. 37).

Appendix 1

Fragment on Ancient and Modern Writers on Art

The relatively few alterations in the manuscript suggest that this passage was removed from the text of the first lecture early in its development. It followed an eventually deleted paragraph that began:

Most of the writings and the paintings of the ancients are known to us only by name; Pamphilus, Parrhasius, Apelles, and Metrodorus, were painters who left writings illustrative of their principles, but they are no longer. . . .

Significant deletions have been included in brackets.

. . . longer extant. Of their character, we know nothing but what may be gleaned from extracts in Pliny and Quintilian [and these are sufficient to cause us to lament that the entire volumes are lost to us forever]. Of Pliny it may be said that he was a better historian than connoisseur; his own opinion of works of art is of little value, but in his extracts from the above mentioned writers, he gives the opinions and rules of the Greek artists, and has thus rescued from oblivion a small portion of real treasure to the Artist and man of Taste.[1] Quintilian, engrossed in the discussion of his own Art, Oratory, confines his observations on Painting to a few scattered remarks.[2] In the writings of Cicero, of Pausanias, of the elder and younger Philostratus, of Aelian, Athenaeus, Lucian, and in the works of many other antient writers, we find incidental allusions to Painting often in illustration of some other subject, altogether furnishing but unsatisfactory gleanings of the antient principles and rules of Art.

Leaving the antients we come to notice the more modern writers on Painting. Of these Vasari among the Italians takes the lead; "He was," [says Fuseli,] "theorist, artist, critic and biographer in one."[3] His principal work is the Lives of the Painters for which the world of taste will ever be indebted to him; he is accused of many inaccuracies, and too great fondness for the detail of unimportant circumstances.

Du Fresnoy, De Piles, and Felibien, are the principal French critics on Painting. The Latin poem of the first, translated by Mason, is useful chiefly from the notes and illustrations of Sir Joshua Reynolds.[4] Rules founded on authority, and not always on the principles of nature, make up the chief matter of the two last mentioned critics, and these rules implicitly followed by the young artists of France, narrowed the boundaries of art in

1. Pliny the Elder's observations on the history of art occur mostly in his *Natural History,* bk. 35. Morse's valuation of Pliny is very like that of Fuseli *(Lectures,* 338–39). The note "See 35th lib. Pliny" appears inside the front cover of Morse's "Thoughts on Painting" notebook (National Academy of Design).

2. *Institutes of the Orator,* chap. 10, bk. 12.

3. Fuseli, *Lectures,* 342.

4. *The Art of Painting,* translated into English verse by Mason and annotated by Reynolds, London, 1783. "If he [Du Fresnoy] be useful, he owes his usefulness to the penetration of his English commentator; the notes of Reynolds, treasures of practical observation, place him among those whom we may read with profit" (Fuseli, *Lectures,* 344).

that country, and are doubtless the Parent of that mass of mediocrity which has issued, and to some extent still issues from the French schools.[5]

The Abbé Winkelmann [*sic*] and Raphael Mengs of the German critics were in great reputation in the last century; the former, says Fuseli, "was [the parasite of the fragments that fell from the conversation of the tablets of Mengs,] a deep scholar, and better fitted to comment a classic than to give lessons on art and style."[6]

Mengs, whatever may have been his merit as a painter, [and his title to more than mediocrity has often been questioned,] was skilled in the Philosophy of his Art, and his critical knowledge has not been surpassed. His writings abound with correct sentiment, and show profound investigation, but there is a great deficiency in the lucid arrangement of his subjects and much vagueness and obscurity, especially in his reasonings on beauty and matters connected with the Philosophy of the mind; this defect may in some degree perhaps be attributed to his translator, but in a greater to that fondness which Mengs was known to possess for the speculations of Platonic philosophy.[7]

Among the more recent writers on the Art, [I notice Artists principally as of the best authority,] are Reynolds, Barry, Fuseli, Opie, and West. These have each written a course of Lectures successively delivered at the Royal Academy of London. Sir J. Reynolds was the first of note who delivered a course of Lectures on Painting in England. Of a refined taste, and highly cultivated mind, he has spread a charm over his writings seldom equalled by the most distinguished writers of our language. The works of his pen deservedly rank among the English classics, and like those of his pencil serve as models for future study. It is no small compliment to him that his enemies have attributed his lectures, some to Johnson and others to Burke, adducing, however, no other proof of the charge than his intimacy with those distinguished men, while the internal evidence combined with other direct and positive proof have forever overthrown this complimentary slander. While his discourses are distinguished for elegance of style and abound in general with sound and philosophical sentiments, they make no pretensions to a systematic investigation of principles, nor would the occasions on which they were delivered, or the long interval of a year between each discourse, allow of such a plan.

James Barry has also left Lectures on Painting and other writings comprized in two large quartos.[8] There is much learning variously displayed through them. His Lectures add but little to the stock of knowledge which Sir Joshua Reynolds had collected and his works generally form a striking contrast by their coarseness and invective, to the refinement and amiable suavity of Sir Joshua's; indeed, refinement in Barry was not of native growth, it was a scion grafted onto a most ungenial stock, and the fruit that it might have borne, was shaded and kept from its maturity by the rank luxuriance of the more natural but ignoble productions of the native tree. With his writings are so blended his own private quarrels, his petty jealousies of his contemporaries, and his wild and ridiculous prejudices, mixed too with much that is desultory and affected, that he who peruses his works will rise from them little edified and with feelings of pity that a mind so

5. "What can be learnt from precept, founded on prescriptive authority, more than on the verdicts of nature, is displayed in the volumes of De Piles and Félibien" (Fuseli, ibid.). Morse's attribution of the mediocrity of modern French art to the influence of De Piles and Félibien is a digest of Fuseli's discussion.

Morse shared the English contempt for French neoclassical painting. It was nurtured both by English traditions of colorism and painterly effect that made French art seem cold and hard in comparison ("It seems to be the principal aim of a French artist to rival Medusa's head, and turn everything into stone" [Opie, *Lectures*, 255]), and by political distaste for its revolutionary associations.

6. Fuseli, *Lectures*, 344.

7. "He reasoned himself into frigid reveries and Platonic dreams on beauty" (ibid.). ·

8. In *The Works of James Barry*, 2 vols., London, 1809.

ardent, and touched as it was with the fire of real genius, should have had its ardour subdued by the violence of ungoverned tempers.

The late Henry Fuseli, Professor of Painting in the Royal Academy of London, is another Artist who has left a series of Lectures on Painting.[9] Distinguished as an artist for bold conception and severity of manner, excelling in the visionary and the mystical, his writings partake in no small degree of the eccentricities natural to such a mind; learned, studious and profound, he has given to them a richness of illustration and grandeur of style altogether peculiar.

John Opie was the temporary successor of Fuseli in the Professorship of Painting. He was the protegé of the celebrated Dr. Wolcott [*sic*], better known by his fictious name of Peter Pindar.[10] Taken from the mines of Cornwall by his patron he pursued the study and practice of his profession in London with the greatest success, but for want of that early discipline of mind necessary to form a profound thinker, he was not so well fitted for the professor's chair as either of his illustrious predecessors. His lectures are marked for plain good sense. But they are wanting in originality. Many of his expressions and illustrations indicate a mind not entirely free from the grossness of his early habits of life.[11]

[Benjamin West, our distinguished countryman and late President of the Royal Academy, has also left a volume of Lectures and I regret to urge as an excuse for not speaking of their character my inability to procure a copy of them in our country.[12]

The last five writers that I have mentioned are English Artists.] Various circumstances have combined to deprive us of the more recent writings of the Continent on the Arts. Hidden in a foreign language, they are not so accessible to most persons as works in our own. This circumstance, connected with the more powerful one that little interest comparatively has as yet been excited in our country in favor of the Fine Arts, has rendered it extremely difficult to obtain correct information of the state of these Arts, or of the writings of their Artists, or men of Taste. It may be remarked. . . .

Appendix 2

Fragment on Beauty and Sublimity

This is a discarded opening of the second Athenaeum lecture. It contains observations on beauty and, briefly, sublimity that do not occur in the final version of the lecture. Judging from the fragment itself and from Morse's many notes pertaining to it, they were subjects that greatly interested him and to which he gave considerable thought. This kind of philosophical speculation does not, on the whole, figure in the lectures as they were delivered. Significant deletions are included in brackets.

9. *Lectures on Painting*, London, 1820.
10. John Wolcot (1738–1819) was a writer of satirical verse, sometimes directed against artists, as in his *Lyric Odes to the Royal Academicians*, London, 1782–1785.
11. *Lectures on Painting*, London, 1809.
12. West's discourses are given, in part, in John Galt, *Life, Studies, and Works of Benjamin West*, London, 1820, pt. 2, chaps. 8–12.

In my last Lecture I [gave you a brief sketch of European writers and Lecturers on Painting, showing you that the course pursued by them was not adapted to an American audience, that with us foundations were to be laid, and that in order that these be firm they should be based on the unchanging principles of nature and not on authority however ancient or respectable. I] endeavored to ascertain the number and nature of the Fine Arts that, by comparing them together principles common to all, a clearer light might be concentrated on Painting; concluding the Lecture with some remarks on Imagination as the faculty to which was the common aim of the Fine Arts, and on Taste as the faculty selecting objects of Beauty and Sublimity to excite it. We now proceed to inquire[1] what is this beauty which it is the part of taste to select? As in Mathematics the quadrature of the circle, in Chemistry an universal solvent, in Mechanics perpetual motion, and in Geography the discovery of a N. W. passage, are problems ever afloat to occupy the minds of the ingenious, so in the science of Taste does the definition of Beauty seem to remain to exercise the ingenuity of the Philosopher and the Artist. No word appears so averse to the confinement of ordinary definition, or escapes from the toils with such phantomlike dexterity; like the *mirage* of the desert it comes into the field of vision to create a longing desire to approach it, but recedes as we advance, and leaves us as distant and unsatisfied as before. We are usually sensible of its presence while we are unable to explain its nature; it is not my intention, therefore, either to attempt to define it, or to detain you on a topic so well handled by others. I will merely advert to some particulars concerning it which I have not met with in the works of any writer on the subject. Beauty is of various kinds; there is a beauty of form, of color, of contrast, of variety &c., all which may exist separately or combined; in contemplating any object possessing such combination, there is a succession of agreeable impressions arising from these different sources. This property of beauty of increasing, which may be called its *accumulative* power, we shall now briefly illustrate.

To the pleasure we feel in looking at a single brilliant color, we give the name of beauty. The single color can occupy our attention but a moment; add to it another color, and if pleasure is the result we still call it beautiful but it is evident the sum of beauty is increased. To colors add forms and as long as pleasure is the result so long will beauty be increased: the pleasure may arise from various causes, it may be from a particular arrangement which accords with our ideas of order, from utility, from variety, from a certain proportion, from association, or from all these sources together. From whatever cause our pleasure proceeds we call it beautiful, and the more the qualities are multiplied, the greater will be the sum of beauty, and the more lasting its effects. The works of nature are full of illustrations on this subject; you pluck a flower that from its brilliancy has attracted your attention; ignorant of its properties and of its uses, or its rank in creation, you gaze at it a moment and throw it away; a botanist takes it up and shows you its construction, fixes your attention on the delicate texture of the corolla, shows you the nectarium and the seed vessel, and the beautiful formation of the parts to nourish the fruit and the seed, and its mechanism skilfully adopted to the gradual change it must undergo before it is brought to perfection; he dilates on the uses to which it may be applied in medicine and the arts, shows the resemblance to other flowers of the same class and thus

1. The foregoing, to this point, is a separate sheet added to the text that follows. The phrase "What is . . . as in" was added to the top of the second page.

gives you its rank in the scale of creation. You will not now view that flower with so much indifference as at first, for you are prepared to discern its accumulated beauty.

In works of art the same accumulation is observed. An epigram may please us by its ingenious thought and well-turned point, it is singly beautiful; but a poem abounding with sprightly wit and many ingenious thoughts, whose every line is an epigram, will please us more for possessing the power of pleasing longer. It is this accumulation of beauty in the works of art which assimilates them to works of nature, and which gives them their reiterated attraction. Fenelon had a sense of this power when he says of the verses of Horace and Virgil, "Their charms never decay. They are so far from pleasing less upon a review that every reading discloses new beauties."[2]

Horace also bears his witness to the same power in describing different works of Poetry and Painting. "Haec placuit *semel,* has *decies repetita* placebit."[3] ["Some please but once, others please *ten* times reviewed."]

The Bible furnishes an illustrious example of accumulated beauty, and the works of Homer, Shakespeare, of Addison, of Raphael, of Phidias, of Handel, and numerous others in various arts, give abundant proof to the pleasure of a *decies repetita* perusal.

These remarks lead to one important deduction, that the full impression of beauty is not received in a moment; it is not the first reading of a poem, the first hearing of an air, the first sight of a picture or statue, [if they are excellent of their kind,] that yields the fullest pleasure. Lord Bacon perceived this property of beauty when he said, "That is the best part of it, which a picture cannot express; *no, nor the first sight of life.*"[4]

There is a class of beauties in works of art which are addressed almost exclusively to temporary or local customs and is therefore transitory; while there is a higher class addressed to universal principles which must remain as long as man preserves his characteristic nature. Of the first class the *Hudibras* of Butler may be cited as an example written to ridicule particular manners and opinions which were temporary in their character, the humor of much of it must necessarily be lost to times where different manners and opinions are prevalent; all that can render Hudibras at present entertaining to the generality of readers must be confined to those passages formed on universal principles.[5] An example of the latter is *Homer.* Extolled from the beginning until now, he must to his first admirers have had more charms than we can know from local allusion, idiomatic expression, music of language, and perhaps eloquence of utterance, from nearly all of which we are excluded; but shorn of all these beauties he shines at this day with a splendor that eclipses every other poet; and why is this, but that beside the local and temporary beauties which have perished, his writings teem with *accumulated beauty,* addressed to principles lasting as the nature of man.

On Sublimity there is neither time nor necessity for more than a passing remark. Whether it be believed with Longinus to consist in a *"proud elevation of mind,"*[6] or with

2. The source of this quotation from Fenelon has eluded me.

3. *The Art of Poetry,* 1. 365.

4. Francis Bacon, "Of Beauty," in *Essays Moral, Economical, and Political* (London, 1801), 200. Barry quoted this passage in his second lecture *(Lectures,* 96).

5. Morse's view of *Hudibras* may be based on Samuel Johnson's; see *Idler 59,* and his life of Butler in *The Lives of the English Poets.*

6. ". . . The true sublime uplifts our souls; we are filled with a proud exaltation and a sense of vaunting joy" *(On the Sublime,* trans. T. S. Dorsch, Harmondsworth, 1965, 107).

Burke in *"terror,"*[7] or with Lord Kames in *"magnitude and elevation,"*[8] or with Dr. Priestley in an *"awful stillness,"*[9] or with Dr. Blair in *"mighty force or power,"*[10] or whether with more modern writers it be thought to differ only in degree from Beauty we shall not now enquire. The emotions of Beauty and Sublimity doubtless often approach each other so as to lose their distinctive character, but in most instances the difference is strongly marked. Sublimity is more confined to a single and comparatively transient impression, Beauty to many successive impressions. Sublimity, to larger objects, Beauty to smaller. Sublimity contemplates a whole, Beauty the parts. Sublimity absorbs the mind, Beauty leads it onward in a pleasing dream. Sublimity is connected with awe and all the graver passions, Beauty with cheerfulness and all the more sprightly passions.

7. "Whatever is fitted in any sort to excite the ideas of pain, and danger, that is to say, whatever is in any sort terrible, or is conversant about terrible objects, or operates in any manner analogous to terror, is a source of the *sublime"* (*A Philosophical Enquiry into the Origin of Our Ideas of the Sublime and Beautiful* [1757], ed. J. J. Boulton, London, 1958, 39).

8. "The elevation of an object affects us no less than its magnitude" *(Elements,* 109).

9. ". . . The pure sublime, by strongly engaging, tends to fix the attention, and to keep the mind in a kind of *awful stillness;* whereas it is of the nature of every species of pathetic to throw it into *agitation"* (Joseph Priestley, *A Course of Lectures on Oratory and Criticism,* London, 1777, 160).

10. "In a general way we may observe, that great power and force exerted, always raise sublime ideas" *(Lectures,* 47).

Appendix 3

This draft of a discussion of the elements of painting, reproduced in facsimile from the original in the National Academy of Design, is not directly related to the fourth Athenaeum lecture. Perhaps it was made in preparation for teaching at New York University. But because it includes diagrams, as that lecture does not in its present form, it may indicate the kinds of illustrations Morse used when he delivered the lecture, and may also clarify his methods of formal analysis.

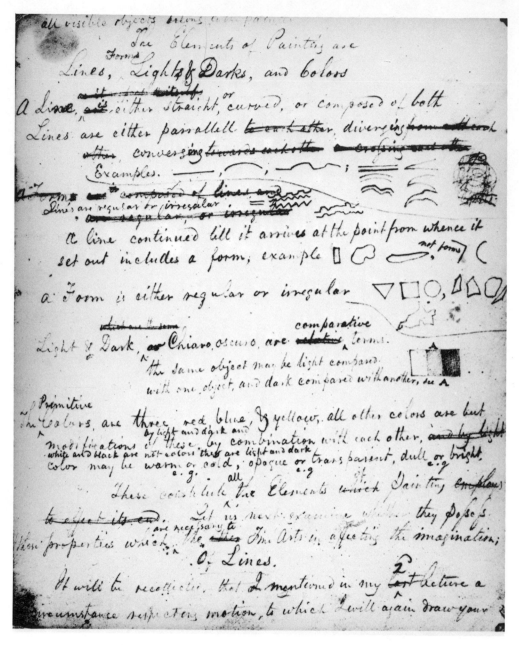

all visible objects being also presented

The Elements of Painting are
 Forms
Lines, ~~Lights & Darks~~, and Colors

A ~~Line, is it~~ either straight, or curved, or composed of both

Lines are either parrallell ~~to each other~~, diverging ~~from each~~
other, converging ~~towards each other~~ ~~crossing each other~~

Examples. —— , ⌒ , ∿ ; ≡ ≣

~~Forms are composed of lines and~~
Lines are regular or irregular. ≡ ∿
~~regular, or irregular~~

A line continued till it arrives at the point from whence it
set out includes a form; example ▯ ⬭ ⬳ [not forms])

a Form is either regular or irregular ▽ ▢ ○ , ◇ △ ◻

 comparative
Light & Dark, or Chiaro oscuro are ~~relative~~ Terms.

the same object may be light compared
with one object, and dark compared with another, see A

Primitive
The Colors are three, red blue, & yellow, all other colors are but
 by light and dark and
modifications of these, by combination with each other, ~~and by light~~
white and black are not colors they are light and dark
color may be warm or cold, opaque or transparent, dull or bright.
 e.g. all e.g. e.g.
 These constitute the Elements which Painting ~~employs~~
~~to effect its end~~. Let us next examine what they posess
 are necessary to
their properties which ~~the~~ ~~the~~ Fine Arts in affecting the imagination;

Of Lines.

It will be recollected, that I mentioned in my 2d lecture a
circumstance respecting motion, to which I will again draw your

attention; it is that the motion of the eye as it travels over objects at rest which produces an effect similar for the mind to the motion of the objects themselves. Lines have this property, to affect the eye, a straight line expresses velocity, quick motion (e.g.) the eye passes with ease from one end to the other, an undulating line, (e.g.) gentle motion, produces the eye is detained in its course by the unevenness of it, a line that returns a little as it proceeds (e.g.) produces retarded motion. That lines can be arranged according to a particular order. so as to produce novelty and variety, needs no illustration. Lines may also be connected, or disconnected (e.g.) Lines are capable of Resemblance and dissimilitude

(e.g.) Gradation may be applied to lines, they may diverge or converge gradually the eye may pass from a straight line to a circle by gradation (e.g.) or from a straight line to a very crooked one, for example (e.g.) these are examples of gradation of lines. Contrast applies to lines, they may be contrasted by situation or by kind (e.g.) or or by both .

Mystery or obscurity, may be produced by lines by indistinct, indefinite lines the relation of whole and parts is clearly applicable to lines. for example this line is a whole made up of 4 straight lines, and 7 curved lines. — Thus have lines the properties necessary to affect the imagination,

Of Forms or Shapes

Forms, of the same size and kind if placed in a line contigu

to each other [diagram] are passed over by the eye with the same quickness that it passes from one end of a line to the other forms that are undulating, [diagram] detain the eye producing more gentle motion as in lines. as we naturally look at a large before a smaller object the eye may be made to pass from my object to quality in the order of size form to smaller object, forms being of all sizes & kinds may be arranged in any order, and by infinite combination produce novelty and variety. Forms are capable of connexion as thus [diagram] of gradation in size [diagram] and from one kind to another as thus [diagram]

in size & kind [diagram] or thus [diagram]. Resemblance & Dissimilitude are discoverable in forms as thus [diagram] or thus [diagram] dissimilitude thus [diagram] or thus [diagram]. Contrast of forms may be in size [diagram] in kind [diagram] and in [diagram], and in size and kind [diagram] long and short [diagram] length and breadth [diagram]

in their general shape so as to create dissonance a form of an entirely different character from many others around it is a dissonant form [diagram], a form agreeing in its general character with many others around it is a consonant form [diagram] a form which is undefined, produces mystery the relation of whole and parts is peculiarly applicable to forms — a large form may include many smaller forms as thus [diagram] all these are parts which go to compose the whole. — Forms are capable of producing expansion which a line from its nature cannot do; it being length without breadth; a form on the contrary being of any breadth may confine the eye to a certain extent and then allow it to expand as in the example

Chronology of Morse's Artistic Life

1791 Samuel Finley Breese Morse born 27 April, in Charlestown, Massachusetts, the only survivor into adulthood of eleven children of The Reverend Jedidiah Morse and Elizabeth Ann Breese. His mother was a granddaughter of Dr. Samuel Finley, president of the College of New Jersey (later Princeton). Jedidiah Morse (1761–1827) was pastor of the First Congregational Church in Charlestown and also a noted geographer, author of the first American geography. He was an orthodox Calvinist in religion and a Federalist in politics.

1799–1805 "Finley," as he was known to his family, prepared at Phillips Academy, Andover, Massachusetts.

1805 Entered Yale, where he was an academically indifferent student. In his junior year he began to paint miniature portraits of friends, classmates, and teachers. In college he determined to become a painter.

1810 Graduated from Yale. Returned to Boston, clerked in a book store. Painted two historical pictures, *Marius on the Ruins of Carthage* and *The Landing of the Pilgrims at Plymouth*, which prompted the encouragement of two prominent artists in Boston, Gilbert Stuart and Washington Allston.

1811 15 July, sailed with Allston to study art in England. Worked with Benjamin West at the Royal Academy. His friends in England included the American painters Charles Robert Leslie and Charles Bird King; the American actor John Howard Paine; the English painter Benjamin Robert Haydon; and the poet, critic, and philosopher Samuel Taylor Coleridge.

1812 *Dying Hercules*, the sculpture made as a model for his painting of the same subject, won a gold medal at the Society of Arts exhibition in London.

1813 The painting *Dying Hercules* was favorably noticed by the press at the Royal Academy exhibition.

1815 *Judgment of Jupiter* painted for the Royal Academy exhibition. His funds exhausted, Morse left England before the exhibition, arriving in Boston 18 October. Exhibited the *Hercules* and *Judgment of Jupiter* in his Boston studio; they neither sold nor attracted patrons.

1816 Began itinerant portraiture to support himself, chiefly and most successfully in New Hampshire and Charleston, South Carolina, until 1823.

1818 Married Lucretia Pickering Walker, whom he had met two years earlier, in Concord, New Hampshire, her home.

1819 Morse's family moved from Charlestown, after Jedidiah Morse resigned his pulpit, to New Haven, Connecticut.

1821–1822 *The Old House of Representatives* painted for paid public exhibitions. It was not successful.

1823 Settled in New York City.

1825 Portrait of *Lafayette,* who was on a triumphal tour of America, commissioned by the city of New York. 7 February, sudden death of Lucretia Morse in New Haven, while her husband was in Washington for sittings with Lafayette. President of the New York Drawing Association.

1826 16 January, elected first president of the National Academy of Design, which grew from the Drawing Association. March and April, delivered four lectures titled *The Affinity of Painting with the Other Fine Arts* for the New York Athenaeum.

1827 Death of Morse's father. Lecture "Academies of Art" delivered at National Academy of Design. Delivered the lectures on painting again at the Athenaeum in February. Attended James Freeman Dana's lectures on electricity at the Athenaeum.

1828 Death of Morse's mother.

1829 Second trip to Europe, spent mostly in France and Italy, which he had not visited on his first.

1831–1832 *Gallery of the Louvre.* Like *The Old House of Representatives,* painted for paid public exhibition; like it, unsuccessful.

1832 Return from Europe. On the return voyage had the first practical ideas for the magnetic telegraph. Appointed Professor of Painting and Sculpture at newly founded University of the City of New York (later New York University). Active in Native American politics and anti-Catholic agitation.

1835 Began teaching at New York University as Professor of the Literature of the Arts of Design, using his lectures on painting. First model of the telegraphic recorder.

1836 Ran unsuccessfully for mayor of New York on the Native American ticket.

1837 Failed to receive from Congress a commission to paint a mural for the rotunda of the United States Capitol.

1839–1840 Met Daguerre in Paris and was one of the first to make daguerreotype photographs in America.

1841 Ran again, unsuccessfully, for mayor of New York.

1842 Resigned the presidency of the National Academy of Design.

1844 Successful telegraphic transmission from Washington to Baltimore of the message "What hath God wrought!," proving the practicality of Morse's invention. His artistic career was effectively ended; the remainder of his life, filled with honors and fame, was that of scientist and inventor.

1872 2 April, Morse died in New York, aged 81.

Bibliography

Sources Used by Morse

This section of the bibliography contains literary materials Morse used in preparing these lectures on painting. It includes works actually cited in the lectures or drawn upon without citation, as well as pertinent works named in Morse's preparatory notes. It also includes works mentioned in Morse's notes (Reid's *Essays on the Powers of the Human Mind* and Stewart's *Philosophy of the Human Mind* are the most important examples), which, although their contribution to the lectures is neither clear nor direct, nevertheless greatly solicited his interest at the time he was composing them. References in Morse's notes to works distant from the subject of the lectures have not been given.

The specific editions that Morse used are seldom known. Dates given are of first editions, unless otherwise indicated.

Arts

Barry, James. "Lectures on Painting." In vol. 1 of *The Works of James Barry*. London, 1809.

Burney, Charles. *A General History of Music*. London, 1776–1789.

du Fresnoy, Charles Alphonse. *The Art of Painting*. Translated by William Mason and annotated by Sir Joshua Reynolds. London, 1783.

Field, George. *Chromatics, or An Essay on the Analogy and Harmony of Colours*. London, 1817.

———. *Chromatography; or, A Treatise on Colours and Pigments, and of their Powers in Painting*. London, 1835.

Fuseli, Henry. *Lectures on Painting*. London, 1820.

Hazlitt, William. "Fine Arts." In *Supplement to the 4th, 5th and 6th Editions of the Encyclopedia Brittanica*. Edinburgh, 1824.

Hoare, Prince. *Academic Annals*. London, 1805.

Hogarth, William. *Analysis of Beauty*. London, 1753.

Lacombe, Jacques. *Dictionnaire portatif des beaux-arts*. Paris, 1753.

de Lairesse, Gerard. *La Grande Livre des peintres*. Paris, 1787 (Morse's edition).

Leonardo da Vinci. *A Treatise on Painting*. London, 1802 (Morse's edition).

Lomazzo, Giovanni Paolo. *Idea*. Bologna, 1785 (Morse's edition).

Mengs, Anton Raphael. *The Works of Anton Raphael Mengs*. London, 1796.

Opie, John. *Lectures on Painting*. London, 1809.

Reynolds, Sir Joshua. *Discourses*. London, 1797 (first collected edition).

Verplanck, Giulian C. *Address Delivered before the American Academy of Fine Arts*. New York, 1824.

West, Benjamin. "Discourses." In vol. 2 of *Life, Studies, and Works of Benjamin West*, ed. John Galt. London, 1820.

Whately, Thomas. *Observations on Modern Gardening*. London, 1770.

Criticism

Alison, Archibald. *Essays on the Nature and Principles of Taste.* London and Edinburgh, 1790.
Bacon, Francis. *Essays.* London, 1597.
Beattie, James. *Essays on Poetry and Music.* Edinburgh and London, 1776.
Blair, Hugh. *Lectures on Rhetoric and Belles Lettres.* London, 1783.
Burke, Edmund. *A Philosophical Inquiry into the Origins of Our Ideas of the Sublime and Beautiful.* London, 1757.
Gerard, Alexander. *An Essay on Taste.* London, 1759.
Harris, James. *Three Treatises.* London, 1744.
Kames, Lord. *Elements of Criticism.* Edinburgh, 1762.
Knight, Richard Payne. *An Analytical Inquiry into the Principles of Taste.* London, 1805.
Price, Uvedale. *An Essay on the Picturesque.* London, 1794.
Priestley, Joseph. *A Course of Lectures on Oratory and Criticism.* London, 1777.
Reid, Thomas. *Essays on the Powers of the Human Mind.* Edinburgh, 1803.
Rollin, Charles. *Method of Teaching and Studying the Belles Lettres.* London, 1734.
Stewart, Dugald. *Elements of the Philosophy of the Human Mind.* London, 1792.
Twining, Thomas. *Aristotle's Treatise on Poetry.* London, 1789.

Classical Literature

Aristotle. *Poetics.*
Homer. *Iliad.*
Horace. *Art of Poetry.*
————. *Epistles.*
Pliny the Elder. Book 35 of *Natural History.*
Quintilian. *Institutes of the Orator.*
Virgil. *Aeneid.*

English Poetry

Atherstone, Edwin. *Last Days of Herculaneum.* London, 1821.
Beattie, James. *The Minstrel.* London, 1771.
————. *The Hermit.* London, 1771.
Byron, Lord. *Lara.* London, 1814.
Cowper, William. *The Cricket.* In *Poems by William Cowper.* London, 1782.
Dryden, John. *Alexander's Feast.* London, 1697.
Mason, William. *Caractacus.* London, 1759.
Milton, John. *Paradise Lost.* London, 1667.
Pope, Alexander. *Epistle to Mr. Jervas.* In *The Art of Painting by C. A. du Fresnoy.* London, 1716.
————. *Epistle to Mr. Addison, Occasioned by his Dialogue on Medals.* In *The Works of Alexander Pope.* London, 1720.
Shakespeare, William. *Macbeth.* 1605.



Miscellaneous

Butler, Joseph. *Analogy of Religion.* London, 1736.

Chalmers, Thomas. *Discourses on the Christian Revelation Viewed in Connexion with Modern Astronomy.* New York, 1817.

Chambers, Ephraim. *Cyclopedia.* London, 1728.

Forsyth, Joseph. *Remarks on Antiquities, Arts, and Letters, During an Excursion in Italy, in the Years 1802 and 1803.* London, 1813.

Gillies, John. *History of Ancient Greece.* Dublin, 1784–1785.

Kett, Henry. *Elements of General Knowledge.* Oxford, 1802.

Pomey, François Antoine. *Indiculus Universalis.* London, 1679[?] (English edition).

Villers, Charles. *An Essay on the Spirit and Influence of the Reformation of Luther.* London, 1805.

Whitlock, Richard. *Zootomia: or, Observations on the Present Manners of the English.* London, 1654.

Periodicals

Edinburgh Review (Edinburgh).

Magazine of the Fine Arts (London).

Quarterly Review (London).

SOURCES USED BY THE EDITOR

Cikovsky, Nicolai, Jr. " 'To enlighten the public mind, . . . to make the way easier for those that come after me': Samuel Morse as a Writer and Lecturer." In *Samuel F. B. Morse: Educator and Champion of the Arts in America* (exhibition catalogue, National Academy of Design). New York, 1982.

Cummings, Thomas S. *Historic Annals of the National Academy of Design.* Philadelphia, 1865.

Dunlap, William. Chap. 23 in vol. 2 of *History of the Rise and Progress of the Arts of Design in the United States.* New York, 1834.

Howe, Winifred E. *History of the Metropolitan Museum.* New York, 1913.

Larkin, Oliver W. *Samuel F. B. Morse and American Democratic Art.* Boston, 1954.

Mabee, Carlton. *The American Leonardo: A Life of Samuel F. B. Morse.* New York, 1943.

Morse, Edward Lind, ed. *Samuel F. B. Morse: His Letters and Journals.* Boston and New York, 1914.

Morse, Samuel F. B. *Academies of Art.* New York, 1827.

———. *Fine Arts: A Reply to Article X, no. LVIII in the North American Review.* New York, 1828.

———. *Examination of Colonel Trumbull's Address.* New York, 1833.

Morse Exhibition of Arts and Sciences (exhibition catalogue, National Academy of Design). New York, 1950.

Prime, Samuel I. *The Life of Samuel F. B. Morse, LL.D.* New York, 1875.

Reynolds, Gary A. "New York University's First Professor of Fine Arts." In *Samuel F. B. Morse* (exhibition catalogue, The Grey Art Gallery, New York University). New York, 1982.

"S. F. B. Morse, LL.D." *Harper's Weekly* 16 (20 April 1872): 311.

Staiti, Paul J. "Samuel F. B. Morse in Charleston, 1818–21." *South Carolina Historical Magazine* 79 (April 1978): 87–112.

————. "Samuel F. B. Morse and the Search for the Grand Style." Ph.D. diss., University of Pennsylvania, 1979.

————. "Samuel F. B. Morse's Search for a Personal Style: The Anxiety of Influence." *Winterthur Portfolio* 16 (Winter 1981): 253–281.

————. "Ideology and Politics in Samuel F. B. Morse's Agenda for a National Art." In *Samuel F. B. Morse: Educator and Champion of the Arts in America* (exhibition catalogue, National Academy of Design). New York, 1982.

————. "Samuel F. B. Morse and the Search for the Grand Style." *Samuel F. B. Morse* (exhibition catalogue, The Grey Art Gallery, New York University). New York, 1982.

Tatham, David. "Samuel F. B. Morse's *Gallery of the Louvre:* The Figures in the Foreground." *American Art Journal* 13 (Autumn 1981):38–48.

Tuckerman, Henry T. *Artist-Life; or, Sketches of American Painters.* New York, 1847.

————. *Book of the Artists.* New York, 1867.

Wehle, Harry B. *Samuel F. B. Morse, American Painter* (exhibition catalogue, Metropolitan Museum of Art). New York, 1932.

Wynne, James, "Samuel F. B. Morse," *Harper's New Monthly Magazine* 26 (January 1862), 224–232.

Index

DATE DUE